THE ADDAMS FAMILY

THE ART OF THE ANIMATED MOVIE

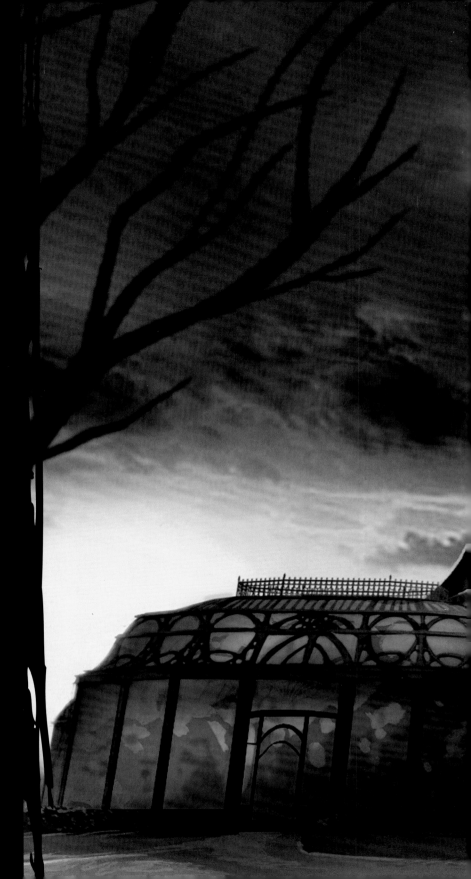

THE ADDAMS FAMILY: THE ART OF THE ANIMATED MOVIE
ISBN: 9781789092752

Published by
TITAN BOOKS
A division of Titan Publishing Group Ltd
144 Southwark St, London SE1 0UP

www.titanbooks.com

First edition: October 2019
10 9 8 7 6 5 4 3 2 1

Did you enjoy this book? We love to hear from our readers. Please e-mail us
at: readerfeedback@titanemail.com or write to Reader Feedback at the above
address.

To receive advance information, news, competitions, and exclusive offers online, please
sign up for the Titan newsletter on our website: www.titanbooks.com

Case: Addams mansion exterior – concept art

Right: Addams mansion exterior – lighting key

Next spread: Pugsley's Sabre Mazurka – lighting key

THE ADDAMS FAMILY

THE ART OF THE ANIMATED MOVIE

TEXT BY
RAMIN ZAHED

FOREWORDS BY
CONRAD VERNON
AND GREG TIERNAN

TITAN BOOKS

Contents

Foreword by co-director and producer Conrad Vernon 006
Foreword by co-director Greg Tiernan 008
Introduction 010

CHARACTERS 016
Morticia 018
Gomez 024
Grandma 030
Wednesday 032
Pugsley 038
Uncle Fester 044
Lurch 050
Thing 056
It 058
Auntie Sloom 060
Socrates 062
Kitty 063
Animals 064
Extended Family 066
Portraits 070
Implements 076
Parker Needler 080
Margaux Needler 084
Eastfield Residents 088

LOCATIONS 094
The Old Country Town . . . 096
Addams Mansion 098
Ichabod 107
Foyer 108
Lurch's Padded Cell 112
Gomez & Morticia's Rooms . 114
Pugsley's Room 120
Wednesday's Room 124
Dining Room 128
Ballroom 130
Living Room 134
Kitchen 138
Fester's Room 140
Eastfield Estates Homes . . 144
Square 146
Middle School 148
Margaux's House 152
Vehicles 154

Anatomy of a Scene: Family Game Night 156
Conclusion 166
Acknowledgements & Glossary 168

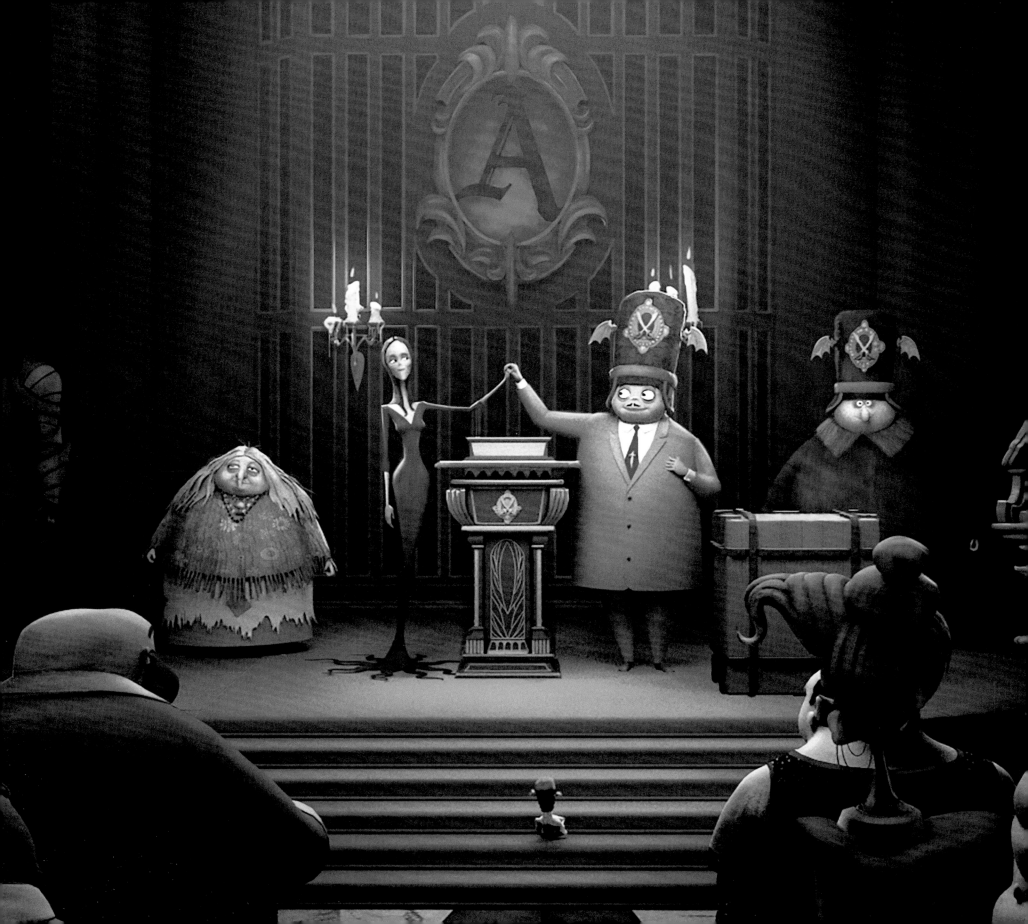

Foreword

By co-director and producer Conrad Vernon

When asked to direct an animated version of the Addams Family for MGM, the first thing I thought was, "There have been so many iterations of this kooky family. How do we make our version unique and fresh?" The answer came, ironically enough, by looking back to Charles Addams' original *New Yorker* cartoons. Writer Matt Lieberman and I decided to delve into a part of Addams lore that had not been explored yet. How the Addams Family came to be.

So, we started thinking about their history, and realized it would be particularly poignant to tell an immigrant story. The *New Yorker* cartoons Charles Addams had created in the thirties hinted at the idea this strange family was not necessarily American made. We realized this would be the lens through which we told this particular Addams Family story.

Once my directing partner Greg Tiernan, producer Alex Schwartz and I started looking at Charles Addams' old cartoons, we found gags, storylines, character designs and extended family members that would help fill out the part of the Addamses' world no one had used in any other adaptation, and with the help of our brilliant crew started crafting the beautifully macabre world which they inhabit.

The unique quality of the movie profoundly deepened with the addition of the wonderful cast we are lucky enough to have. The dialects, accents and speech impediments each member of the family has were mostly made up. From Bette Midler's somewhere in Eastern Europe Grandma, to Charlize Theron's mid-Atlantic, upper crust Morticia. Oscar Isaac's Latin lover Gomez and Nick Kroll's 'best lisp since Daffy Duck' Fester brought these well-known characters to life in a brand-new way.

It was challenging to make sure older die-hard fans would be pleased while also introducing a new generation to this beloved group of kooky characters. Charles Addams' unique sensibility and humor is what they love and is framed in the lyrics of the TV theme: creepy, kooky, mysterious and spooky. Definitely not the typical gross-out humor that can be so easy to fall back on. Looking at the film — which at the time of this writing is still being made — I think we've done what we set out to do. What has grown and found a life of its own is a story about a family that, in spite of their fascinatingly morbid tastes, loves and cares for each other. Something we can all admire and respect. I hope we've done Charles Addams proud in creating a unique and singular Addams Family movie fans of all ages can enjoy.

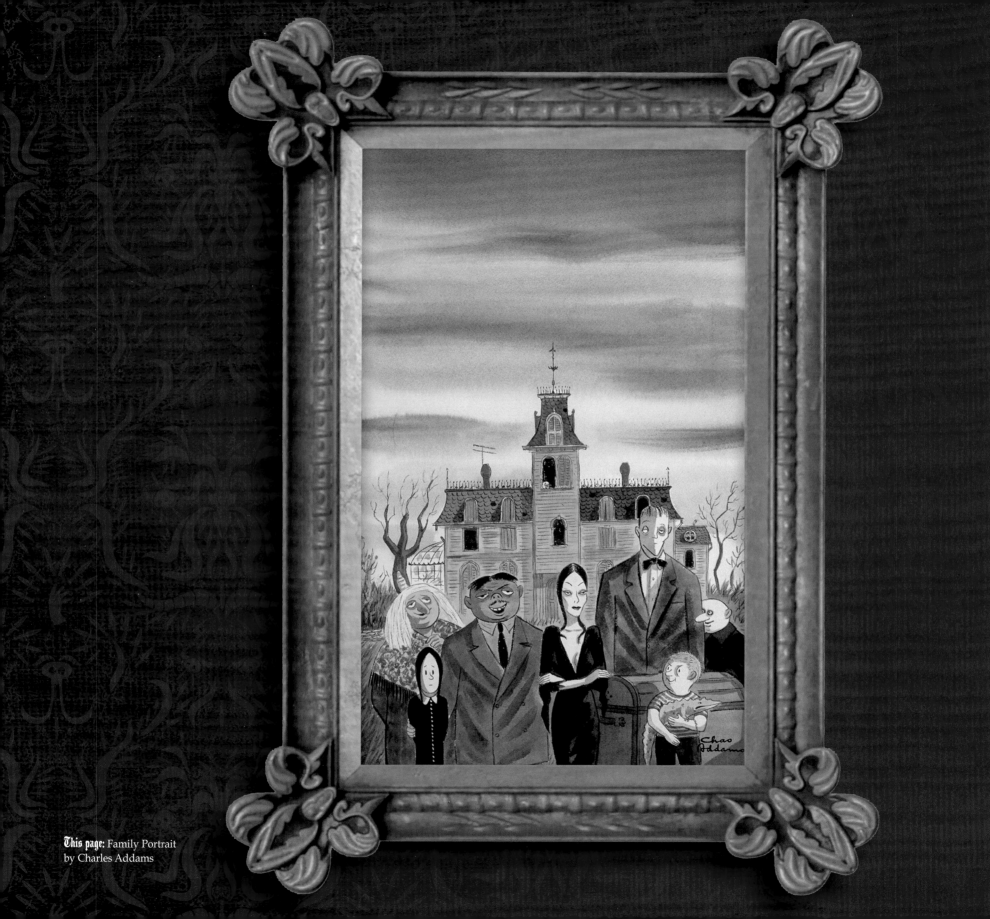

This page: Family Portrait
by Charles Addams

Foreword

By co-director Greg Tiernan

Ever since I was a little kid I've been fascinated by movies from the Golden Age of Hollywood, music from the 1950s, animation, comic strip cartoons and classic TV shows made before I was born. One such TV show was *The Addams Family*, which originally aired from 1964 to 1966 and starred the incomparable John Astin and Carolyn Jones as Gomez and Morticia. I watched and re-watched pretty much every episode during the 1970s when the show would run in an almost constant loop on British TV right after school was out.

When the opportunity presented itself, many years later, via a suggestion from my brilliant directing partner Conrad Vernon, to join him at the helm of an animated feature movie of *The Addams Family* for storied Hollywood studio MGM, I jumped at the chance.

From the outset we wanted to 'return to the well,' so to speak, to draw from the creative source. The work of Charles 'Chas' Addams, the creator of our wonderfully kooky family in his spot cartoons for *The New Yorker*, is so brilliant, and after so many years still so vibrant and full of humor, that it would be a crime of monstrous proportions, aesthetically speaking, if we ignored this inspirational treasure trove and tried to reinvent the wheel. Our version of the family has a

distinct tip of the hat to Chas Addams' original designs. With the amazing talent of production designer Patricia Atchison, character designer Craig Kellman, lighting supervisor Laura Brousseau, our fantastic crews in LA, Vancouver and Montreal, Conrad, myself and Alex Schwartz, our brilliant producer, saw the mysterious and spooky, all together ooky world of *The Addams Family* come to life and we loved it!

And it's not hard to fall in love with our gloriously dysfunctional family. The Addamses are a shining beacon of hope in a world that is so often sadly fearful of anything different. The need to embrace diversity and to accept and revel in the myriad wild and wonderful differences in all of us far outweighs the impulse to fear the unknown or the unusual. Our crew took the family to their hearts and the beautiful artwork in this book is testament to the love and devotion that they poured into our movie. Thank you, to each and every one of you.

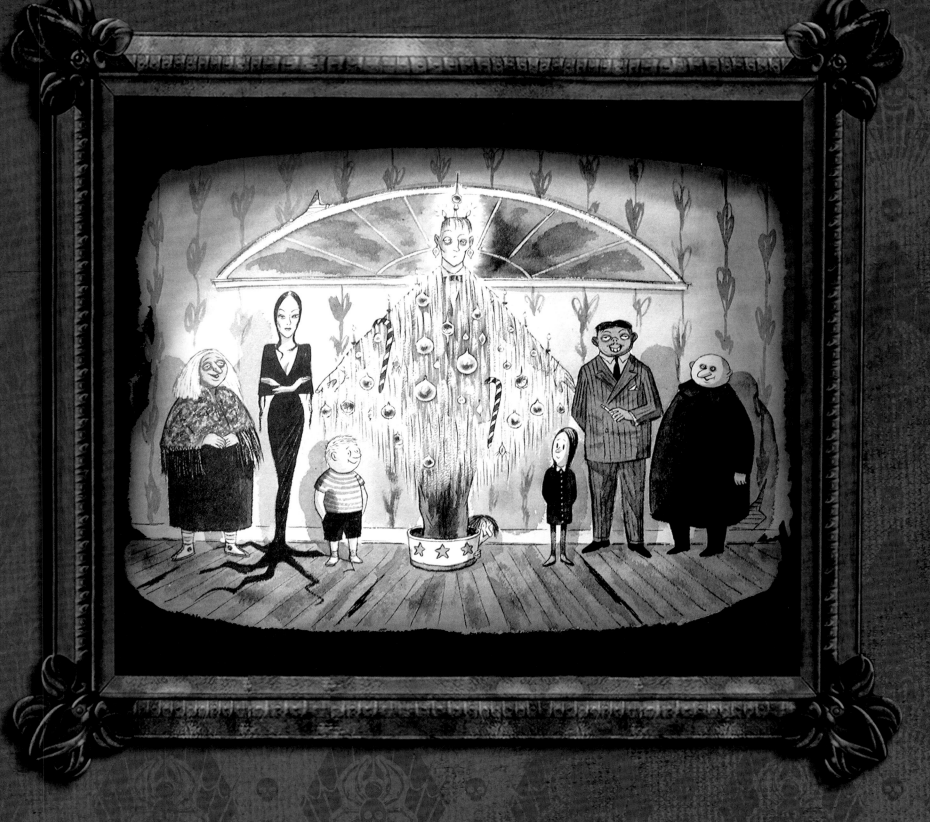

Introduction

Revisiting a Frightfully Fun Family

When *New Yorker* cartoonist Charles Addams introduced *The Addams Family* in 1938, few could imagine that his macabre yet lovable characters would have such a huge impact on the arts and pop culture worldwide, inspiring a hit TV series, several live-action movies, two animated series, and even a Broadway musical through the decades.

Now movie audiences are treated to new CG-animated incarnations of Gomez, Morticia, Wednesday, and Pugsley Addams, and family members Uncle Fester and Grandma, their butler Lurch, the disembodied hand Thing, and It in a charming comedy feature produced by Metro Goldwyn Mayer Pictures and Jackal Group/Cinesite Studios. While the film takes advantage of all the modern possibilities of CG technology, it is deeply faithful to Addams' original creation, which cleverly turned the family comic on its head and satirized the notion of a "normal" suburban household.

Directed by animation veterans Conrad Vernon (*Shrek 2, Monsters vs. Aliens, Madagascar 3, Sausage Party*) and Greg Tiernan (*Thomas & Friends, Sausage Party*), the movie finds the creepy, kooky clan clashing with a duplicitous home-makeover TV-host who is plotting to get rid of them. Echoing Addams' subversive style, the movie explores the very contemporary theme of acceptance of "the other" and the importance of embracing diversity in all its forms.

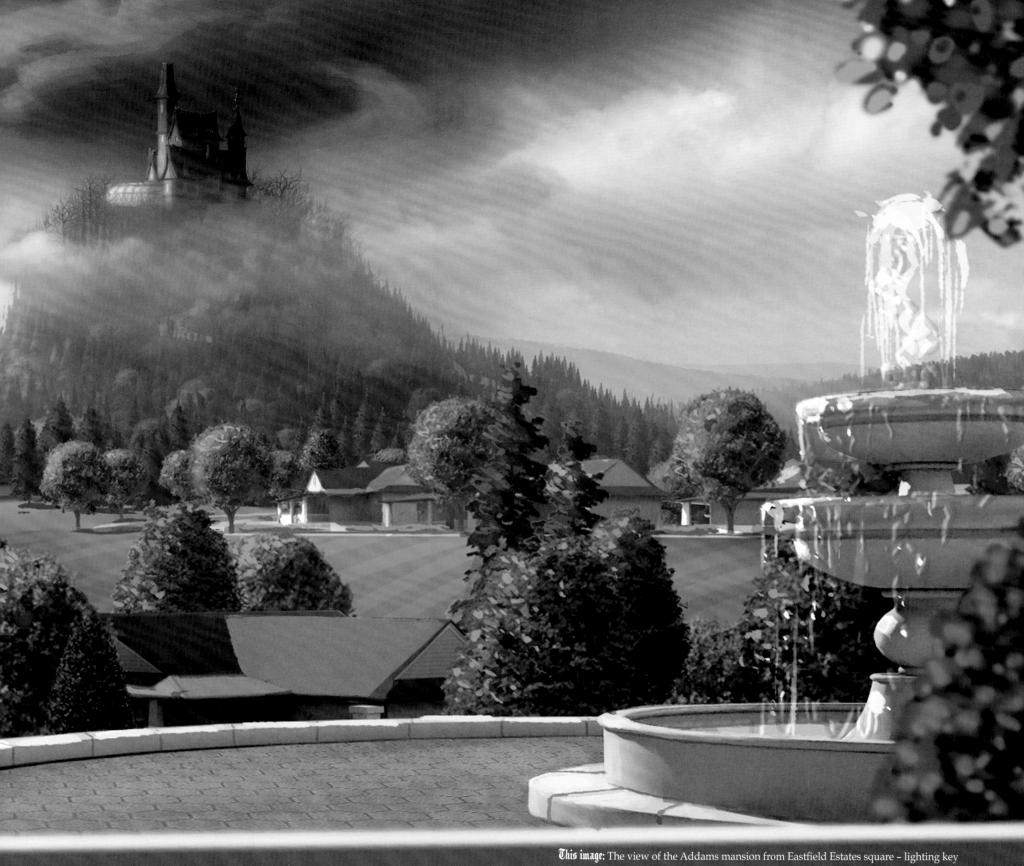

This image: The view of the Addams mansion from Eastfield Estates square – lighting key

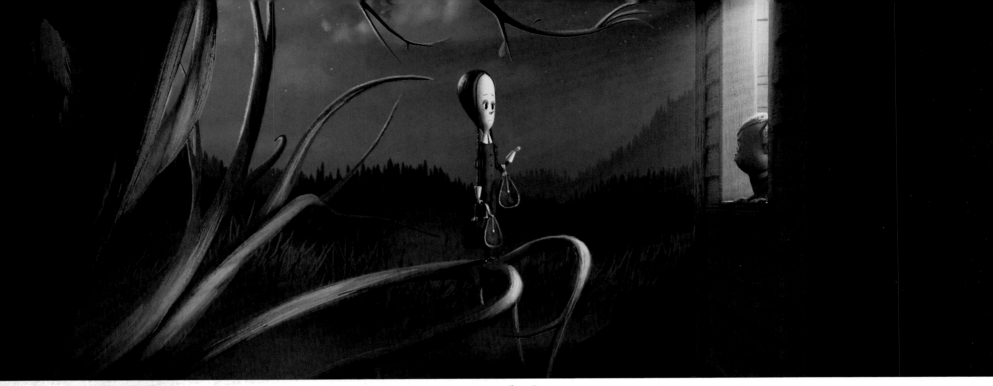

Vernon, who was developing various projects after his 2016 feature *Sausage Party* when he was approached by MGM to work on the property, was a bit hesitant at first. "I was a huge fan of the TV show when I was growing up," he notes. "But there had been so many different versions of *The Addams Family*. I really wanted to do something that hadn't been done before. As we went back to the old print comics, we came across some that were about Morticia before she met Gomez, and she was dating different men. So, writer Matt Lieberman and I thought it would be interesting to start the movie by offering a quick look at how Morticia and Gomez met and got married."

Making the Addamses an immigrant family provided the filmmakers with the opportunity to comment on some timely issues and include some important themes as well. "We thought it tied in very well with what is going on in America today," notes Vernon. "That gave us a good reason to tell the story right now. It let us explore the fact that despite their differences, this family deserves to have their home and realize their dreams just like everyone else in their new town."

Tiernan says he also fell in love with "*The Addams Family* as a young boy since, growing up in the UK, the show was constantly playing in reruns." He says he also embraced the idea of exploring the origins of the family, as Charles Addams never really offered too much of a background for the characters. "I am super proud of the emotional beats of the story, which tells the story about a family of outsiders," he explains. "In this day and age, unfortunately there are those who promote the distrust of people of different nationalities, ethnic backgrounds and sexual preferences. We think our movie offers the perfect opportunity to make a stand against discrimination. The Addamses are not trusted in this new neighborhood because they're different. We wanted to make the point that no matter how weird and different people are on the outside, we are all basically the same inside."

Producer Alex Schwartz says she also loves the fact that each of the Addams family members are such confident and eccentric outsiders. "They show their love and positivity to each other in such unconventional and surprising ways. They may be creepy, but they're also worldly and chic. Animation allows us to portray this rich, funny world in a magical way

where you can defy reality and push the boundaries in a really immersive way."

"I love the fact that the characters are, while different, all very charming, too," says producer Alison O'Brien. "I believe this is the first time we see the backstory of this iconic family. Developing the storyline and simultaneously having a large production team already sprinting for an ambitious release date has been a challenge for us, but it has all been a very interesting learning experience for everyone, since this is the first time the studio has actively produced an animated film."

Producer Danielle Sterling adds, "I love how our directors went back to the original cartoons, which were first seen on the pages of *The New Yorker*, when they and the team designed the characters and the iconic family mansion for our film. By embracing the iconic look and feel of Gomez, Morticia, Wednesday, Pugsley, Lurch, Grandma, Thing, and the family home, they were able to bring an authentic and genuine feel to the film, yet make it completely relatable and contemporary. This technique draws you into the movie and ensures that our version of *The Addams Family* will be timeless."

Devilishly Detailed

To flesh out the visuals of the movie, Vernon decided to contact one of his favorite character designers, former CalArts schoolmate Craig Kellman, who had also worked with him on *Madagascar 3, Monsters vs. Aliens* and *Sausage Party*. "When Conrad told me about the project, I thought it would be so much fun to go back to the original Charles Addams comics and use his remarkable drawings as a springboard," Kellman notes. "The goal was to take his shape language and make it more exaggerated and exciting. He had so much great iconography, so it's really fun to push and pull it and see how we could really translate it to CG animation."

"We wanted to make sure the movie wouldn't be derivative of anything but Addams' cartoons," says Vernon. "Once the story came together, and we saw this cohesive piece, I knew that we were on the right path and we could do something that was unique in its own way. When I was a kid, I loved the fact that the show made me squirm a little bit inside. They were like this car accident from which you couldn't turn away. You really fell in love with these characters and they have a wonderfully creepy class to them."

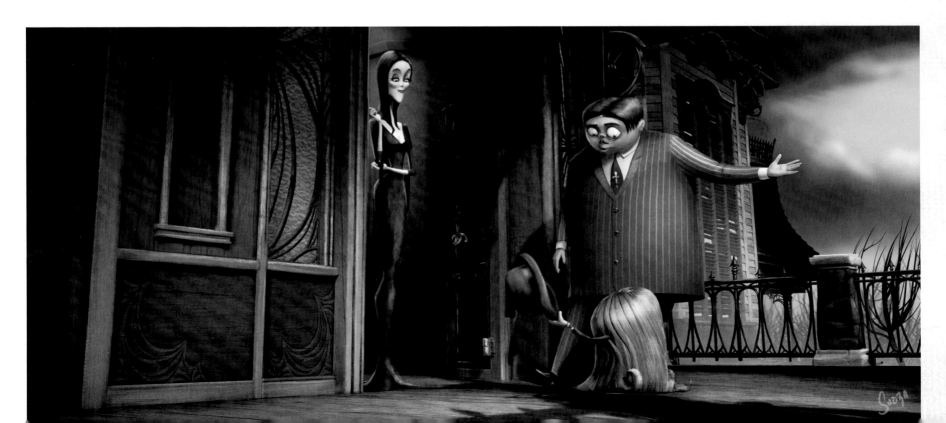

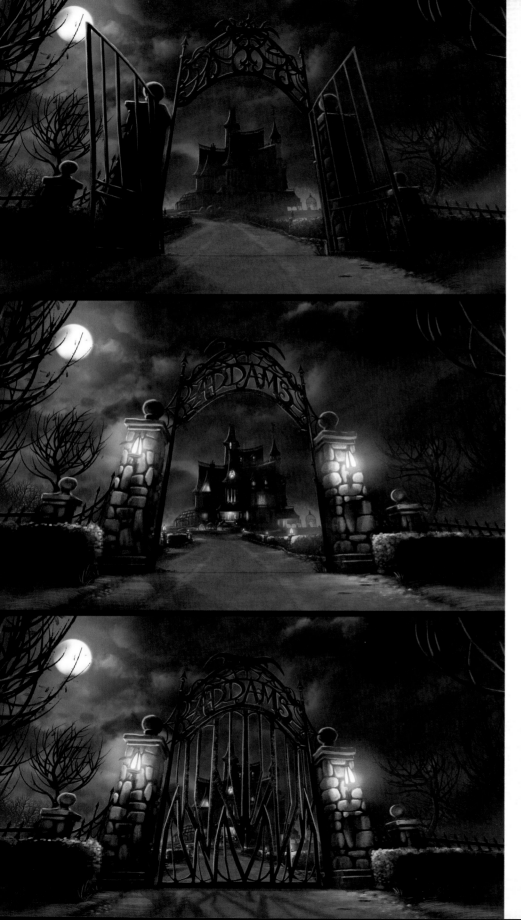

One of the most valuable resources for Vernon and his team was a book by H. Kevin Miserocchi (director of the Tee & Charles Addams Foundation) called *The Addams Family: An Evilution*, which includes character descriptions by the cartoonist himself. "He had written a paragraph on each one of the characters when the first TV show was being developed," explains Vernon. "That was everything we needed. I sent all of those descriptions to Craig Kellman, and we instantly knew who these characters were."

Vernon and Tiernan's previous movie collaboration, 2016's *Sausage Party*, was produced by Tiernan's animation studio Nitrogen, which was then acquired by visual effects house Cinesite in 2017. "What was nice about this plan was that since Greg didn't have to run his studio anymore, he could just be the co-director with me," says Vernon. "We used most of the same crew that worked on *Sausage Party* and hired some new people, about a hundred people at Cinesite and about eleven people at our satellite studio in Burbank. We just dove in and started production in the fall of 2017. This is possibly one of the fastest animated movies ever made, and I don't recommend anyone else doing it!" he says with a smile.

Now Serving Dilapidated Elegance

Vernon and Tiernan are very pleased with the striking visuals and dark, saturated colors of the movie. "We were very happy that the look of the movie was left to us one hundred percent," elaborates Vernon. "These days, there is a real aversion in the industry to doing anything that may look too dark or gloomy. Well, we weren't going to put Easter-egg colors in this movie. That would have been a recipe for disaster."

Production designer Patricia Atchison proved to be an invaluable addition to the team. "Like everyone else who worked on the project, Patricia really loves *The Addams Family*. She did a couple of incredible spec paintings where she repainted two original cartoons without the characters to give us an idea of the overall production design."

Atchison's paintings captured the spirit of Addams' original drawings beautifully, and they provided the team

the perfect guideline for the look of the movie. "We knew she had simply nailed it," recalls Vernon. "We wanted the whole movie to look like her paintings, which are a hyper-realistic version of the comics. Of course, because it was painted, it looked animated, but we didn't try to skew it or *cartoonize* the look. We left everything pretty straightforward and came up with this term 'dilapidated elegance.' That became our guide every step of the way."

Vernon believes what makes the Addamses' lifestyle so fascinating to us is how they enjoy the macabre with seamless sophistication and class. "With them, it's never about gross humor," he notes. "They are just weird and creepy, kooky, mysterious and spooky—like the TV theme song says. They are an elegant, sophisticated family who love each other—because they are the only people like them that they know. Patricia was finding that delicate line— it wasn't just [US documentary] *Grey Gardens*, with mice running everywhere. They have very elegant dinners… It just happens that they are serving a jello mold with a sea cucumber in it. It's nothing we'd ever eat, but it sure looks lovely. And they like spider-webs, only they have to be in the right place and hanging properly!"

"I absolutely love how dark the movie is," says Atchison. "So much of children's animation is always bright and colorful. So, creating something that was moodier and darker was a welcome challenge. It was a daring direction to go in as we emphasized the darkness and lack of color in the Addamses' world. I was afraid that they were going to add more color to the movie, but we did the opposite. They actually wanted to darken things a bit. As a result, the movie is beautiful and different, and I think audiences are going to absolutely fall in love with all the characters."

The movie's head of story Todd Demong says the team also found inspiration in classic movies such as Mel Brooks' *Young Frankenstein*. "We all love the classic Mel Brooks movie, and I think it helped us get the right comedic language for our movie. One of the hardest things about the Addams family is that when you think of them, you might think Halloween, or zombies, or the occult. But the Addamses never do any

of that. They're just spooky and weird. They don't summon the dead or use witchcraft. You get hints that they enjoy the darker side of things, but you never see them walk with a zombie or call upon the powers of the underworld!"

Demong thinks the characters' weirdness may be why they lend themselves so well to animation. "Animation allows you to do things with the family physically that would be a lot more complicated in live action," he explains. "Their expressions and shapes look so perfect because they echo the original illustrations by [Charles] Addams."

Opposite: The Addams mansion gates closing – lighting keys
Below: Gomez and Morticia share a tender moment – final frame still

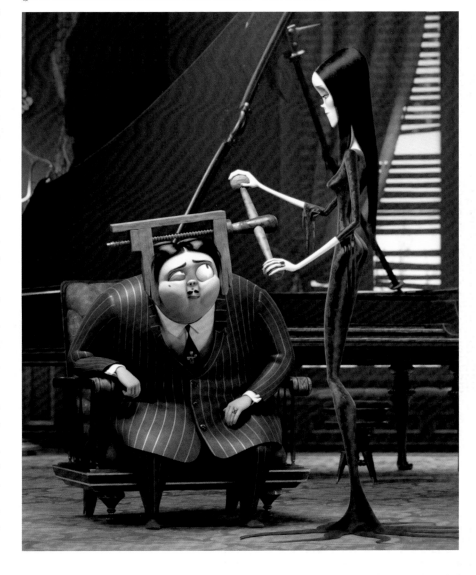

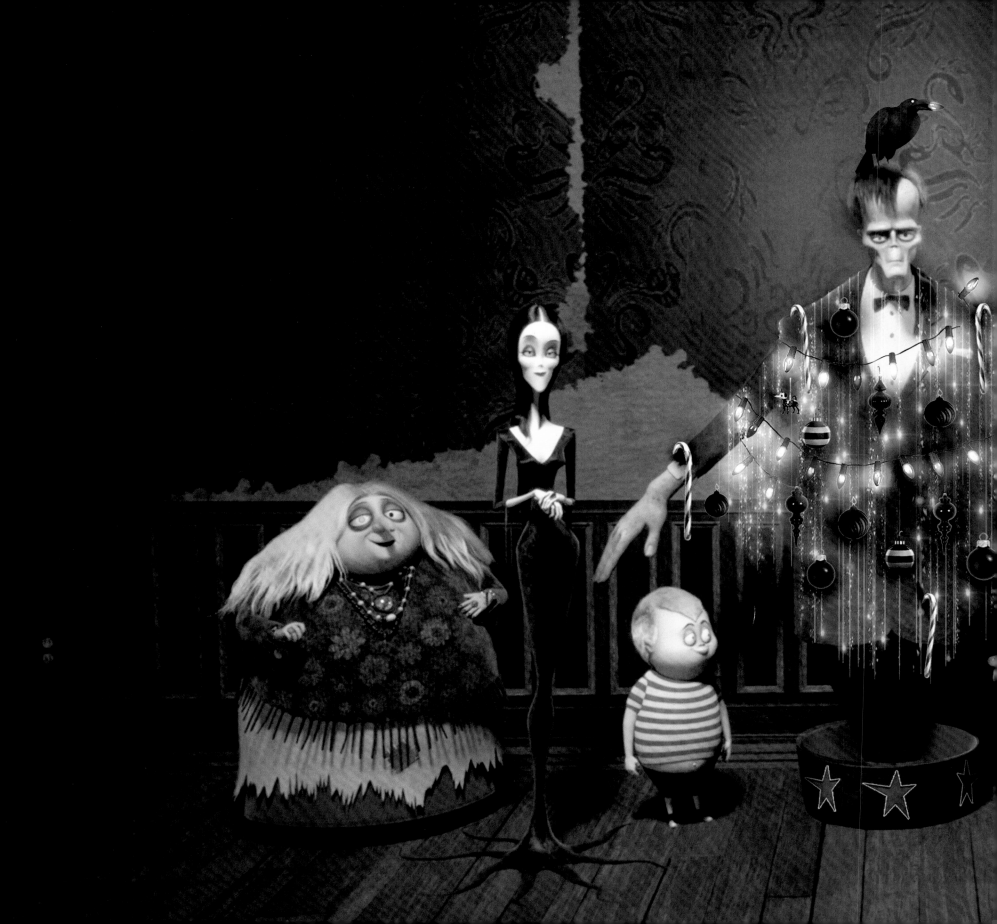

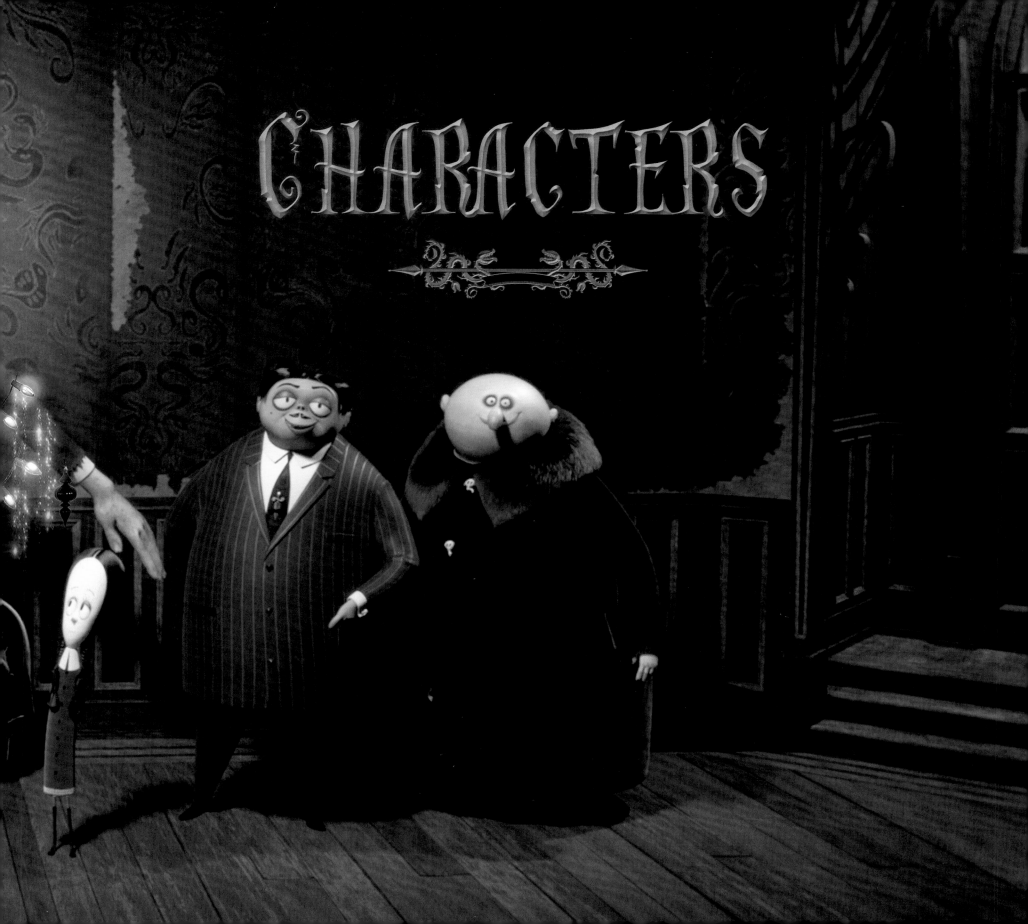

CHARACTERS

Morticia

Charles Addams claimed to have named the mysterious matriarch of the family by looking at the Yellow Pages and coming across a long "Morticians" section. He also considered Morticia to be the real head of the family.

Previous spread: Lurch Tree image – design surfacing study
Left: Young Morticia – final frame still
Above: Morticia and her iconic wicker chair

For director Conrad Vernon, Morticia is also the true heart and soul of the movie. "We knew she had to emote a little more in our story, since she is the one who is worried about Wednesday," he notes. "She also smiles a little more."

The always elegant and charming Morticia has been played by talented actresses, beginning with Carolyn Jones in the TV series (1964-1966), and also including the unforgettable Anjelica Huston in director Barry Sonnenfeld's movies in 1991 and 1993. "We knew we were certainly not going to be able to redo what Anjelica Huston did in the live-action movies," says Vernon. "That would have been a recipe for failure. I do love what Charlize Theron brought to the character. She emotes a little more, and we see more of the concerned mother side of Morticia. She worries about the family, and that gives her more uniqueness."

For character designer Craig Kellman, Morticia was a real dream to recreate on the page. "She is cold and stoic," he recalls. "She seems distant and disassociated, but that's part of her attraction. She glides instead of walking, and we were trying to really emphasize the way she floats… She never bounces."

Below: Young Morticia and Young Gomez – final frame still

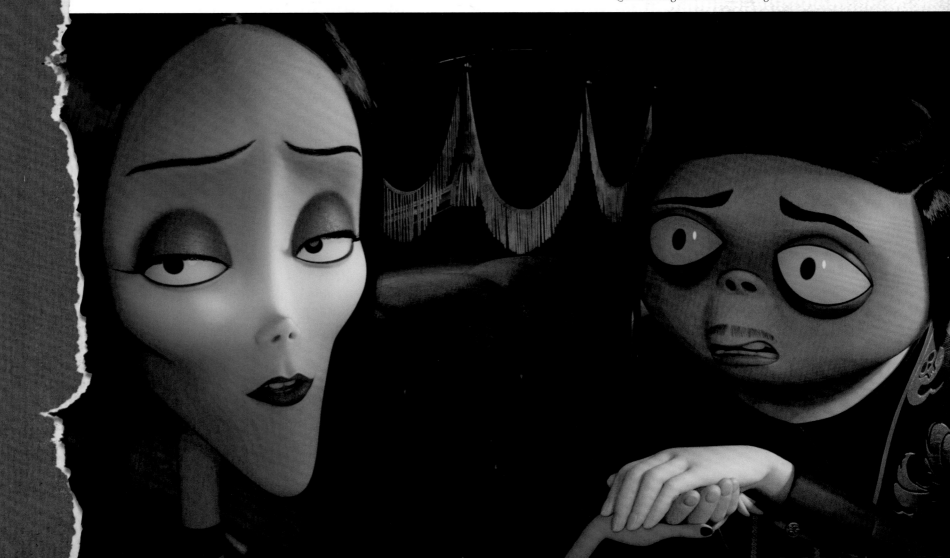

Kellman says Morticia is supposed to be witchy and beautiful—with supernaturally white skin. "She's cut from the same cloth as Vampirella [the comic-book vampire heroine created by Forrest J. Ackerman and Trina Robbins]," he says. "Her hair is straight and always parted in the middle, accentuating her very large forehead, and her chin is pointy. In fact, she is more angular than the other characters. Although she's gaunt and sharp, her body has feminine curves, and her hair echoes that."

Not surprisingly, the bottom of Morticia's long black dress resembles the tentacles of an octopus, so that when she glides across the floor, those tentacles articulate. She is certainly one of the most memorable gothic characters ever created, and one that is a pleasure to follow throughout the movie.

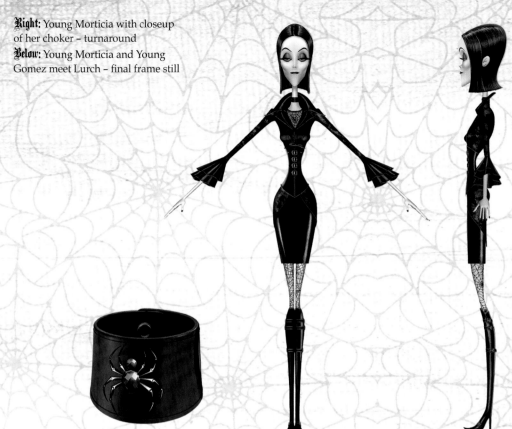

Right: Young Morticia with closeup of her choker – turnaround
Below: Young Morticia and Young Gomez meet Lurch – final frame still

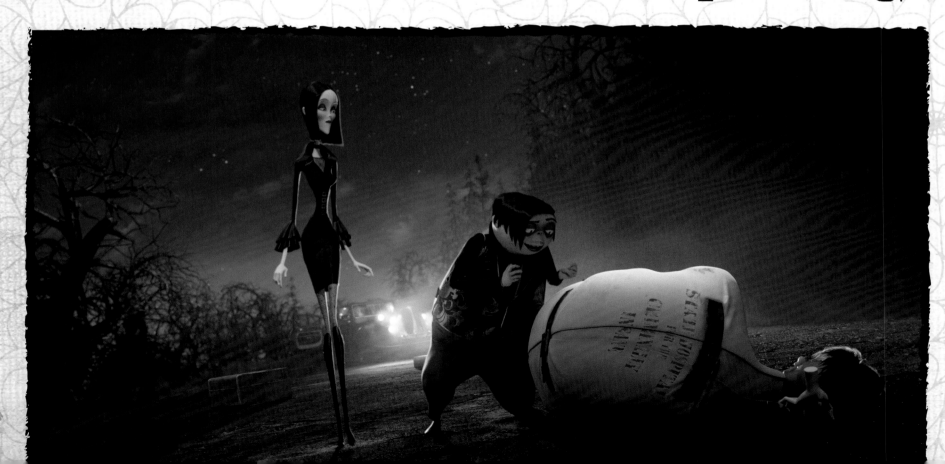

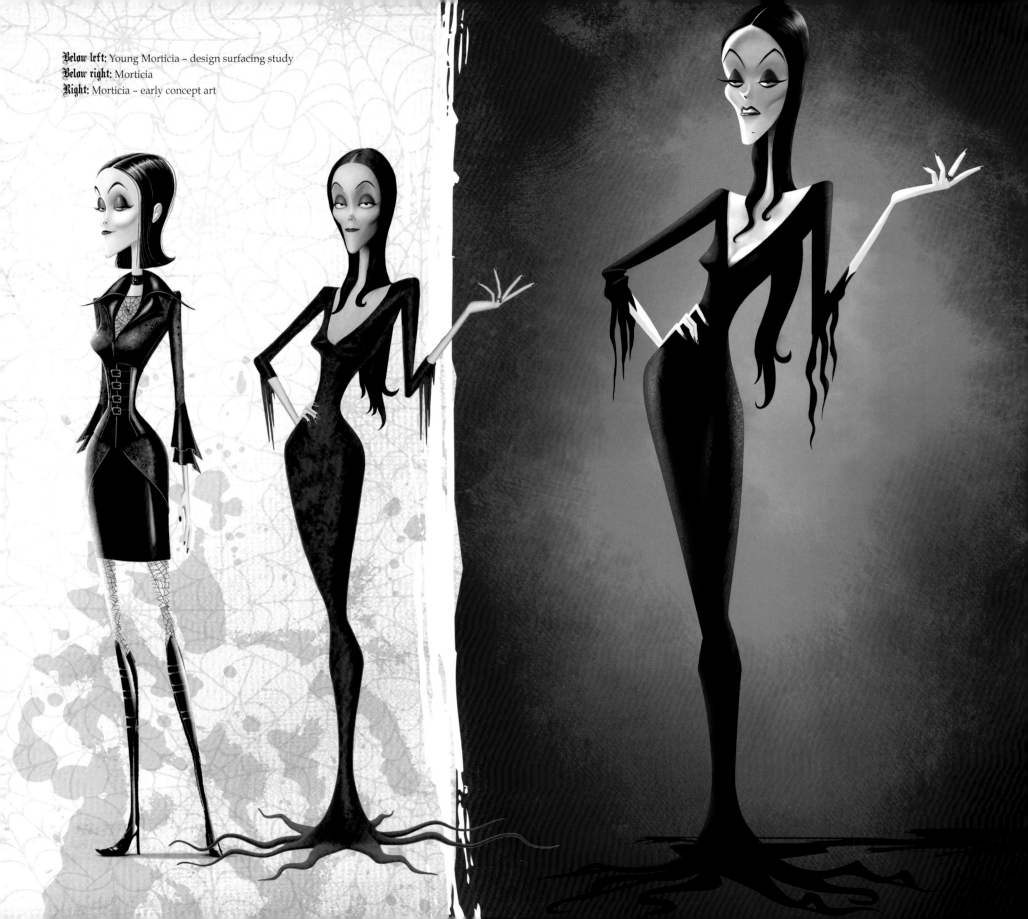

Below left: Young Morticia – design surfacing study
Below right: Morticia
Right: Morticia – early concept art

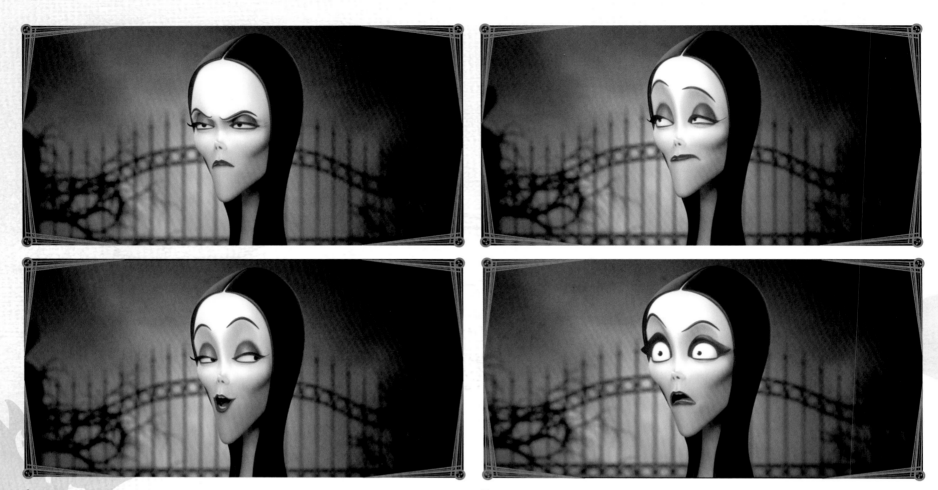

Above: Morticia – expressions study
Below: Morticia – modeling

Below: Morticia embracing the stormy weather – final frame still

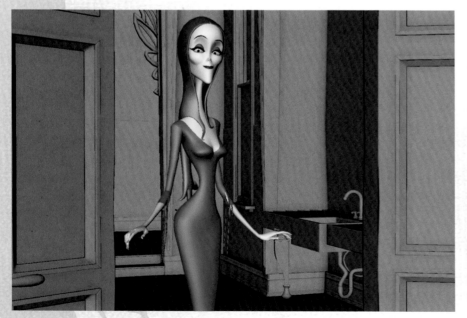

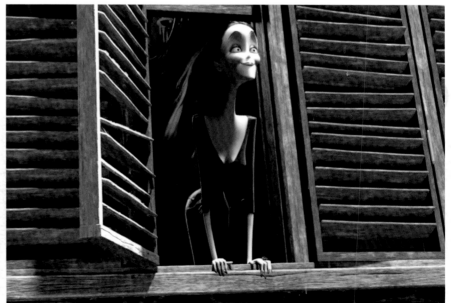

"One of the big challenges for the surfacing team was creating the right skin tone for Morticia and Wednesday. They are very pale, but you don't want them to look dead, so we had to spend a lot of hours making sure the final result looked good. In many instances, what looks great in the painting stage can look off when you put it on the models."
Marie-Eve Kirkpatrick,
Surfacing Head

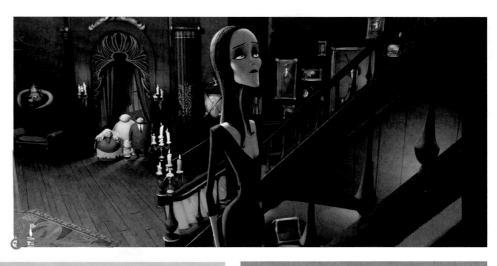

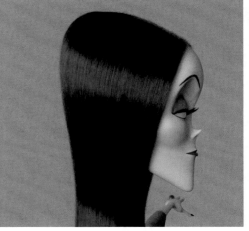

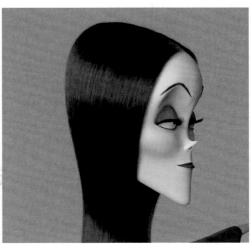

Left: Morticia – design surfacing study
Far left: Neckline lace trim for Morticia's Sabre Mazurka dress – design surfacing study
Top: Morticia worries about Wednsday – final frame still
Above: Morticia's face – modeling turnaround
Right: Morticia's face – look render turnaround

Gomez

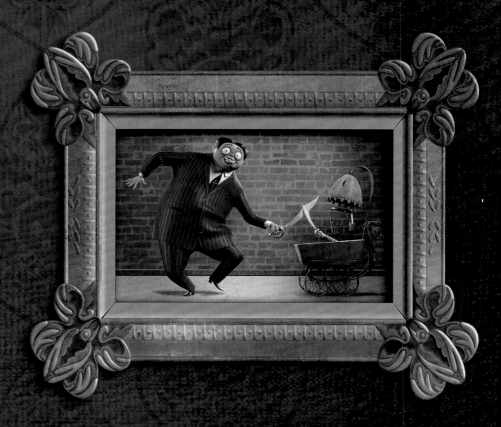

While most people think of Gomez as a suave, handsome lady's man, thanks to the popular portrayals by John Astin and Raul Julia in the previous TV and movie versions of the Addams clan, he is physically quite different in the original *New Yorker* cartoons. Shorter and rounder than the live-action versions, Gomez is crafty, but also sentimental, jolly, and enthusiastic.

Left: Gomez
Right: Gomez and baby Pugsley – design surfacing concept art
Opposite: Gomez in the dining room – concept art

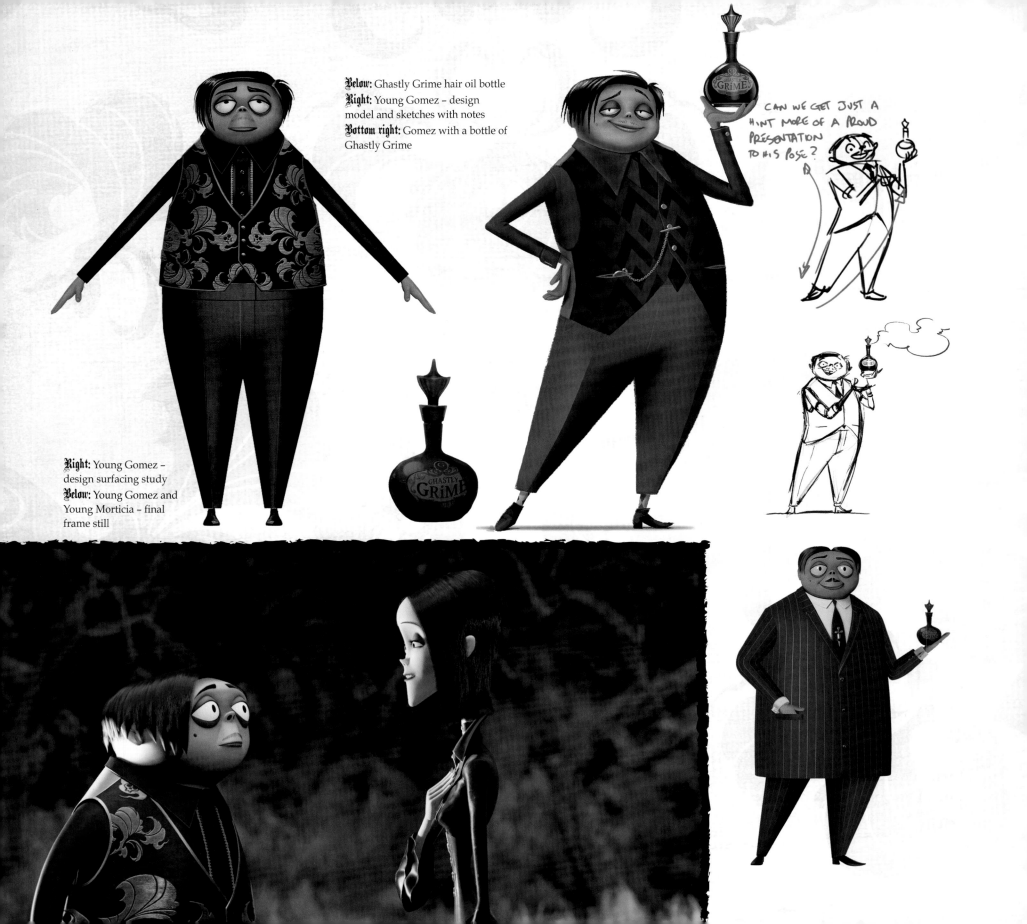

Below: Ghastly Grime hair oil bottle
Right: Young Gomez – design model and sketches with notes
Bottom right: Gomez with a bottle of Ghastly Grime

Right: Young Gomez – design surfacing study
Below: Young Gomez and Young Morticia – final frame still

CAN WE GET JUST A HINT MORE OF A PROUD PRESENTATION TO HIS POSE?

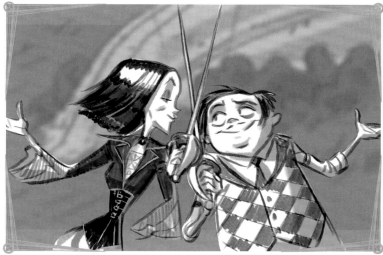

Above: We Meet Young Gomez – storyboard panel
Right: Gomez – early concept art

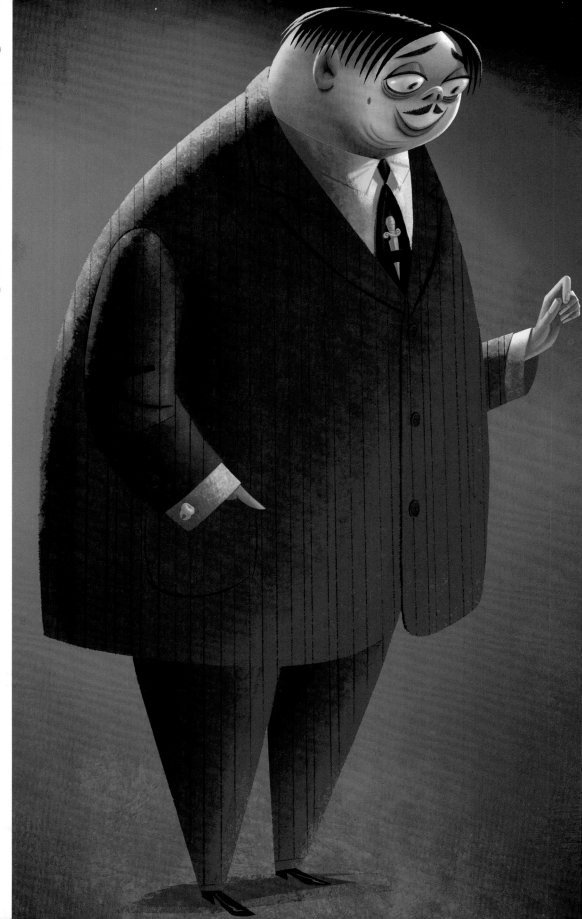

Director Conrad Vernon explains, "With Gomez, we wanted to go back to Charles Addams' version, so he was not going to be Raul Julia. We weren't going to copy that. He is a little tubby, and stockier. But at the same time, he's not lazy, nor a glutton. He's very debonair. We were thinking of someone like Jackie Gleason—a big man who is light on his feet. Gomez wields his sword with perfection. We see him do backflips and cartwheels. We got this from the TV show, where he even stands on his head to relax and meditate. We took these elegant qualities of Raul Julia and John Astin and put them in Charles Addams' original design."

Designer Craig Kellman says Gomez has always been one of his favorite characters. "We decided to stick very closely to the original Addams cartoon for Gomez," he notes. "We started to squash and stretch him a little bit. His drawings and proportions are quite varied in the comics. Unlike characters like the Flintstones or the Incredibles, his head is smaller than his body. Gomez's body is about six heads high. His body shape is almost like a bell—it's quite big and broad. We kept the iconic pointy scalloped hair, which looks like knives and is in contrast to his softer features."

Voiced by Oscar Isaac, the animated movie version of Gomez is just as loving to his wife and children. "He is dark and macabre, but he is a true romantic at heart," says Kellman. "I remember how much fun it was to watch Gomez and Morticia as a couple on TV. He was so warm and vibrant, and Morticia was cool and stoic. The more stoic she was, the more excited he became!"

"I have always loved Gomez best of all, because he has such a great zest for life and it shows. It's also fun to draw, act and watch!"
Todd Demong, Head of Story

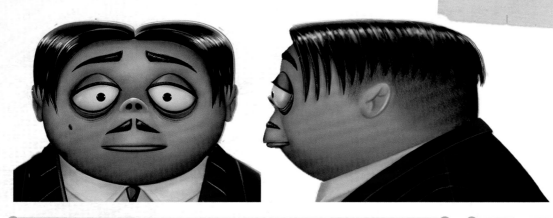

Left: Gomez – design surfacing study
Below: Gomez – expressions study
Opposite top: Gomez and Morticia by a bridge – early unused concept art
Opposite bottom left: Gomez and detail of the pattern on Gomez's tie – look render

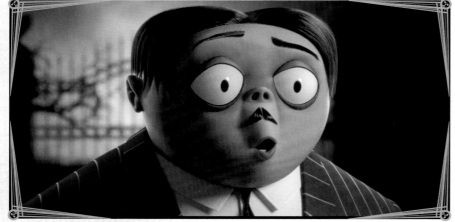

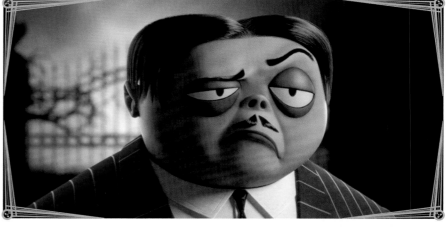

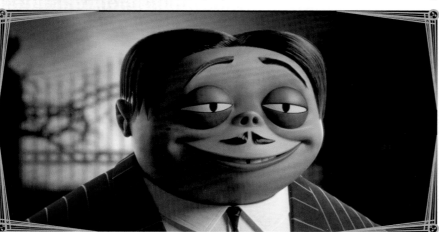

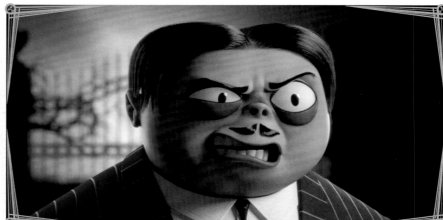

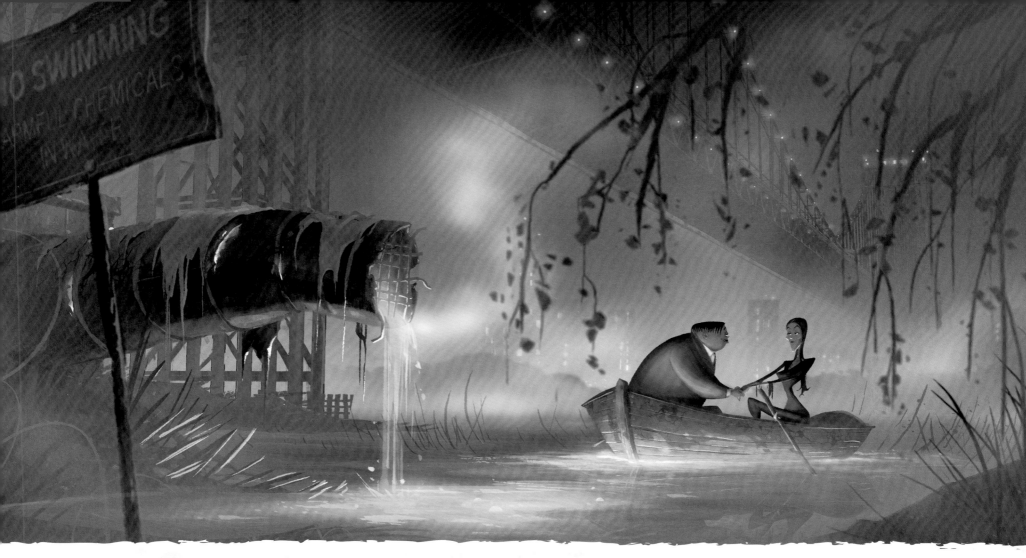

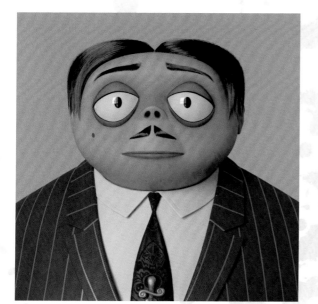

Right: Gomez mummy – unused design concept

Far right: Gomez mummy – early unused storyboard panels

Grandma

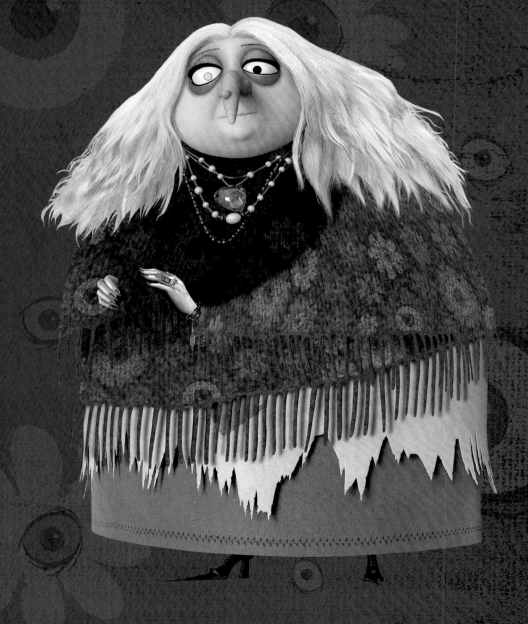

Who can resist Gomez's mother, a white-haired hag who always wears a shawl, loves to make cookies in the shape of bats and skulls, and wears thick socks with fleece slippers? Addams introduced her in 1941 as the smiling old woman from whom Morticia is requesting a cup of cyanide.

For the movie, director Conrad Vernon wanted Grandma to be more of a worldly, eccentric Auntie Mame type of character. "We didn't want her to be an old biddy who just hobbles around and is seen stirring a pot," he explains. "We wanted her to be someone with amazing experiences, someone who

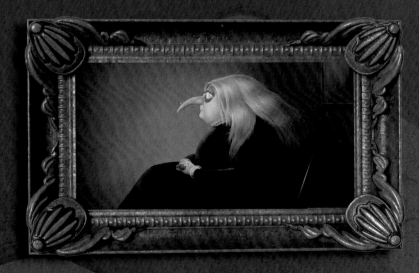

Above: Grandma – design surfacing study
Right: Grandma

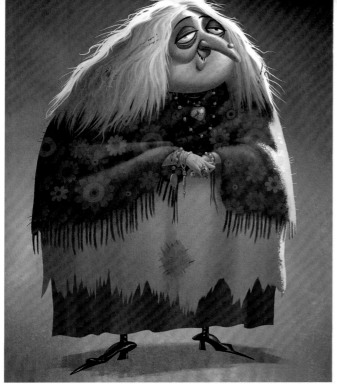

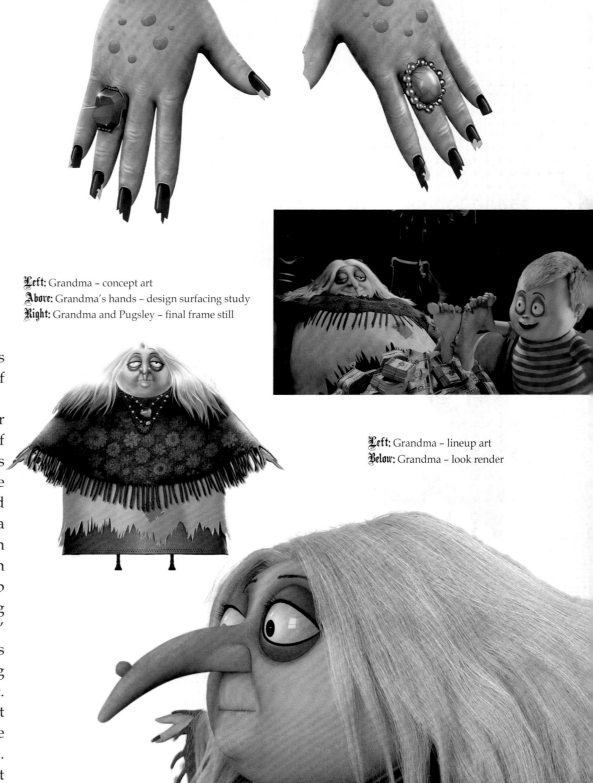

Left: Grandma – concept art
Above: Grandma's hands – design surfacing study
Right: Grandma and Pugsley – final frame still

Left: Grandma – lineup art
Below: Grandma – look render

travels the world, smuggles red cha cha heels from Prague and dances with the prince of Transylvania."

Casting the phenomenal actress Bette Midler to voice the character proved to be a stroke of genius. As Vernon remembers, "She asked us what kind of an accent we wanted her to create for the character. I told her that she didn't need to come up with a specific one. Granny's from a non-specific 'old country.' So, she came up with this perfect accent, which is kind of East European Jewish mixed with Romanian. She could slip in and out of it, and she brought this amazing uniqueness that we all expect from Bette Midler."

"We took some of the Charles Addams drawings for the shapes," recalls designer Craig Kellman. "I tweaked the proportions a little bit. In the comic, she was a stereotypical hag, but she's Gomez's mom, so I wanted her to have the same eyes as her son. We kept the old-hag nose. She seemed pretty grumpy on the TV show, but her character is more colorful in our movie."

Wednesday

Wednesday, the moody young daughter of the family, previously immortalized by Lisa Loring in the TV series and Christina Ricci in the Sonnenfeld movies, is one of the most popular characters in the franchise. In the animated movie, it's Wednesday's identity crisis and questioning of her family's ways in contrast with the outside world that is the emotional center of the plotline.

Left & right: Wednesday

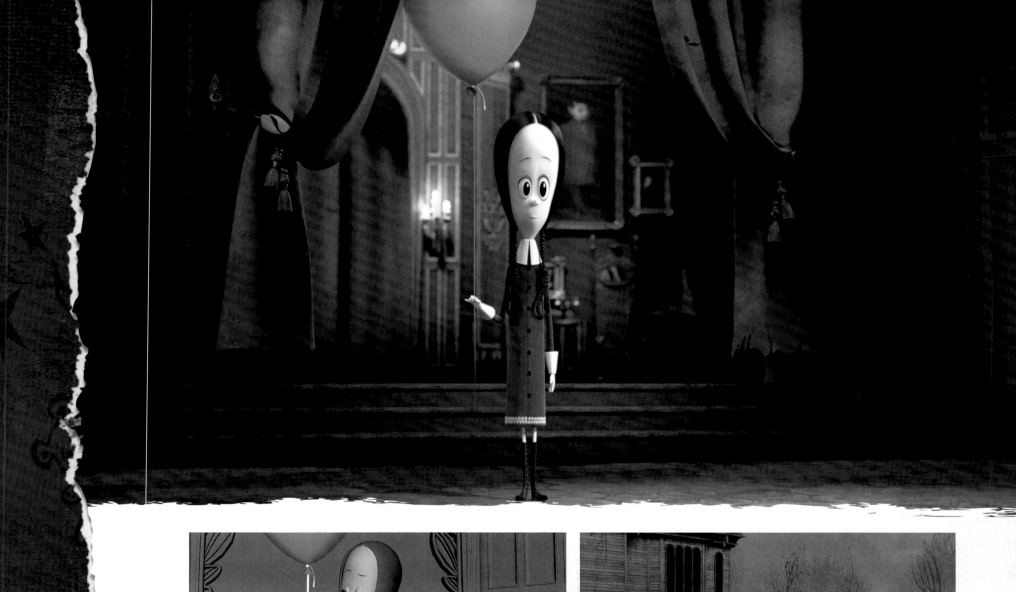

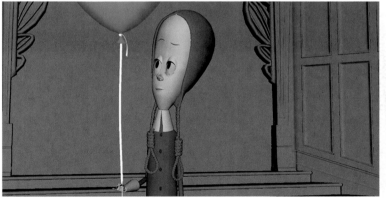

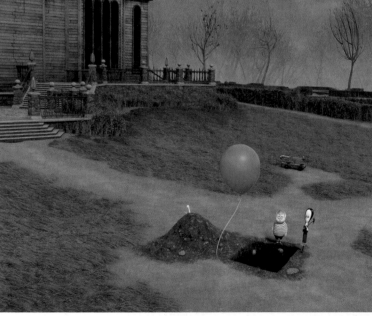

Top & right: Wednesday finds a red balloon – final frame stills
Above: Shot from the same scene – in development

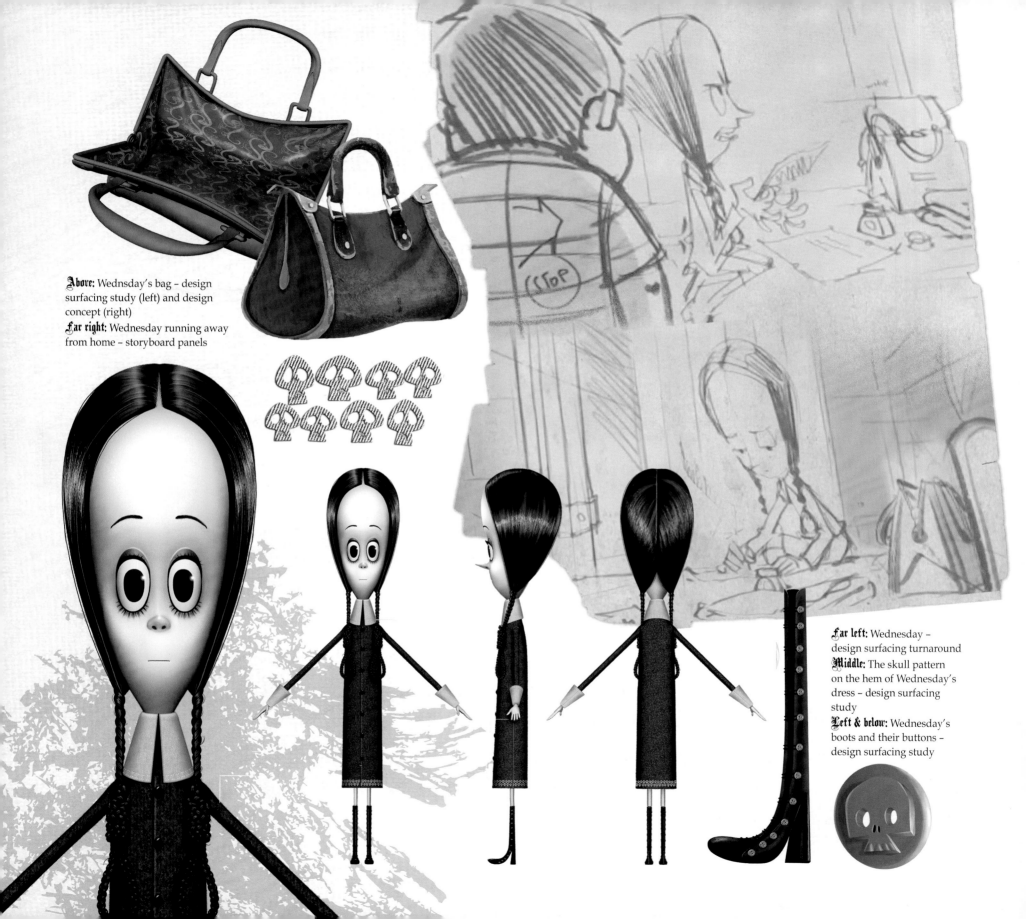

Above: Wednsday's bag – design surfacing study (left) and design concept (right)

Far right: Wednesday running away from home – storyboard panels

Far left: Wednesday – design surfacing turnaround

Middle: The skull pattern on the hem of Wednesday's dress – design surfacing study

Left & below: Wednesday's boots and their buttons – design surfacing study

"Christina Ricci did such a great job in the movies that we had to pivot to the left and right to do something different with the character for our project," says director Conrad Vernon. "We were fortunate to have Chloe Grace Moretz as our Wednesday, and she did a fantastic job with the part. In our movie, she is curious about the outside world and wants to be part of it. She meets Parker, the daughter of a reality TV show star, and she likes having her as a friend."

Below: Wednesday goes to Parker's house – storyboard panel
Bottom: Wednesday runs away from home – final frame still
Right: Wednesday – character lineup line drawing
Far right: Wednesday – early concept art

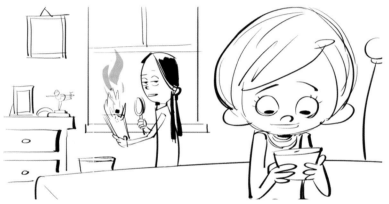

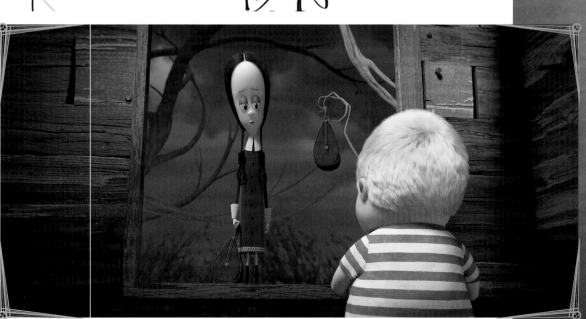

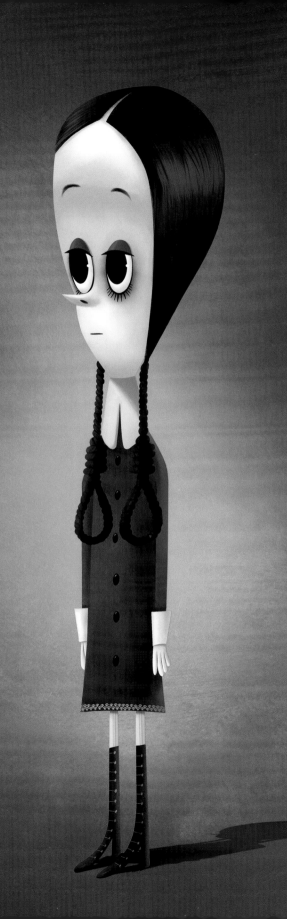

"I loved that Wednesday has these big, dark eyes, and I was afraid that they weren't going to fly," says character designer Craig Kellman. "I kept the pupils very large within the eye shape and brought the eyelids down to give her a little bit of a connection to Morticia, and also more of a connection to Christina Ricci in the movies, as she is a little more deadpan, like her mom. In the comic, she looks a little more wide-eyed and doe-eyed and, I think, in the TV show and later in the movies, she is more stoic, emo and serious."

Producer Danielle Sterling adds, "Wednesday embodies what *The Addams Family* is all about. She steals your heart, makes you laugh, and leaves you wishing she was part of your own family!"

Left: Wednesday's pyjamas – design surfacing study
Below: Wednesday sleeping in her pyjamas – final frame still

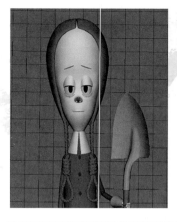 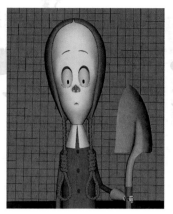 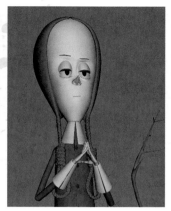

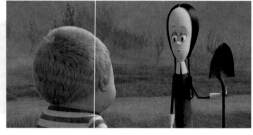 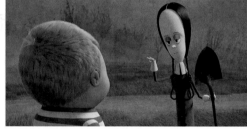

Top: Wednesday in the garden – shots in development
Above: Wednesday and Pugsley in the garden – final frame stills
Below: Wednesday is born – storyboard panel

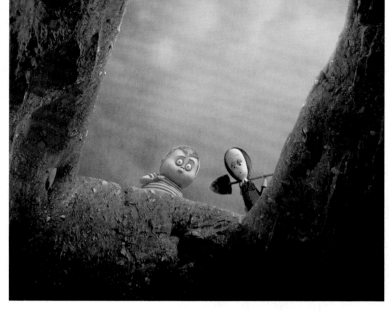

Above: Wednesday in the garden with Pugsley – final frame still
Below: Wednesday and Parker climbing Ichabod – final frame still
Bottom: Wednesday at the Addams mansion gate – final frame still

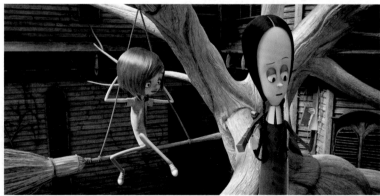

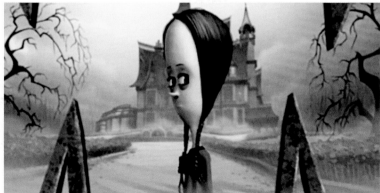

Pugsley

One of Charles Addams' drawings of Pugsley, the nine-year-old son of the family, has him casually tossing thumbtacks to the ground as he walks by with a devilish look on his face. That pretty much sums up the general description of the little monster.

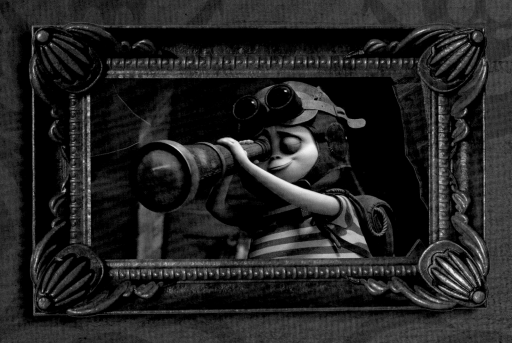

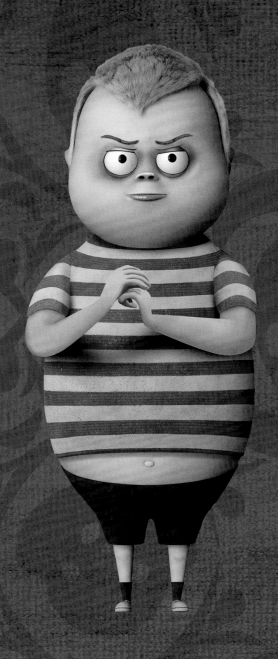

Above: Pugsley spotting his father – final frame still
Right: Pugsley

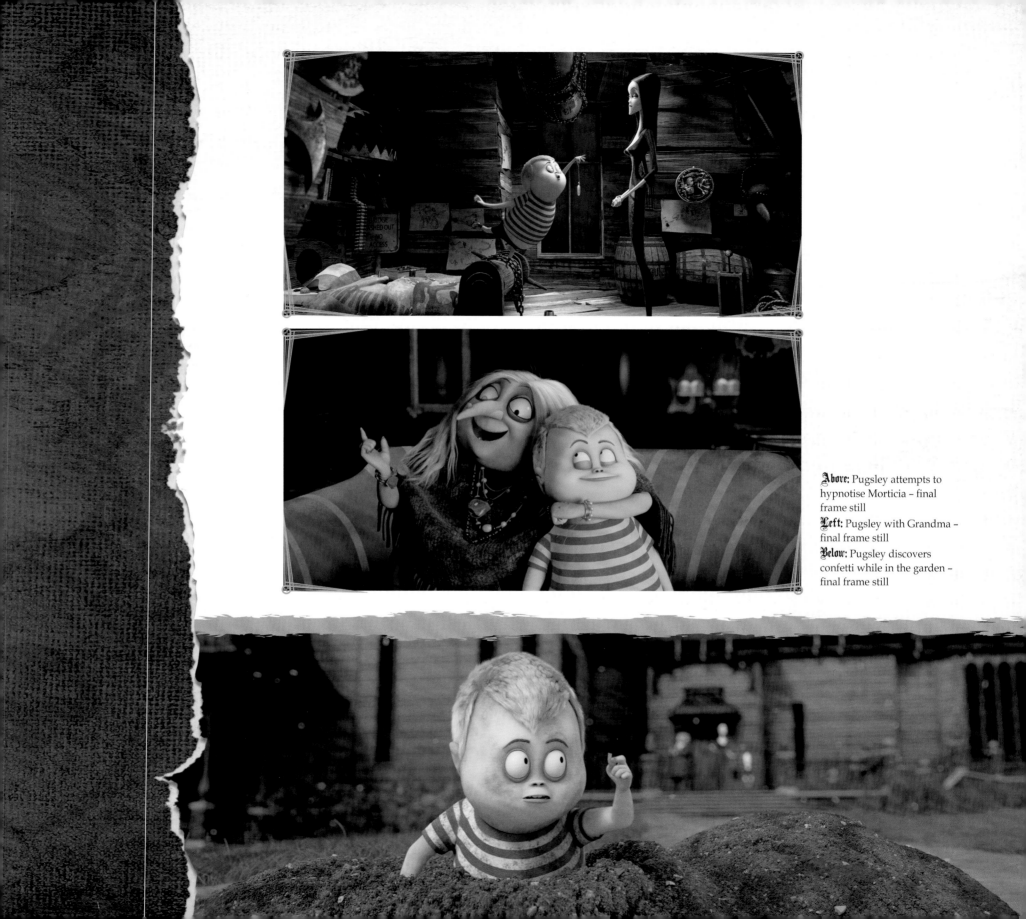

Above: Pugsley attempts to hypnotise Morticia – final frame still

Left: Pugsley with Grandma – final frame still

Below: Pugsley discovers confetti while in the garden – final frame still

Left: Pugsley reads the instruction book for his Sabre Mazurka – storyboard panel

Below left: Pugsley examines the moves of the Sabre Mazurka – final frame still

Bottom: Pugsley creeping on the wall – final frame still

Right: Pugsley – early concept sketch

Director Conrad Vernon says that the little mischief-maker proved to be one of the toughest characters to design for the movie. "In the TV show and the movies, Pugsley is a silent oaf who doesn't do much," he notes. "In the original cartoons, he was like Dennis the Menace with evil intentions—he would steal stop signs and railroad crossing warning signs and hide them in his room. We really wanted to give him a strong personality in the movie. For example, he is constantly trying to kill his father. That's how he and Gomez play with each other!"

Right & below: Pugsley's pyjamas – design surfacing study
Bottom: Pugsley sleeping in his pyjamas – final frame still

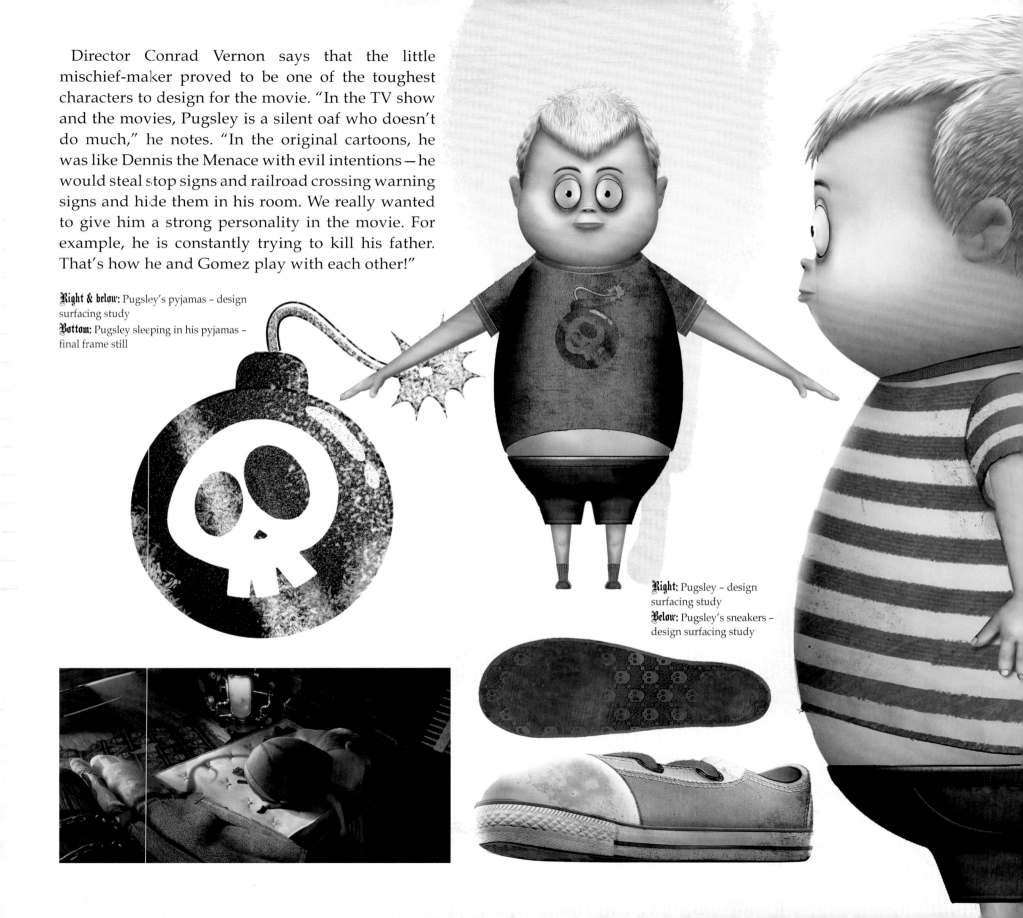

Right: Pugsley – design surfacing study
Below: Pugsley's sneakers – design surfacing study

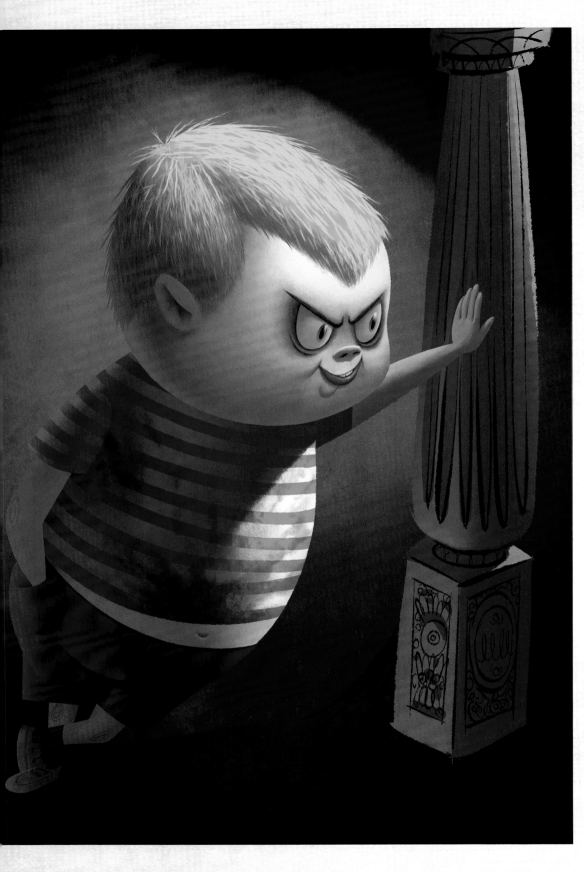

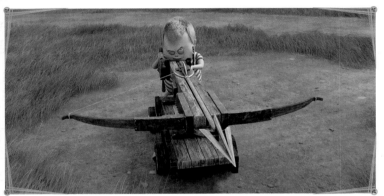

Left: Pugsley – early concept art
Top: Pugsley shoots the ballista – shot in development
Above: Pugsley shoots the ballista – final frame still

Designer Craig Kellman explains that the movie version of Pugsley is an amalgamation of some of the various versions of the character drawn by Addams through the years. "Addams drew him with these dot eyes, and he put these semicircles in front of the dots that made it look like he had 3D eyeballs," he says. "That approach doesn't work in CG, so we gave him these bulgy eyes. I thought it would be kind of creepy to have him always be staring—just never blinking with his pupils kind of jittering."

Pugsley has always been a little pudgy, and that tradition continues in this movie. "He is short and squat compared to Wednesday," adds Kellman. "He has this little fifties crew cut and the red and white striped shirt. I just wanted him to look like a creep, because he's like every annoying kid you ever grew up with."

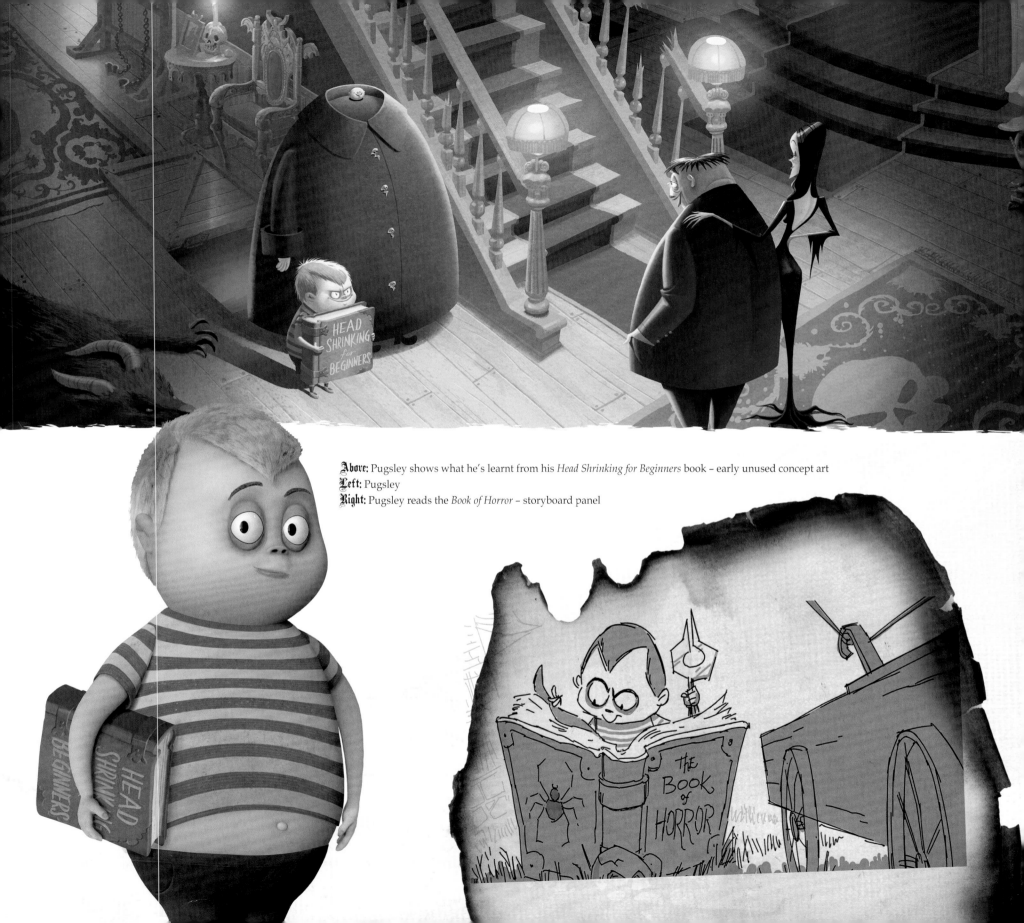

Above: Pugsley shows what he's learnt from his *Head Shrinking for Beginners* book – early unused concept art
Left: Pugsley
Right: Pugsley reads the *Book of Horror* – storyboard panel

Uncle Fester

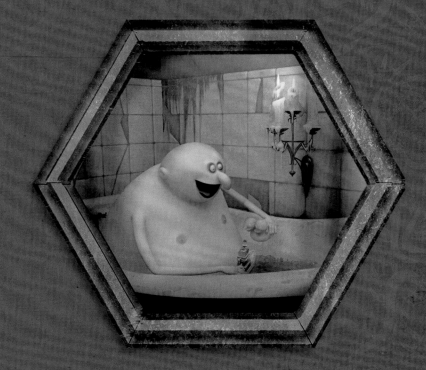

In the book *The Addams Family: An Evilution*, author Kevin Miserocchi points out that Uncle Fester loved to indulge his love for boyhood delight, just like his creator Charles Addams. In fact, Addams used to say that Fester physically resembled him. Fester is fat, his skin is as white as Morticia's, his eyes are pig-like and they always have very unhealthy black circles under them. Oh, and he has no teeth and is completely hairless! For all these reasons, Fester must have been an animator's dream come true.

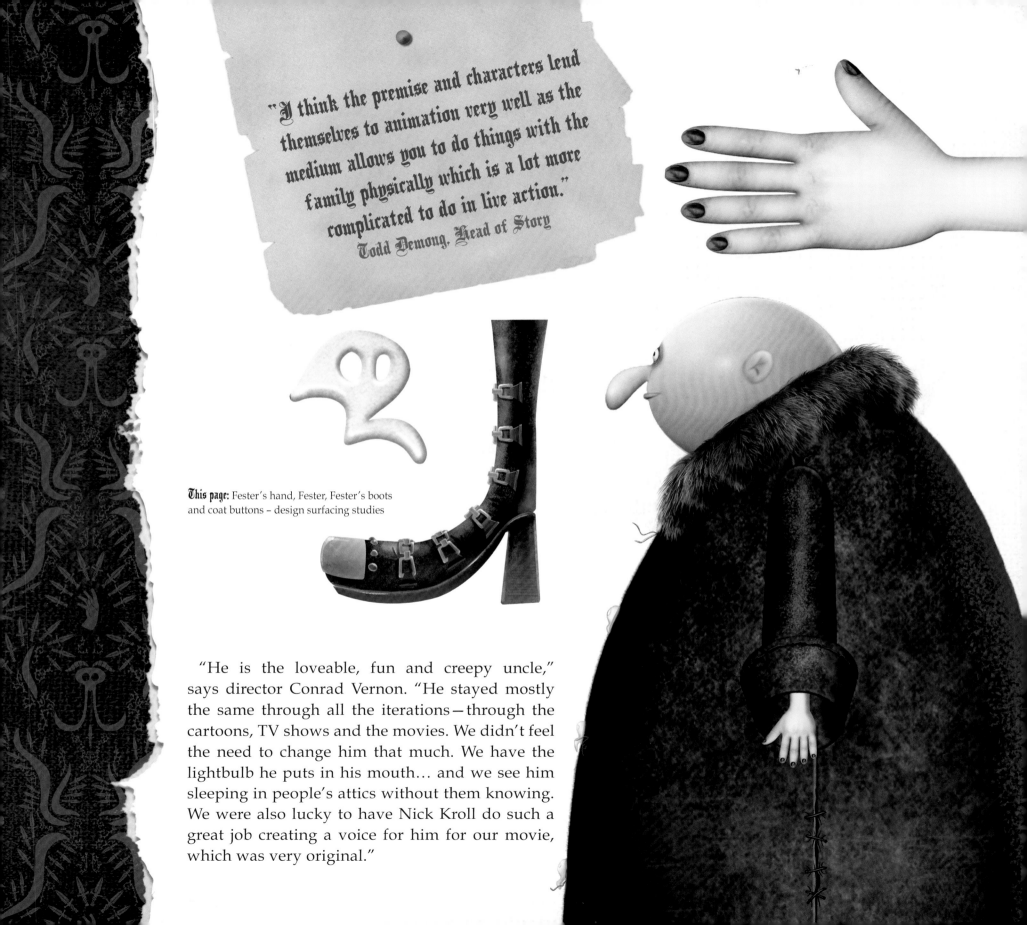

"I think the premise and characters lend themselves to animation very well as the medium allows you to do things with the family physically which is a lot more complicated to do in live action."
Todd Demong, Head of Story

This page: Fester's hand, Fester, Fester's boots and coat buttons – design surfacing studies

"He is the loveable, fun and creepy uncle," says director Conrad Vernon. "He stayed mostly the same through all the iterations—through the cartoons, TV shows and the movies. We didn't feel the need to change him that much. We have the lightbulb he puts in his mouth… and we see him sleeping in people's attics without them knowing. We were also lucky to have Nick Kroll do such a great job creating a voice for him for our movie, which was very original."

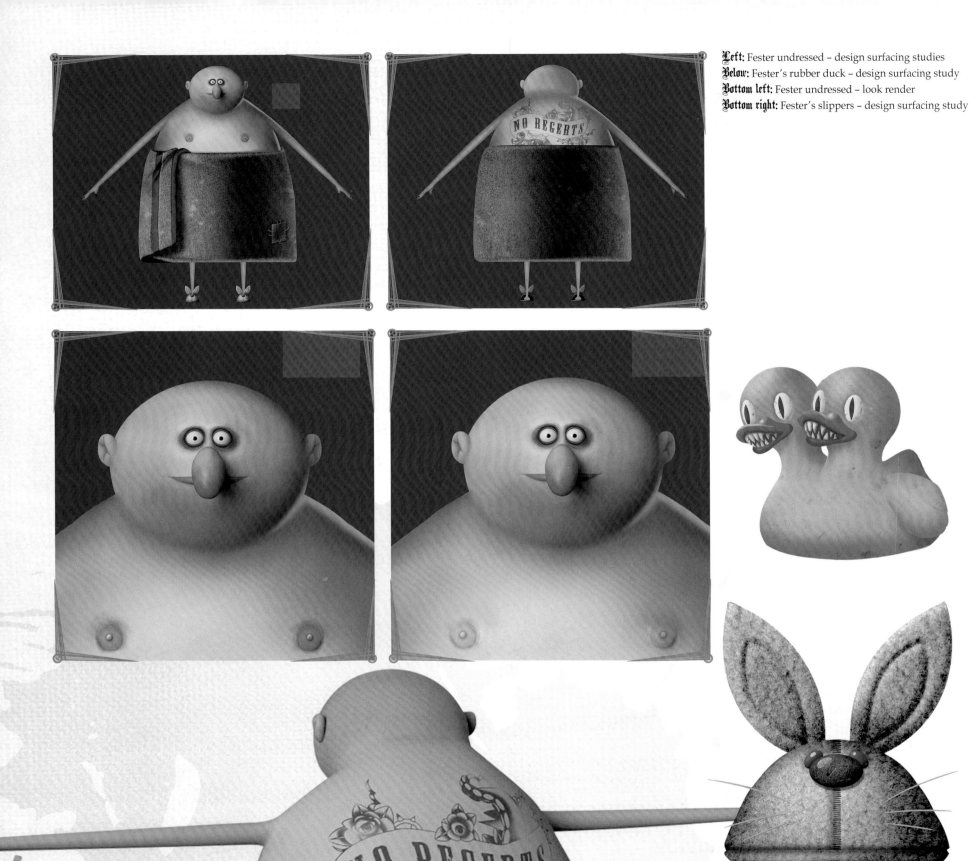

Left: Fester undressed – design surfacing studies
Below: Fester's rubber duck – design surfacing study
Bottom left: Fester undressed – look render
Bottom right: Fester's slippers – design surfacing study

NO REGERTS

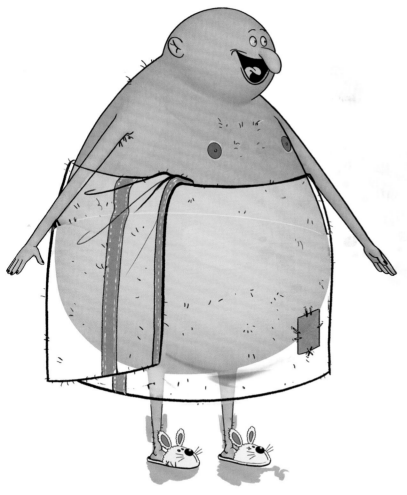

Character designer Craig Kellman agrees. "Fester is the character that has stayed the same and purely faithful to the original Charles Addams drawings," he notes. "His nose may change a little bit, but we thought he had perfect proportions and this simplicity in his original designs. He has no brows, no details on his face, just two ping pong-ball eyes. The smaller his mouth is, the stranger he looks."

It was Vernon's idea to have tiny animal skulls used as buttons on Fester's jacket. "He also has a little bit of an S&M action going on with his boots," says Kellman. "He looks innocent, but he is almost giddy about torturing other people and himself as well. He's lovable because he's so unapologetic about being so weird. Just like the rest of the family, he is the mirror image, bizarre world version of us."

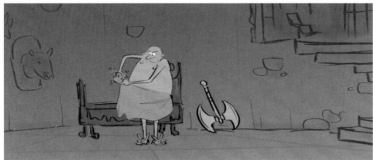

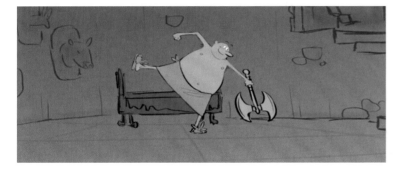

Top left: Fester undressed – design concept
Left: Fester undressed – storyboard panels
Above: Fester's tattoo – design

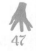

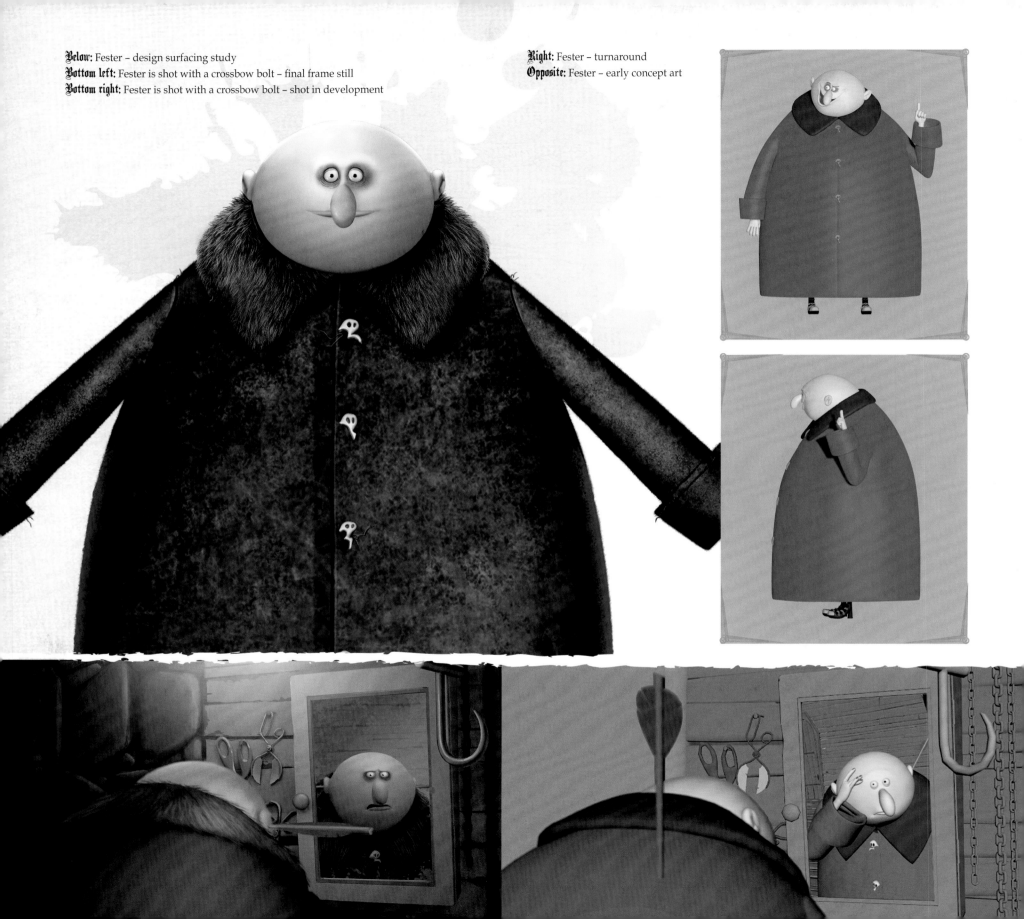

Below: Fester – design surfacing study
Bottom left: Fester is shot with a crossbow bolt – final frame still
Bottom right: Fester is shot with a crossbow bolt – shot in development

Right: Fester – turnaround
Opposite: Fester – early concept art

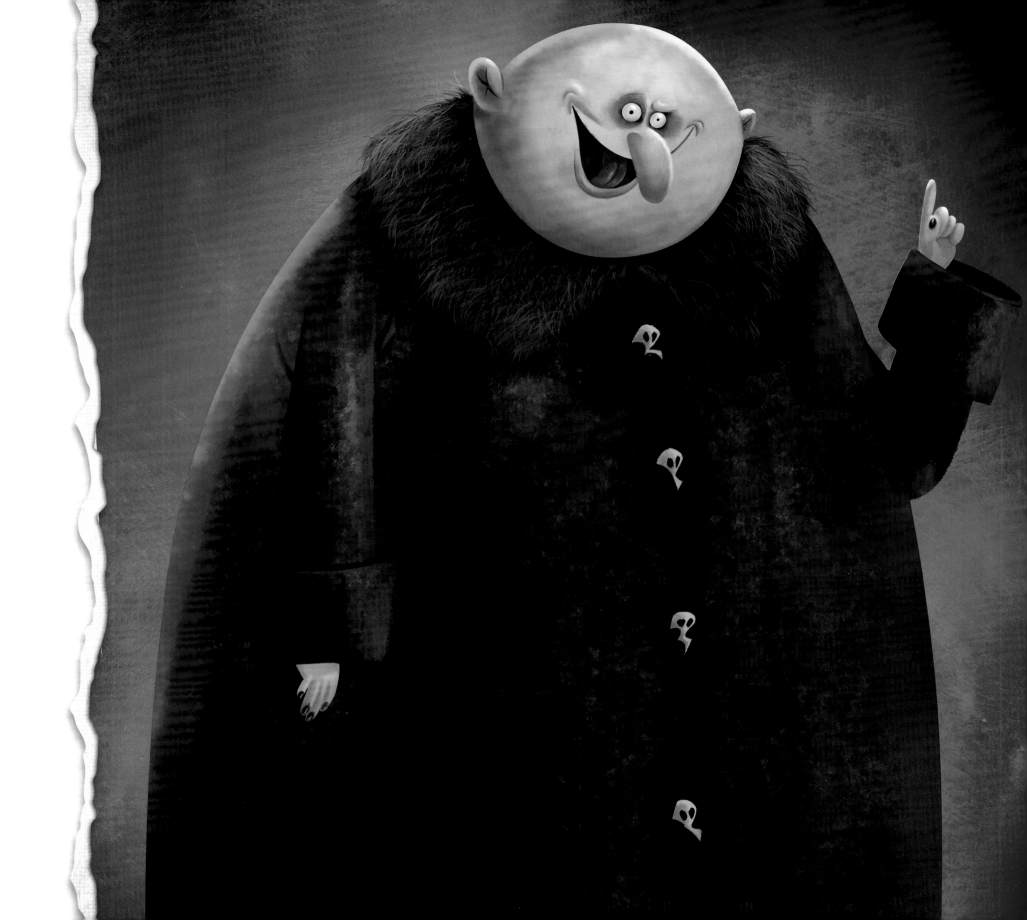

Lurch

Early on in the movie, Morticia and Gomez are on their honeymoon when their car runs over a tall creature who has escaped a nearby asylum that will eventually become the Addamses' new home. That creature will end up becoming their devoted butler, Lurch.

Above: Lurch
Right: Lurch reads *Little Women* – final frame still

"With Lurch, we wanted to show that he knows better than everyone else, although it might seem as if he doesn't know what's going on," says director Conrad Vernon. "It's all about still waters running deep. We show him reading *Little Women*. He also plays songs that underscore what's going on in the movie."

Right: Lurch – design surfacing study
Below: Lurch is introduced – final frame still

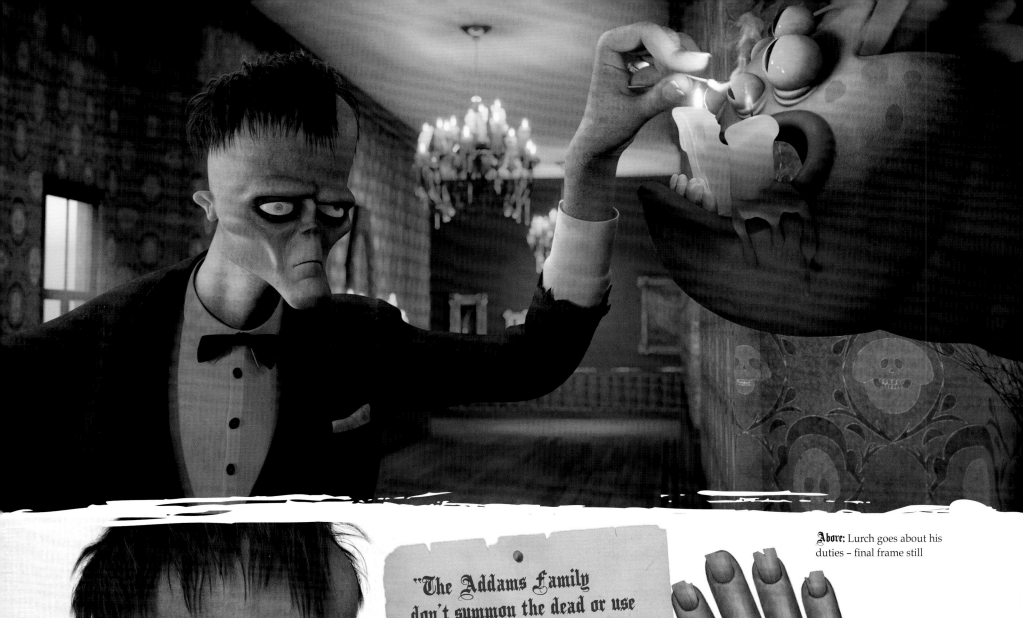

Above: Lurch goes about his duties – final frame still

"The Addams Family don't summon the dead or use witchcraft: They're just spooky and weird. They just hint that they enjoy those things. It's all about finding the weirdness without referring to the occult."

Todd Demong, Head of Story

Left: Lurch – look render
Right: Lurch's hand – design surfacing study

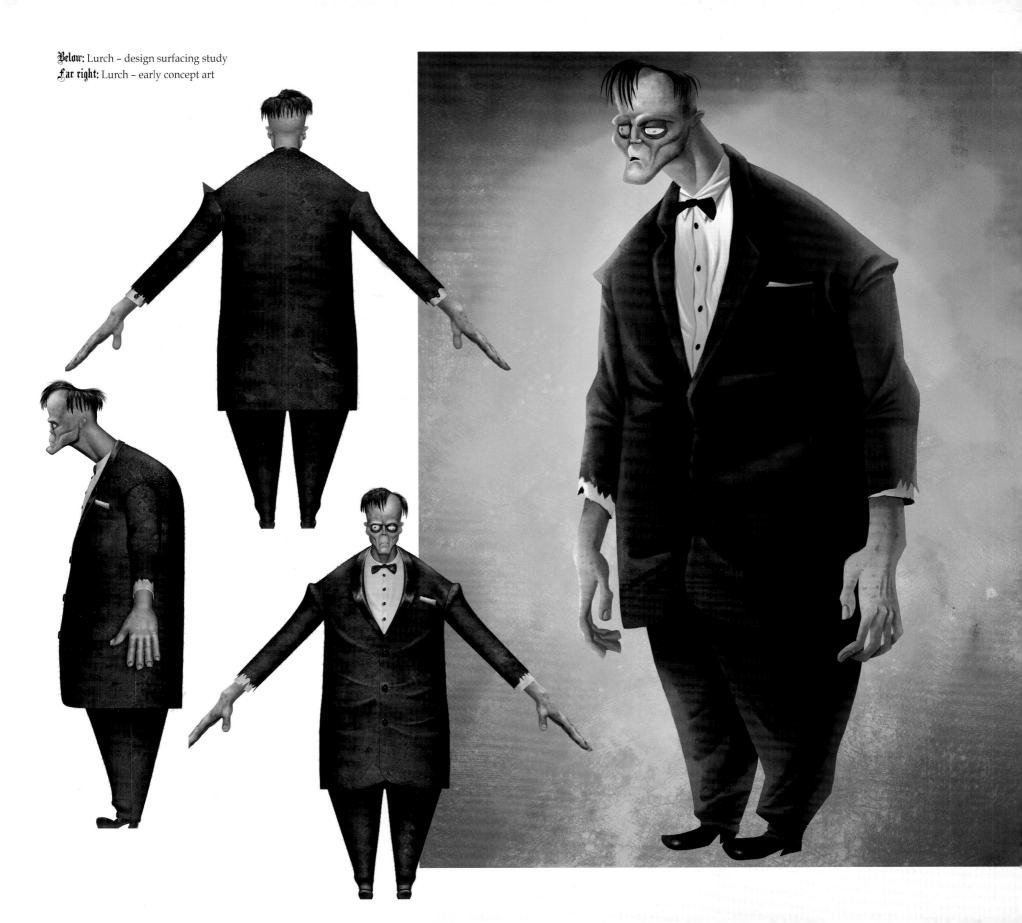

Below: Lurch – design surfacing study
Far right: Lurch – early concept art

Character designer Craig Kellman says Lurch was Addams' version of Frankenstein. "We pushed the proportions a bit," he says. "I wanted him to have a huge head with crazily big hands and feet. In the comics, he has basically a cliché Frankenstein zombie face. One eye is wide open, and the other is half-shut. I wanted to make him more special. So, I started out by making his face a caricature of actor Michael Shannon's, because he has a very distinctive, memorable look. He was definitely a fun character to play with."

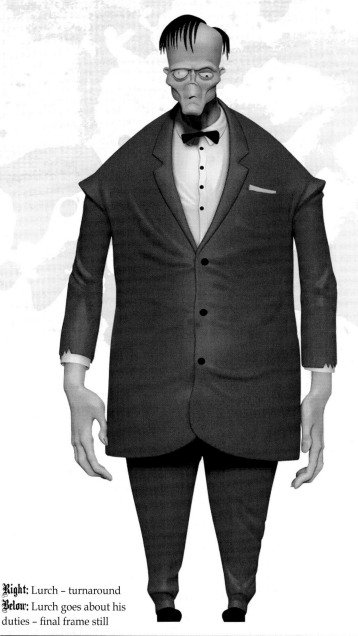

Below: Lurch reading – shot in development
Bottom: Lurch reading – final frame still

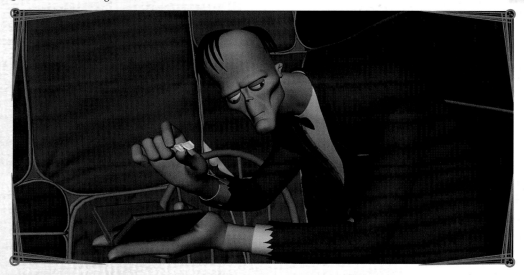

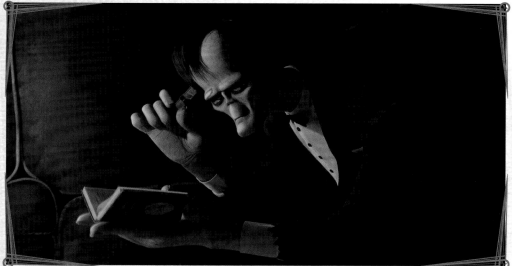

Right: Lurch – turnaround
Below: Lurch goes about his duties – final frame still

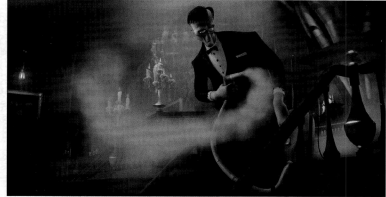

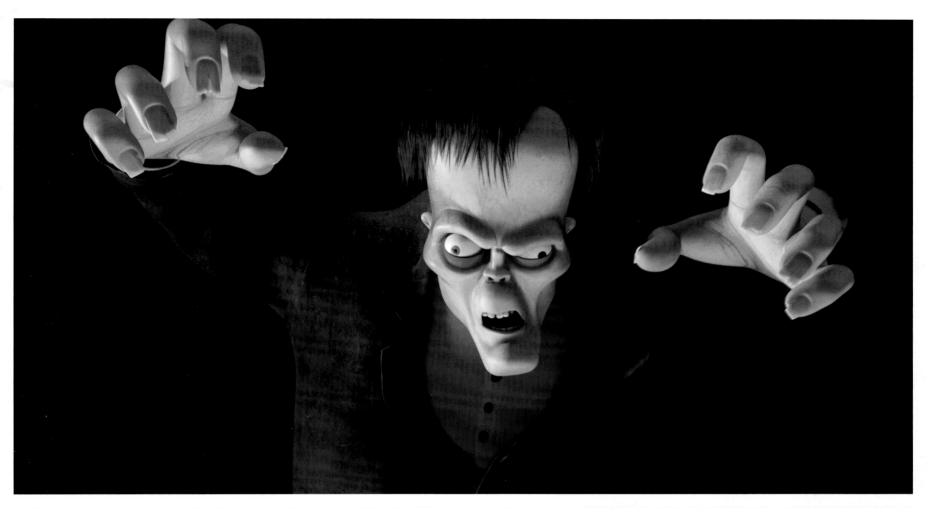

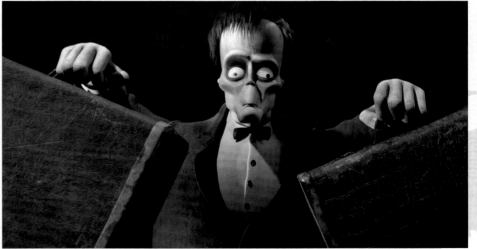

Top & above right: Lurch meets the Addamses – final frame stills
Above: Lurch meets the Addamses – storyboard panel

Thing

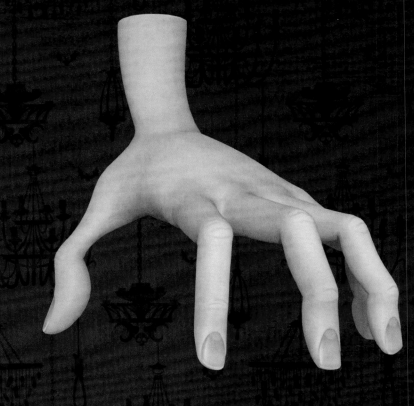

Left: Lurch and Thing play the harpsichord
Above: Thing

Thing is a disembodied hand-and-wrist that was a popular fixture in the black-and-white TV series and the two Sonnenfeld movies. On the TV show, it would emerge from a series of boxes in the Addams mansion, and occasionally out of the mailbox outside. Sometimes, it would also come out from behind a curtain or emerge within a plant pot. In the movies, CG technology didn't require Thing to pop out of boxes and it was able to do things like drive a car or run on its fingertips like a spider. A helpful part of the family, Thing was always glad to give Gomez his cigar or bring Morticia her knitting needles.

In the animated movie, Thing is more technologically savvy than his previous incarnations. "We gave him a smart watch," says director Conrad Vernon. "He has a laptop, and he has an eyeball on his watch. We thought it would be funny if he had a foot fetish!"

"The design was quite simple," says character designer Craig Kellman. "It's definitely a man's hand, but the digits are a little more feminine. We have it cut off a couple of inches above the wrist. On the TV show, Thing always had to come out of a box or from behind a wall, but when I saw Thing in the movies, it was wonderful, because it had free rein and could do whatever it wanted thanks to CG animation."

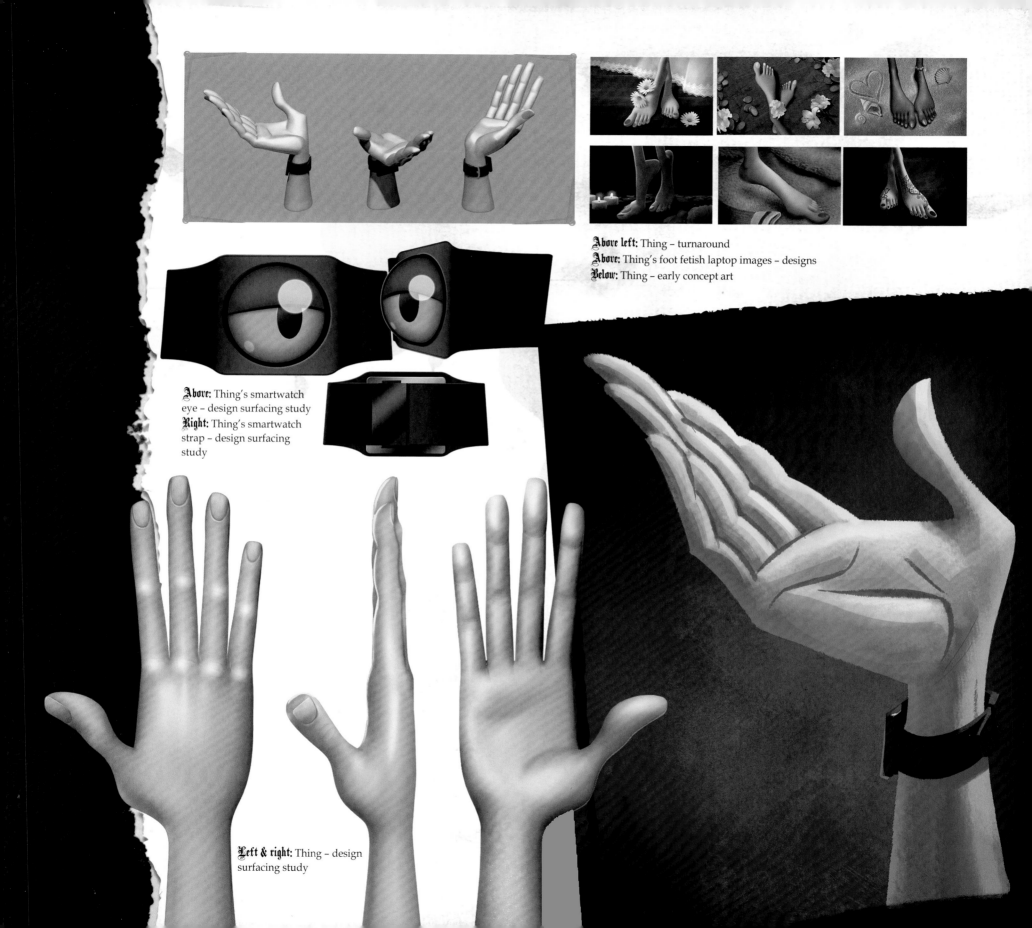

Above left: Thing – turnaround

Above: Thing's foot fetish laptop images – designs

Below: Thing – early concept art

Above: Thing's smartwatch eye – design surfacing study

Right: Thing's smartwatch strap – design surfacing study

Left & right: Thing – design surfacing study

It

Small in stature and covered with floor-length hair, It is an occasional houseguest who traditionally enjoyed entering and leaving the Addams home through the chimney. It, who was created specifically for the 1960s TV series, is related to Gomez and is fond of wearing hats and sunglasses. He speaks in a strange gibberish lingo that is only understood by the Addams clan.

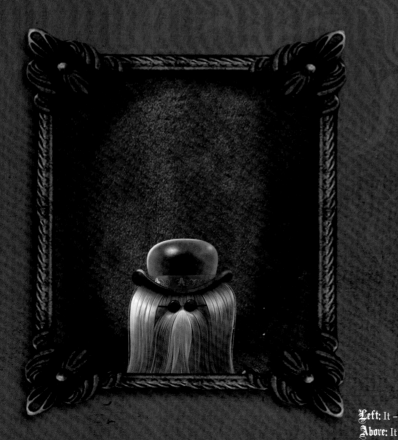

Left: It – design surfacing study
Above: It

Left: It arrives at the Addams mansion – storyboard panel
Below: It – concept drawing turnarounds

* STEREOTYPICAL CARTOON GLOVES * ONLY 4 DIGITS ON IT'S HANDS

"I remember trying out all kinds of different hats on It when I was designing the character," says Craig Kellman. "I thought it would be funny to show him wearing a Rasta hat, a yarmulke, a cowboy hat, a top hat, a 'Make America Great Again' red cap. It was fun to play around and try a bunch of different options. There are only two Charles Addams drawings of It, because he was not part of the original comic and was created just for the TV show. Basically, he is just a big hairy thing walking around, with sunglasses and a hat. He has more of a moustache in my drawings. I also tried giving his hair an extra curl where it hits the floor. And I made him extra short."

Left & below: It's cane, bowler hat and hat ribbon, and sunglasses – design surfacing studies
Right: It – design surfacing study

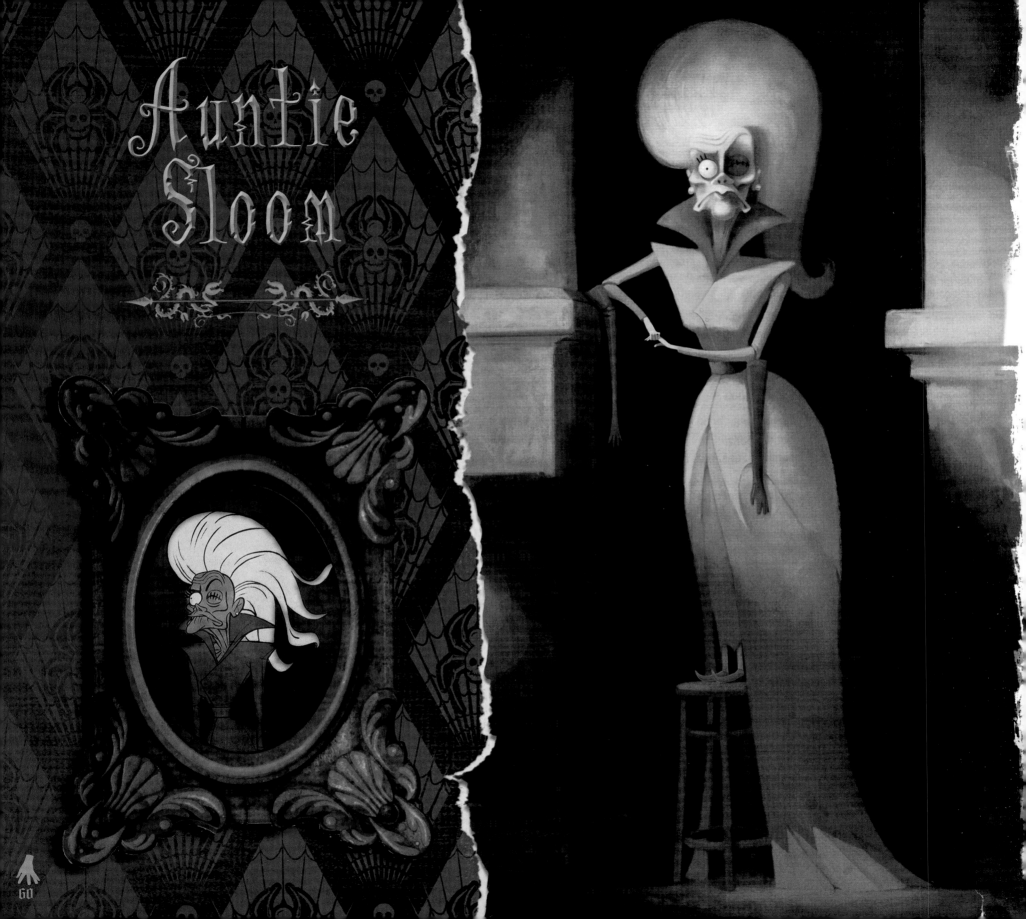

Auntie Sloom

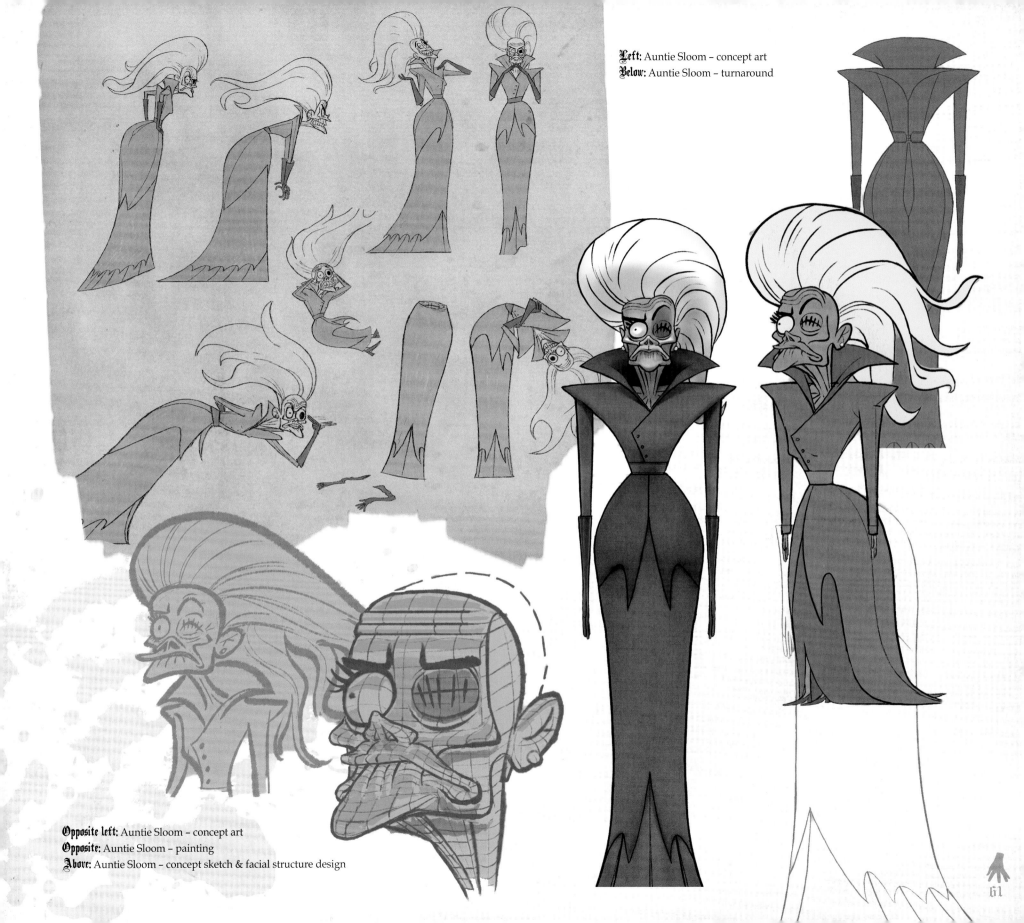

Left: Auntie Sloom – concept art
Below: Auntie Sloom – turnaround

Opposite left: Auntie Sloom – concept art
Opposite: Auntie Sloom – painting
Above: Auntie Sloom – concept sketch & facial structure design

61

Socrates

Left: Socrates – design surfacing drawing
Above: Socrates – design surfacing studies
Below left: Socrates – model turnaround
Right: Socrates

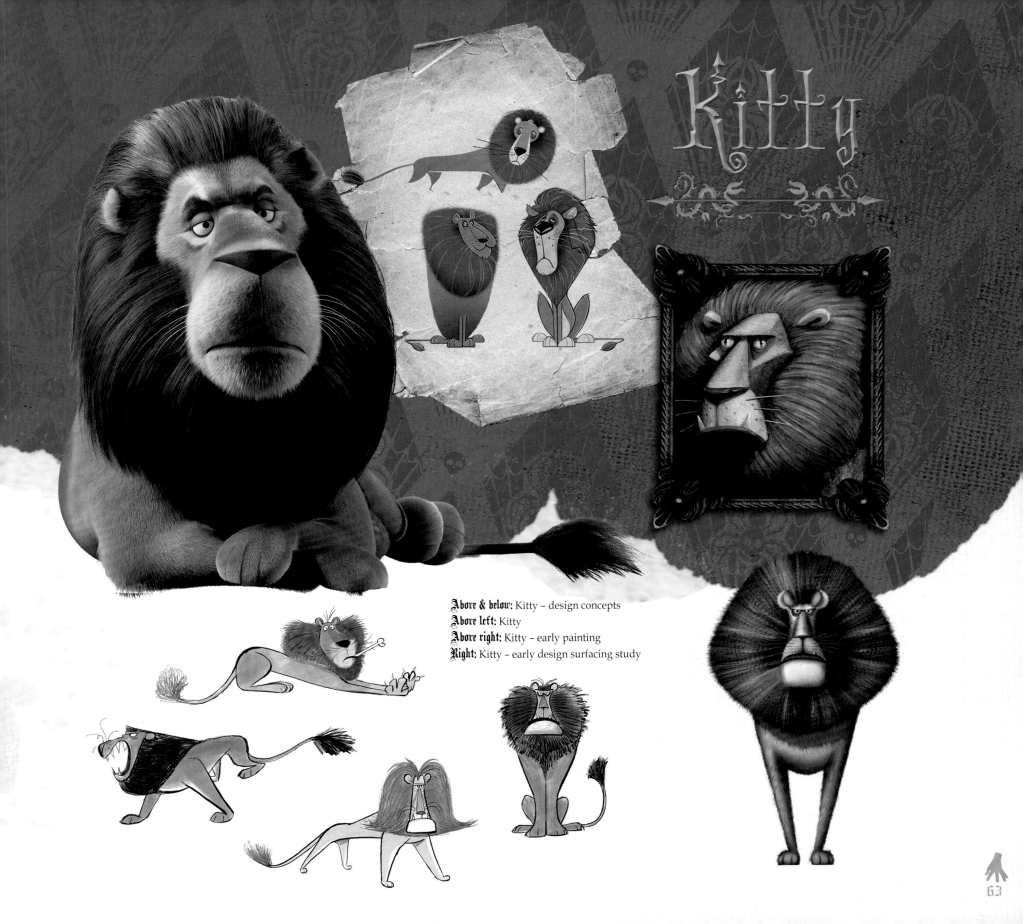

Kitty

Above & below: Kitty – design concepts
Above left: Kitty
Above right: Kitty – early painting
Right: Kitty – early design surfacing study

Animals

Above: Crow – design surfacing study
Top: Crow – concept art and structural study

Right: Hornet – concept art

Right: Rat – design concepts

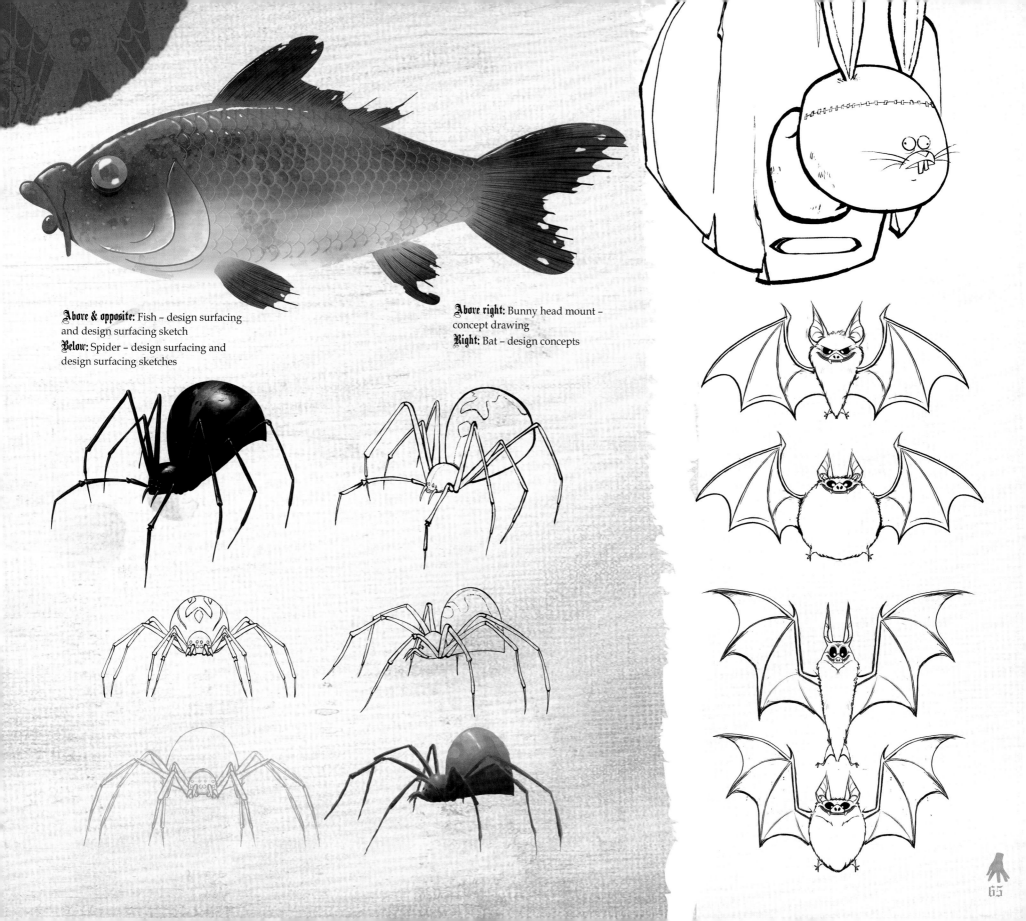

Above & opposite: Fish – design surfacing and design surfacing sketch

Below: Spider – design surfacing and design surfacing sketches

Above right: Bunny head mount – concept drawing

Right: Bat – design concepts

Extended Family

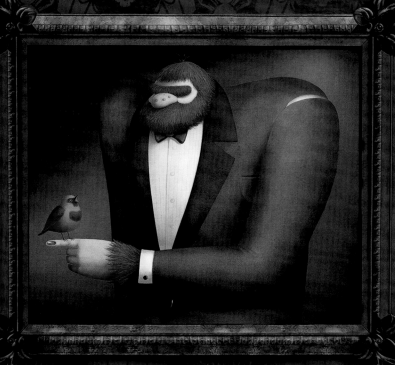

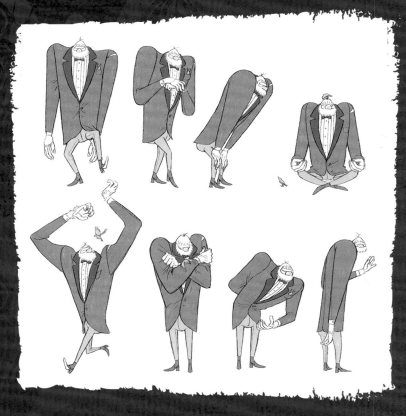

Above: Ringo – painting
Above right & right: Ringo – concept sketches

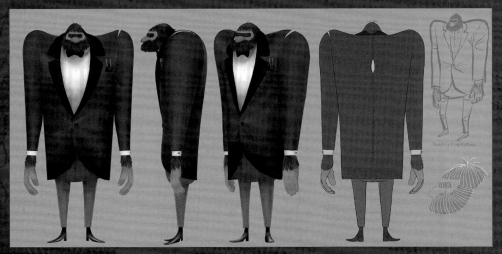

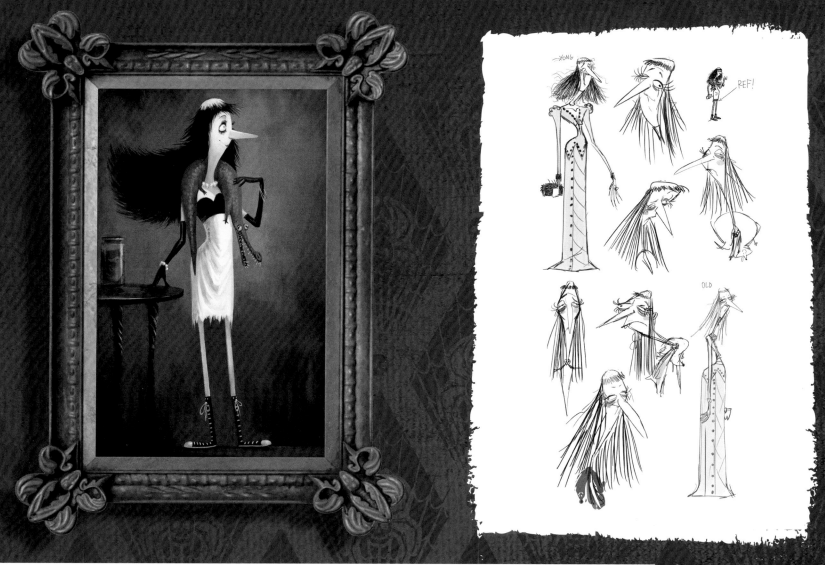

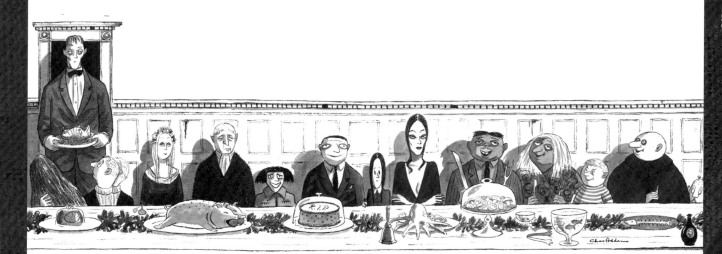

Above left: Carry – painting
Above: Carry – concept sketches
Left: Banquet by Charles Addams

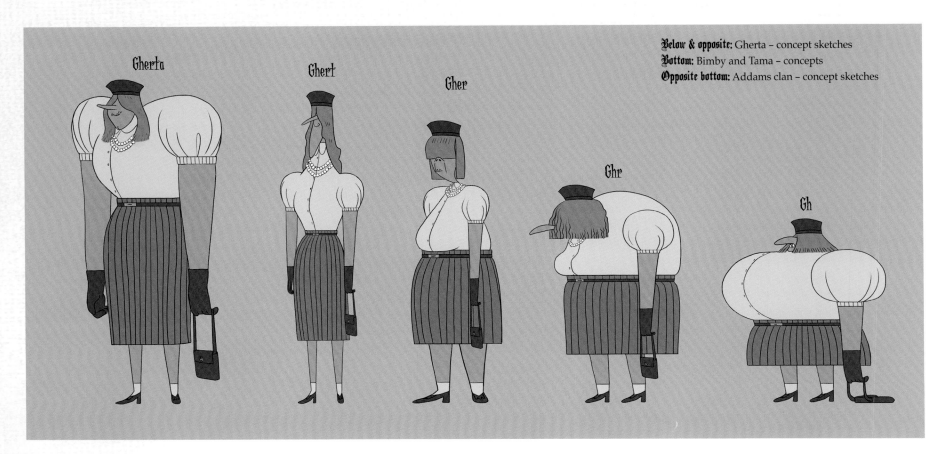

Gherta

Ghert

Gher

Ghr

Gh

Below & opposite: Gherta – concept sketches
Bottom: Bimby and Tama – concepts
Opposite bottom: Addams clan – concept sketches

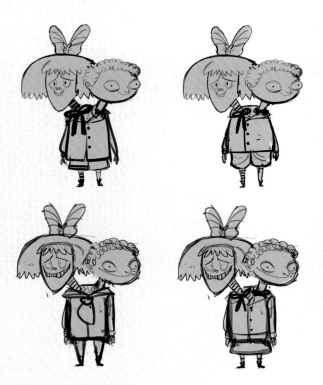

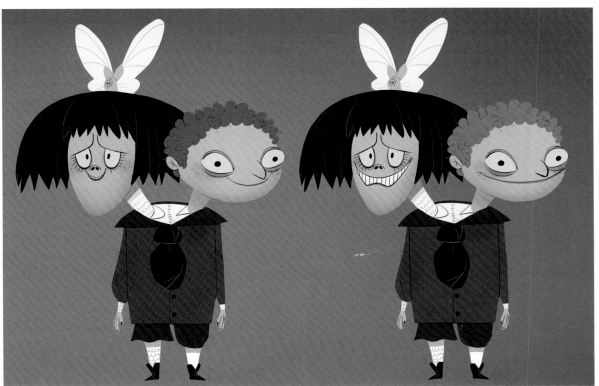

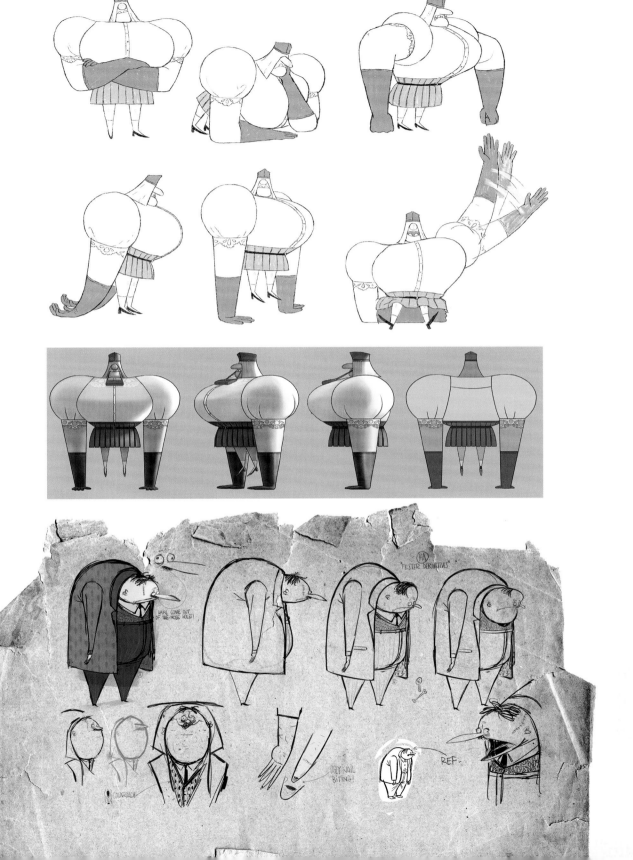

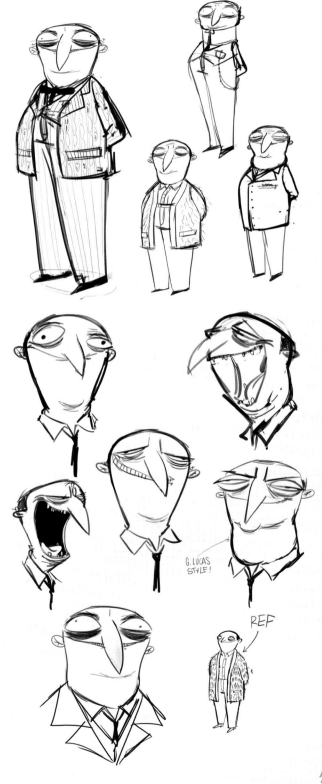

G. LUCAS STYLE!

REF

HAIRS COME OUT OF THE NOSE HOLE!

"FESTER DERIVATIVES"

UGLY NAIL BITING!

REF

COCKROACH

Portraits

This section: Portraits hanging on the walls of the Addams mansion, many inspired by secondary characters found in Charles Addams illustrations

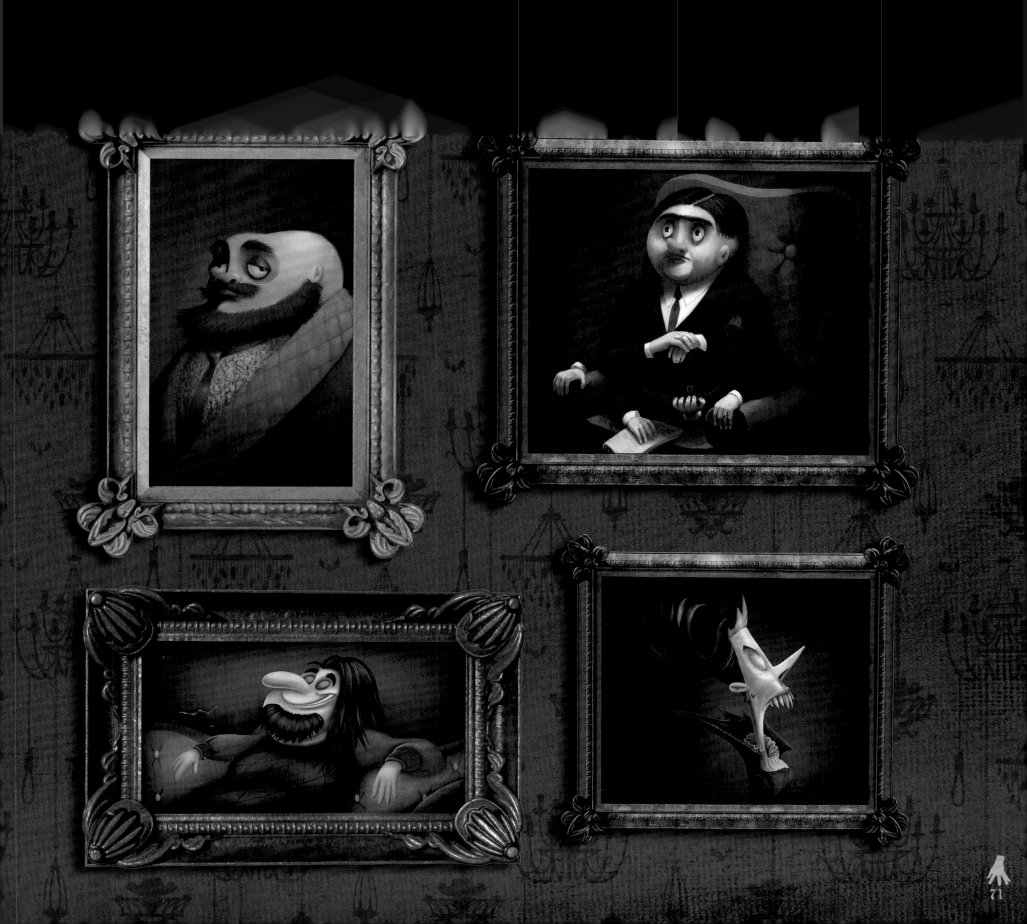

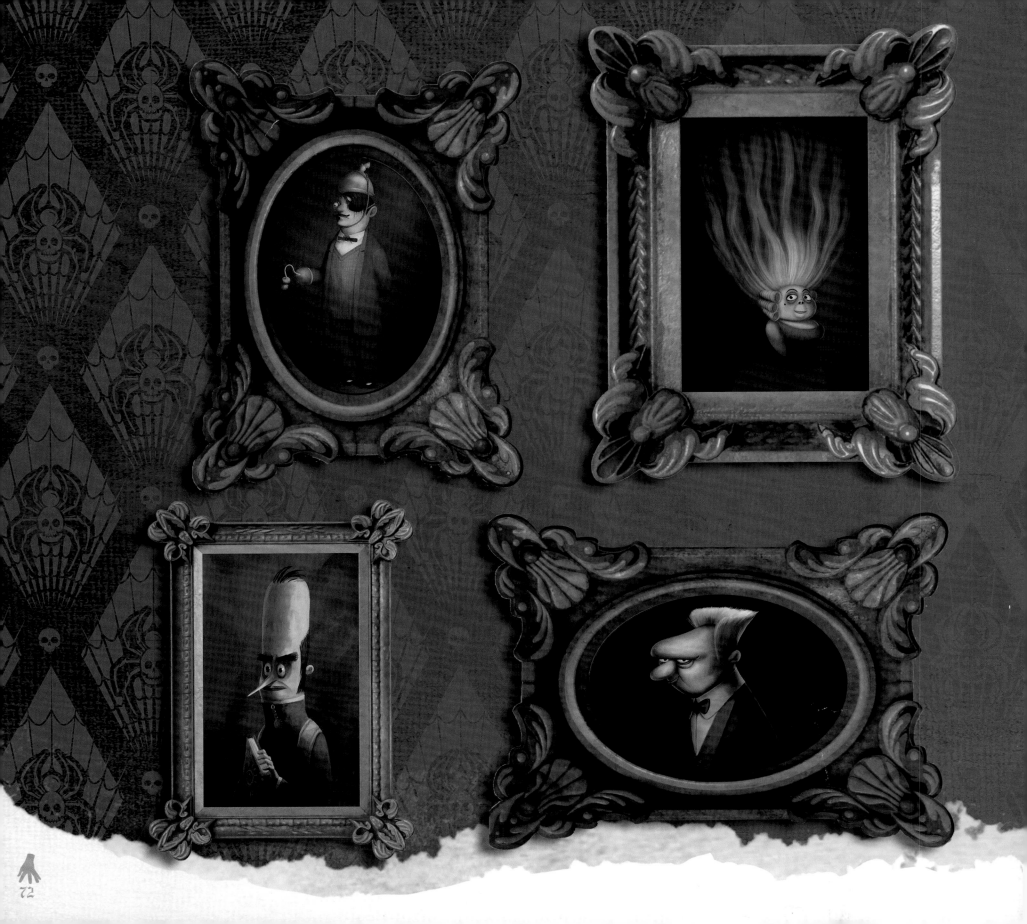

72

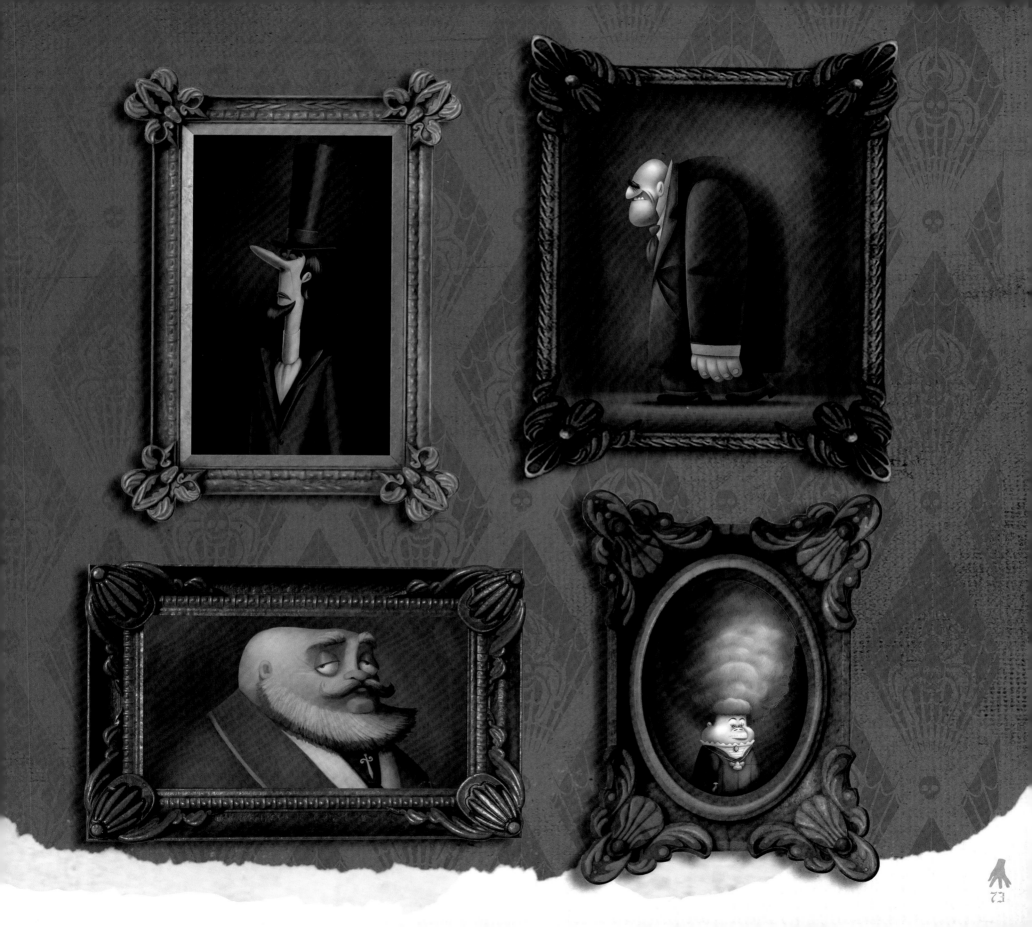

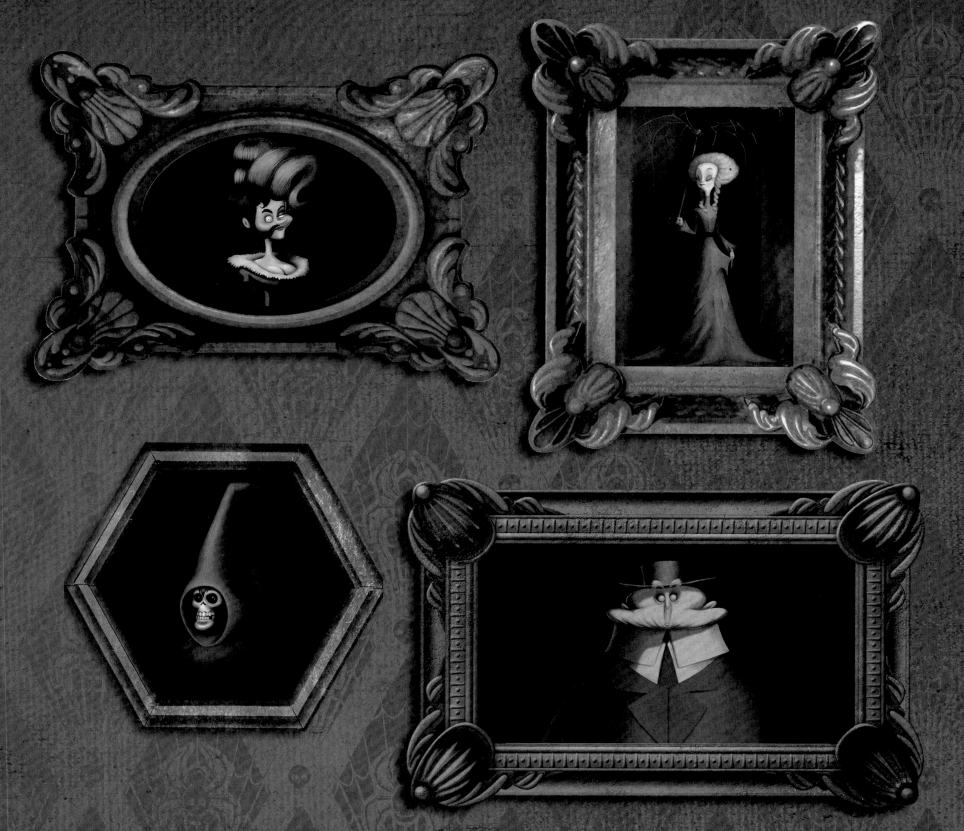

Implements

Left: Ballista – final frame still
Above: Ballista – look render
Below: Ballista – design surfacing study
Below right: Ballista spear – look render

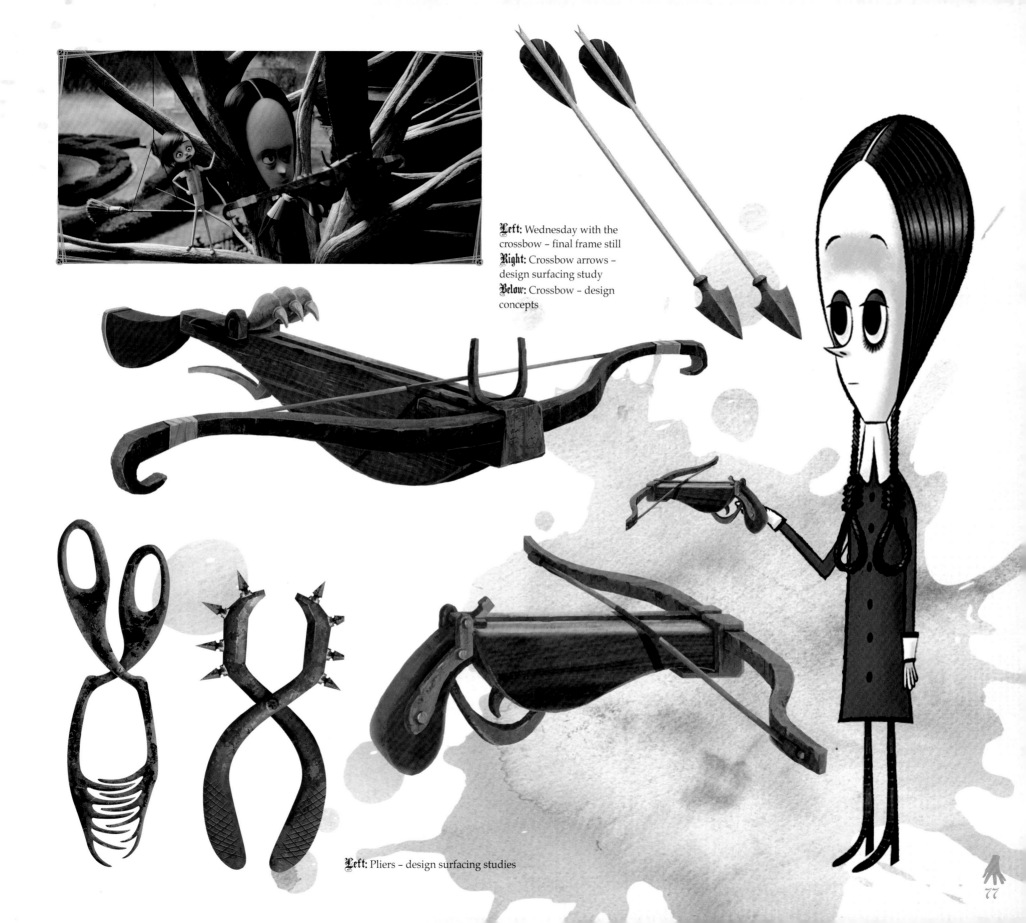

Left: Wednesday with the crossbow – final frame still

Right: Crossbow arrows – design surfacing study

Below: Crossbow – design concepts

Left: Pliers – design surfacing studies

Below: Sword – design surfacing studies and design surfacing reference

Left: Hacksaw and hand-drill – design surfacing studies

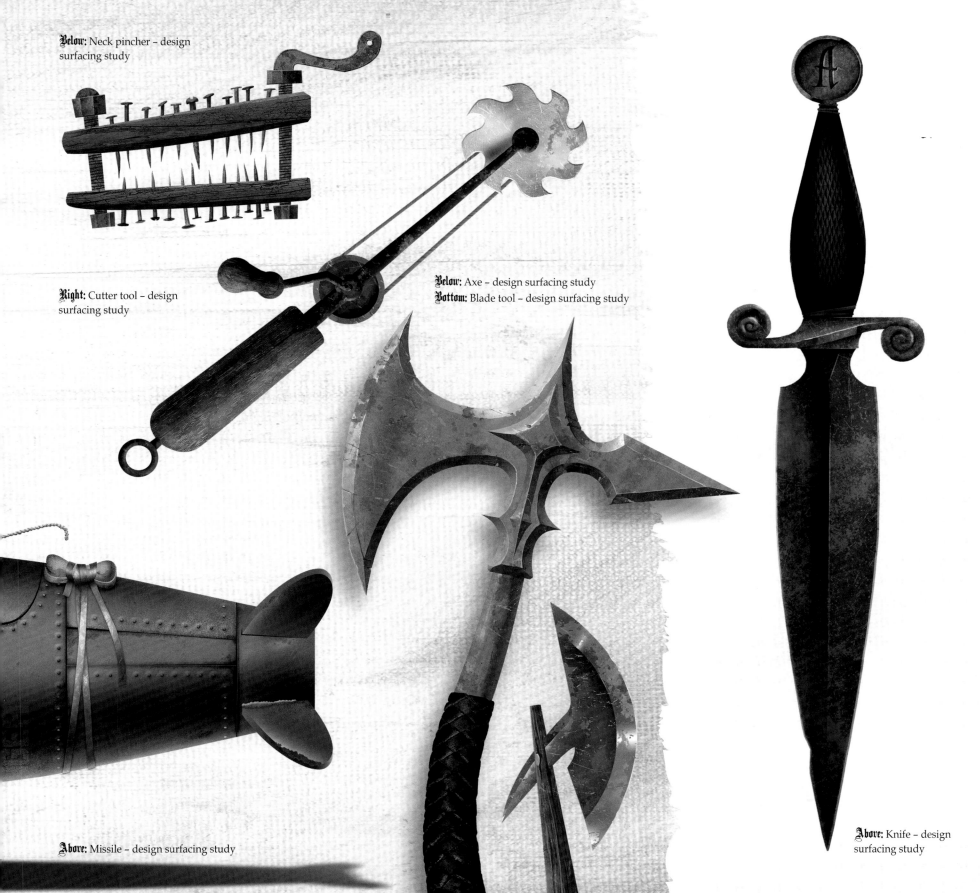

Below: Neck pincher – design surfacing study

Right: Cutter tool – design surfacing study

Below: Axe – design surfacing study
Bottom: Blade tool – design surfacing study

Above: Missile – design surfacing study

Above: Knife – design surfacing study

Parker Needler

Margaux's young daughter Parker has been under the influence of her mother all her life. She is the reason why Wednesday begins to question her own family. Director Conrad Vernon says when Parker meets Wednesday, she really has no mind of her own, and it's Wednesday who opens up the world to her and gives her a makeover—she shaves her head and goths her out!

Far left: Goth Parker – final frame still
Left: Parker

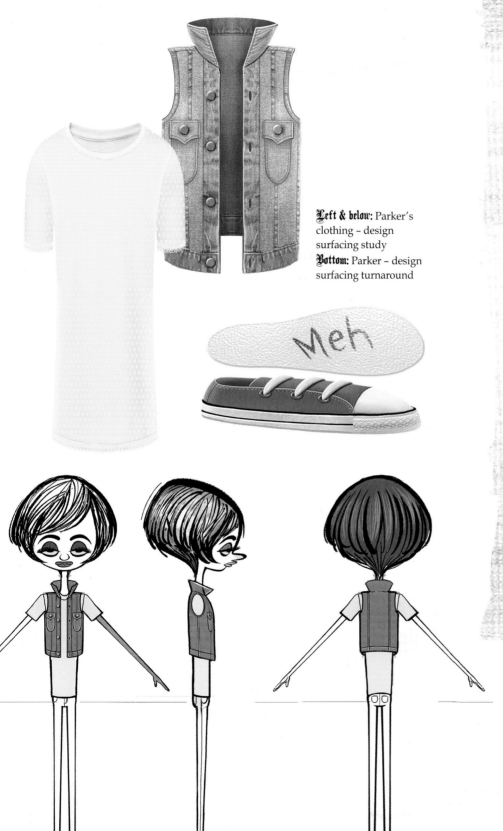

Left & below: Parker's clothing – design surfacing study

Bottom: Parker – design surfacing turnaround

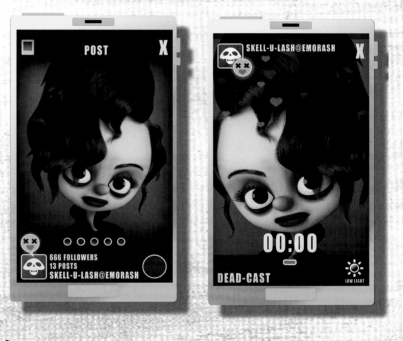

Above: Parker's smartphone – design surfacing studies

Vernon recalls how he asked designer Craig Kellman to do many versions of the character. "He came up with a lot of different ideas," says the director. "He did twenty-five to thirty different teens. When we saw it, we just knew she was the right version. We pulled the ideas into one perfect model. She's one of those 'too cool for school' characters, but nobody really knows it. She's introspective, intelligent and cool. Think Aubrey Plaza or Ally Sheedy."

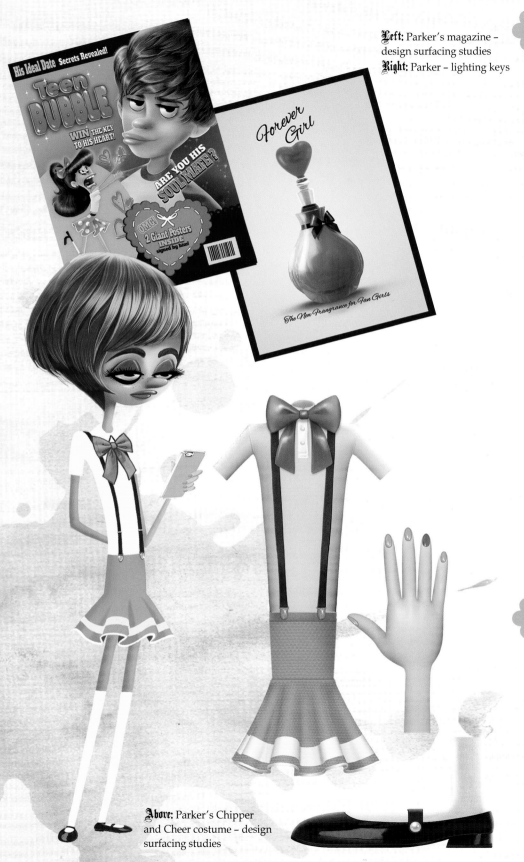

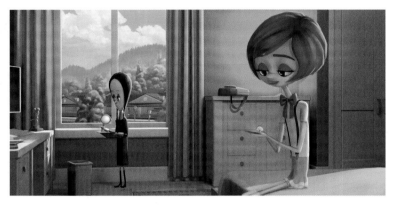

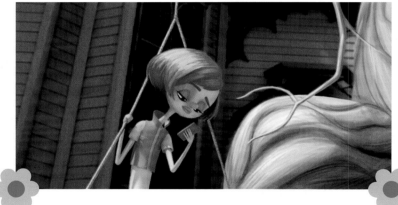

Above: Parker's Chipper and Cheer costume – design surfacing studies

Kellman describes Parker as a "disinterested teen." "She has a rounded nose and big expressive eyes, just like Wednesday. She's cute, but a little bit awkward—but almost a generic teen. She reminds me a bit of a teenage Selena Gomez with her hair cut off. She's not curvy and has a real teen body. She could have been a super positive character, but then Wednesday changed all that."

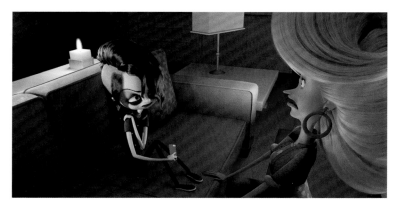

Above: Goth Parker with her mother Margaux – final frame still
Below: Goth Parker – design model turnarounds

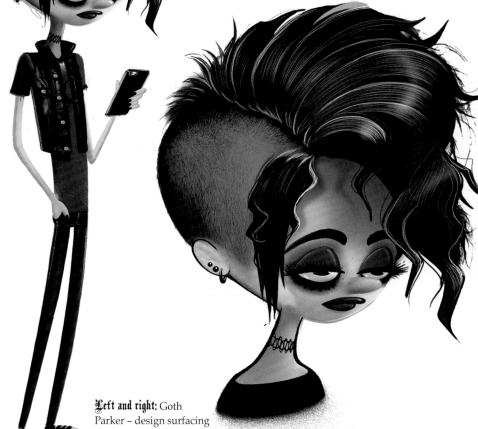

Above: Goth Parker – storyboard panels

Meh

Left and right: Goth Parker – design surfacing studies

Margaux Needler

The hostess of the home makeover show *Design Intervention*, Margaux Needler is the complete antithesis of the Addamses, and the perfect villainess who wants them out of her perfect suburban town. A completely new character created for the animated project, Margaux represents conformity and assimilation. "She is the home-improvement queen," explains director Conrad Vernon. "She wants everything

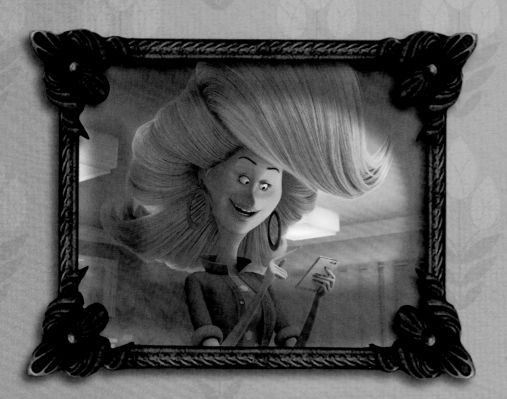

Left: Margaux – final frame still
Above: Margaux – design surfacing study

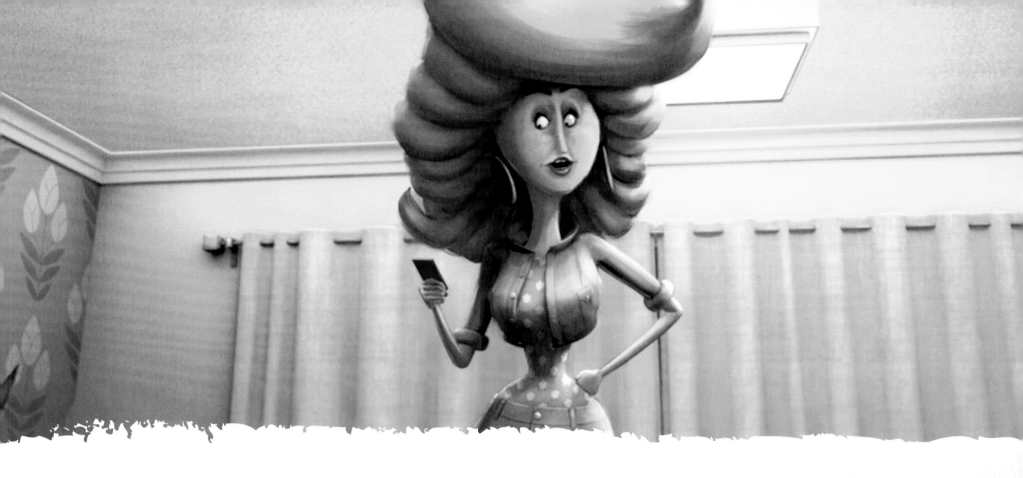

weather

music

mail

insta-mob

camera

photo-app

chat app

phone

Above: Margaux at home – lighting key

Left & below: Margaux's smartphone – design surfacing studies

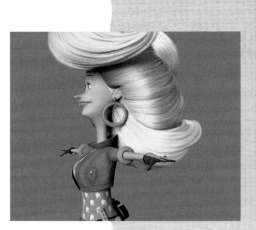

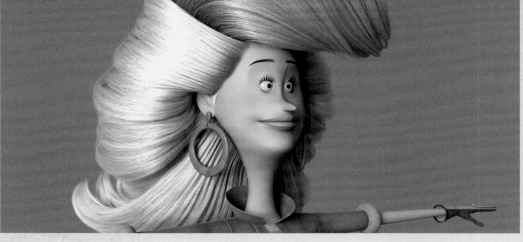

Right: Margaux – look render turnarounds

Below: Margaux – design surfacing sketch

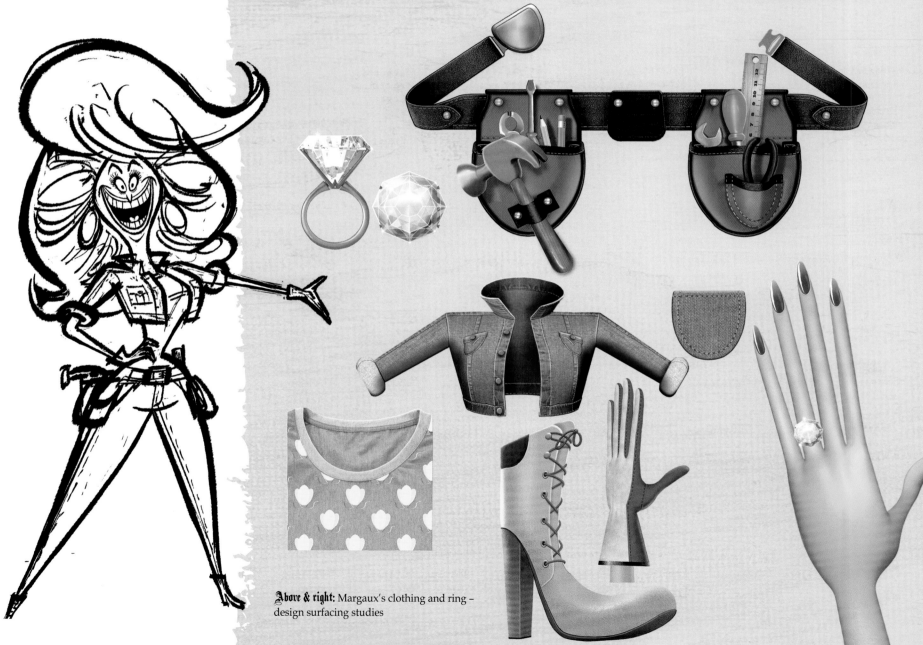

Above & right: Margaux's clothing and ring – design surfacing studies

86

and everyone to look, act and smell a certain way. Otherwise you're considered an outcast. She is like a Home Owners Association gone amok. She encourages people to spy on each other and represents an all-controlling, scared society. Nobody can step outside the lines in her world. She insists that everyone should follow her style. No one gets to be an individual when Margaux is around."

Vernon went to designer Craig Kellman and asked him to design several versions of Margaux for the movie. "We wanted her to remind people of some of the perky reality-show stars on TV. We wanted her to have big hair and be very upbeat when the cameras are rolling."

Kellman describes Margaux as outwardly vivacious and fun, but totally duplicitous and Machiavellian inside. "She can turn on a dime, and we wanted her to look like a phony as well," he says. "She has had a lot of work done, with breast implants, puffed-up lips, and lots of make-up and heavy eyeliner. She is very top heavy and skinny in the hips. I gave her big Dolly Parton/Farrah Fawcett hair. She doesn't have a chin, and I wanted her to look kind of homey. But she is also very wealthy, so is always well put together. She's Hollywood thin and wears these jackets with big pads. Once the make-up is off and the cameras stop rolling, she is a mess underneath it all."

Below: Margaux – storyboard panels

Eastfield Residents

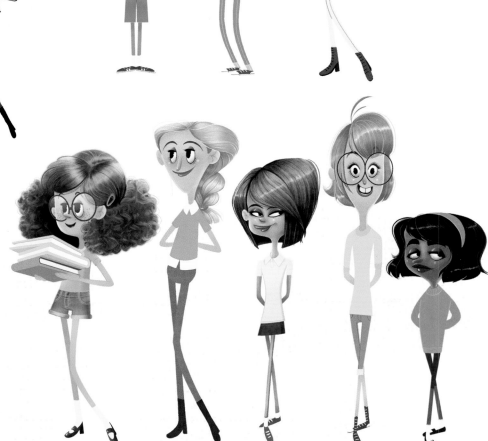

Below: School kids – character concept sketches
Far right: School kids – character concept designs

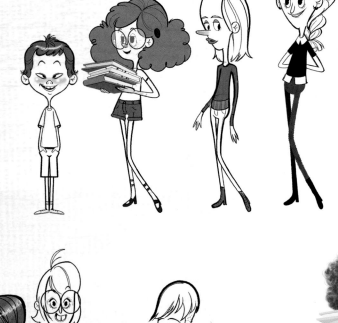

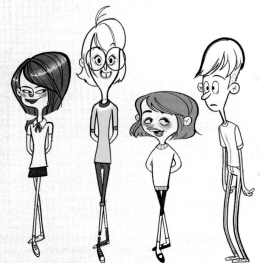

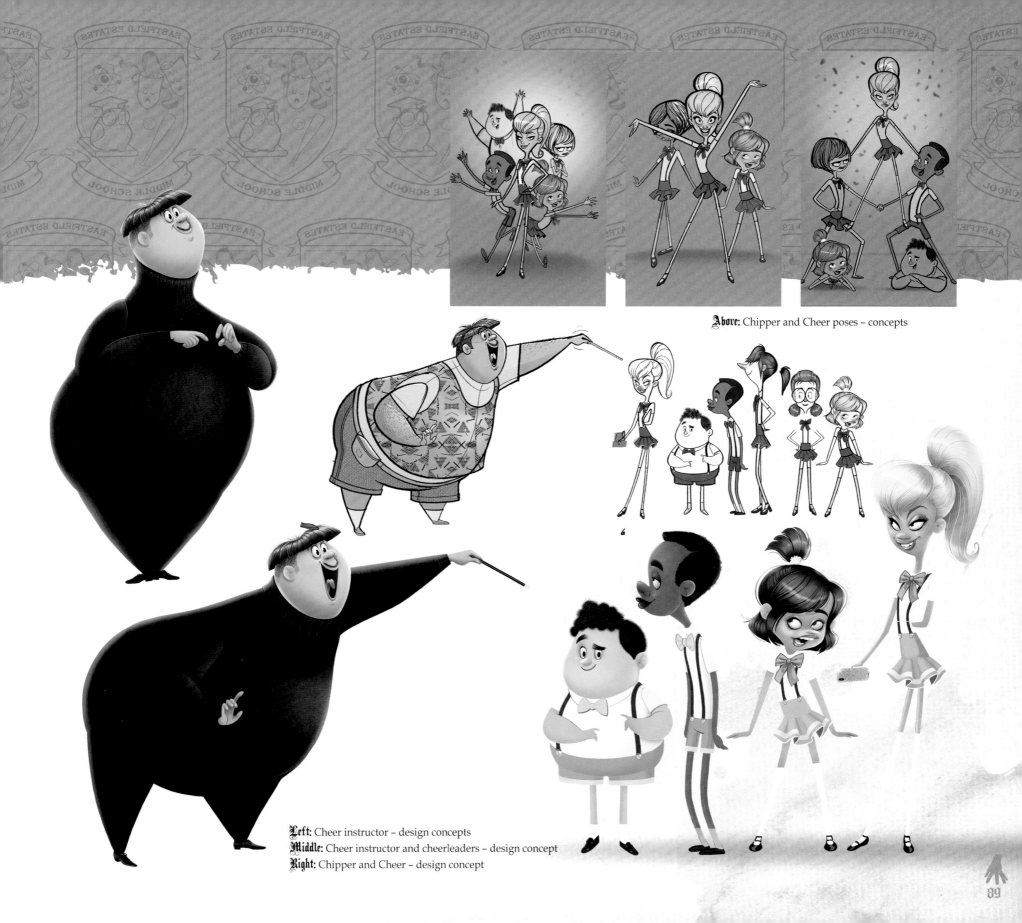

Above: Chipper and Cheer poses – concepts

Left: Cheer instructor – design concepts
Middle: Cheer instructor and cheerleaders – design concept
Right: Chipper and Cheer – design concept

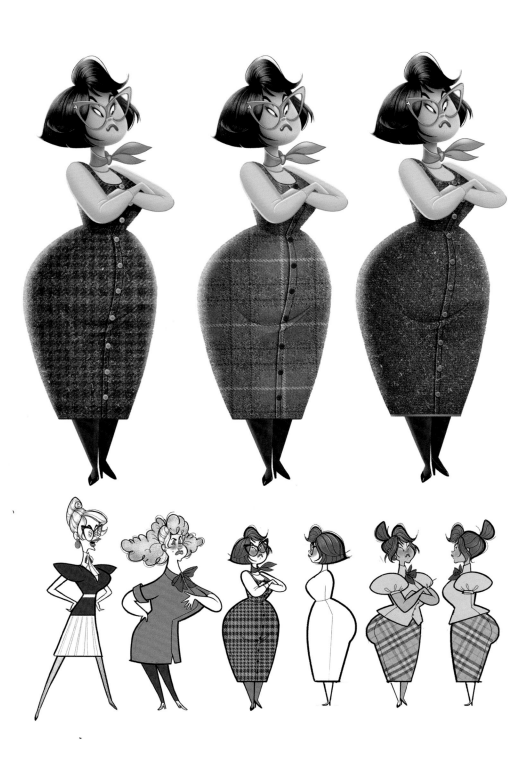

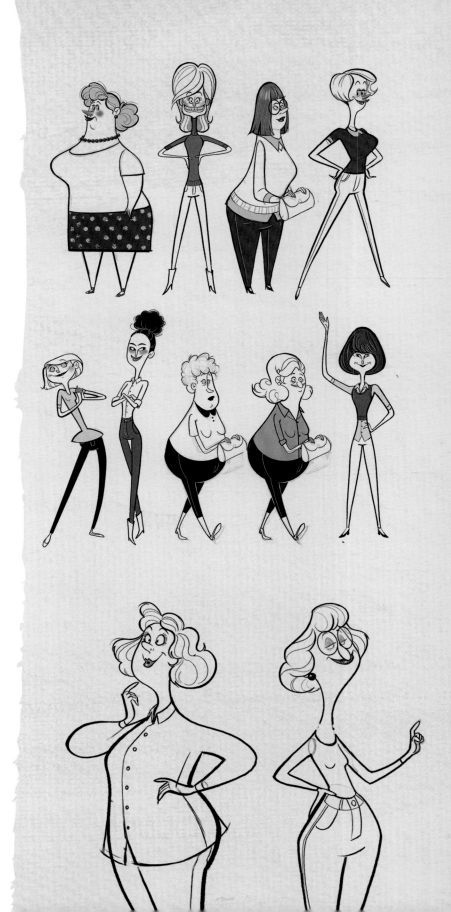

Top: Female teacher – design surfacing studies
Above: Female teacher – design concepts
Right: Female background characters – design concepts

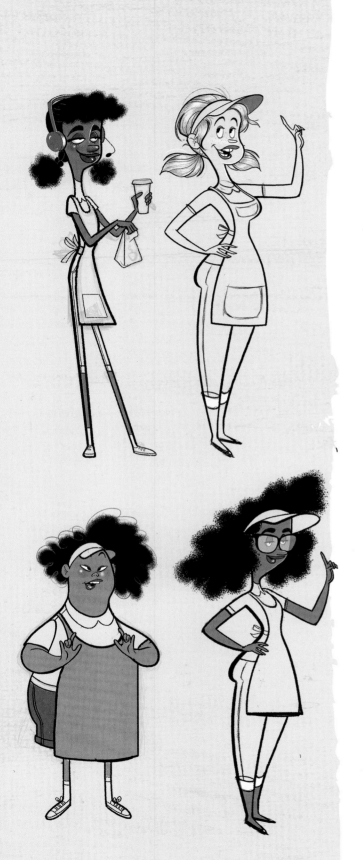

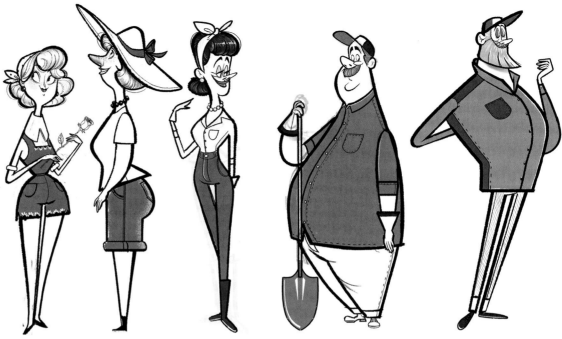

Above: Norman and Trudie – design concepts

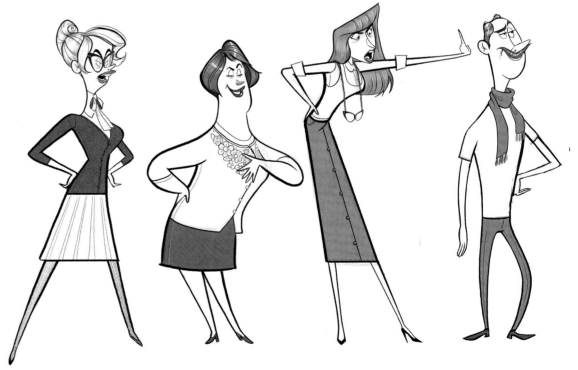

Above: Adult background characters – design concepts
Left: Barista – design concepts

91

Left & above: Denise – design concepts
Above right: Denise – storyboard panels
Right: Male background characters – design sketches
Below: Male background characters – design concepts

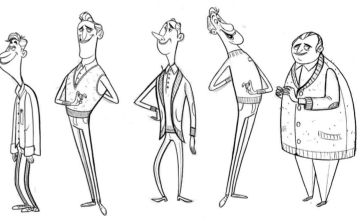

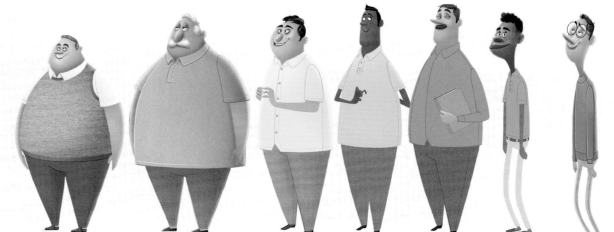

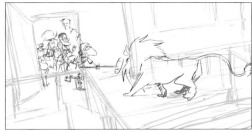

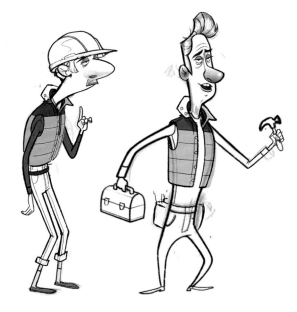

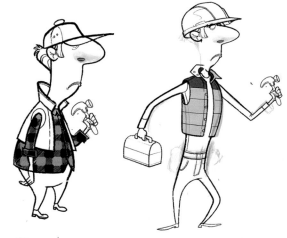

Above: Mitch – storyboard panels
Below: Female background characters – design concepts

Above: Mitch – design concepts
Right: Mitch – design surfacing study

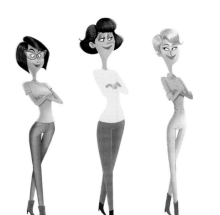

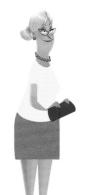

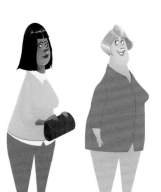

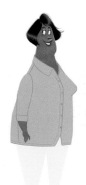

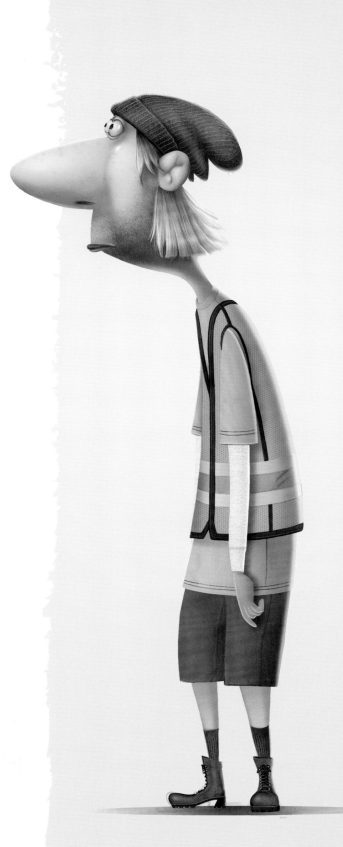

LOCATIONS

The Old Country Town

Previous spread: The Addams mansion at night – lighting key
Below: Old country town – concept art

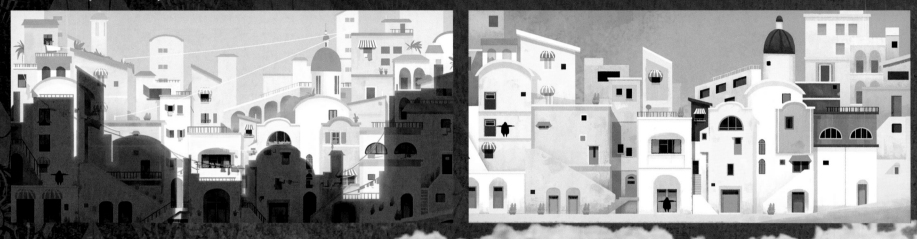

Left: Old country town manhole covers – visual development

Below left: Morticia waking up in her room on the day of her wedding (notice ambulance alarm clock on night stand) – final frame still

Bottom: Morticia waking up in her room on the day of her wedding – design concept

Below: Old country town – concept art

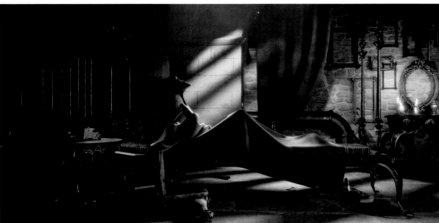 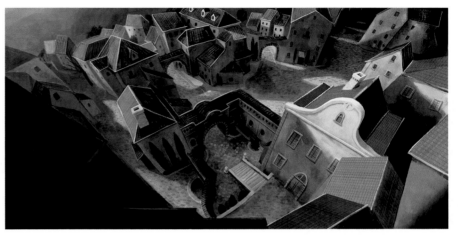

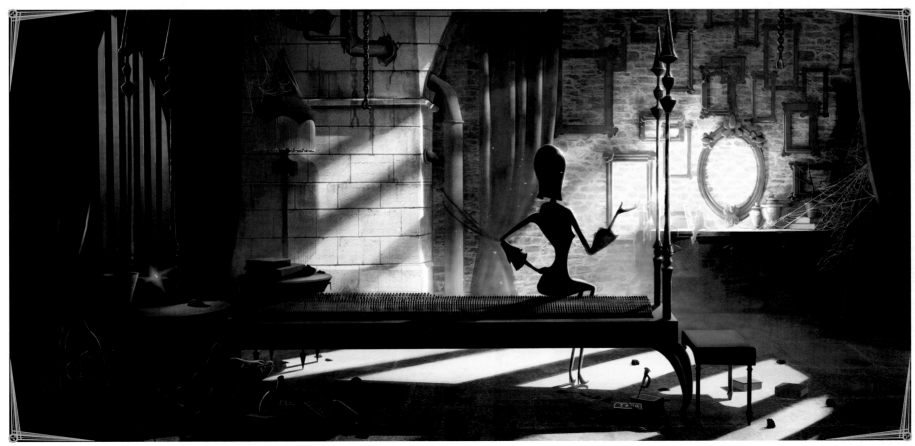

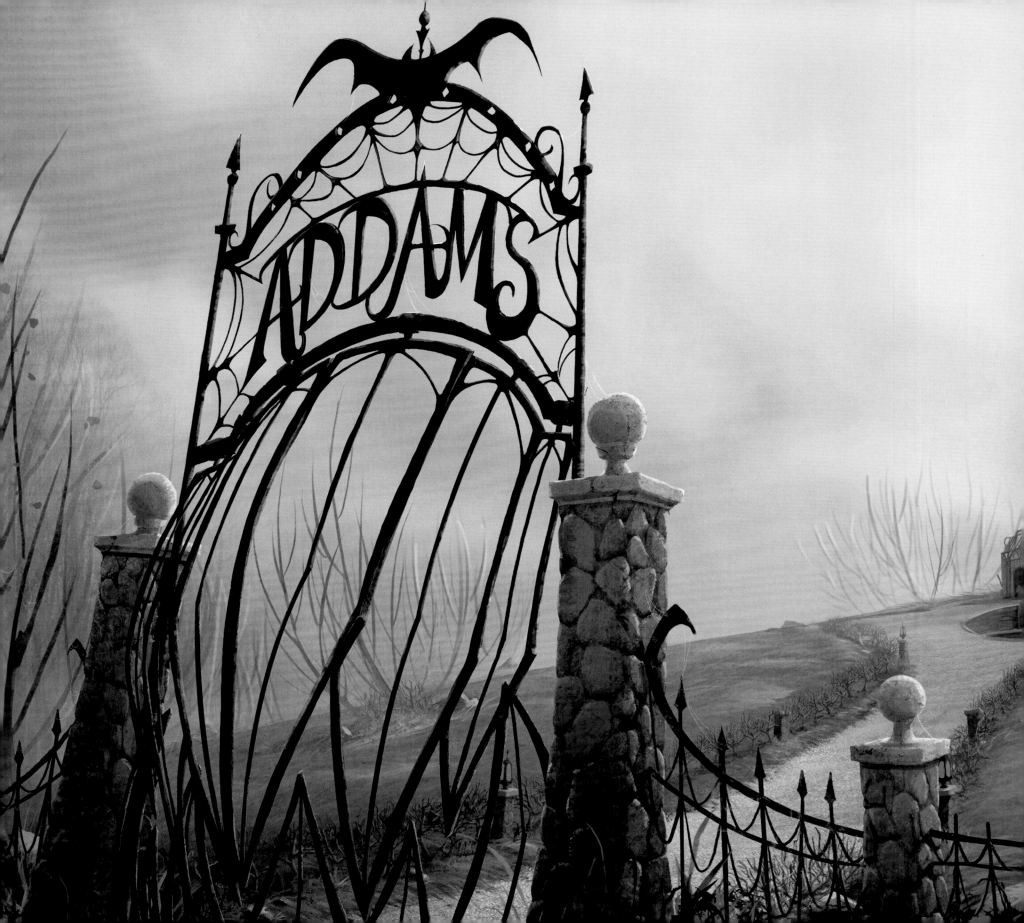

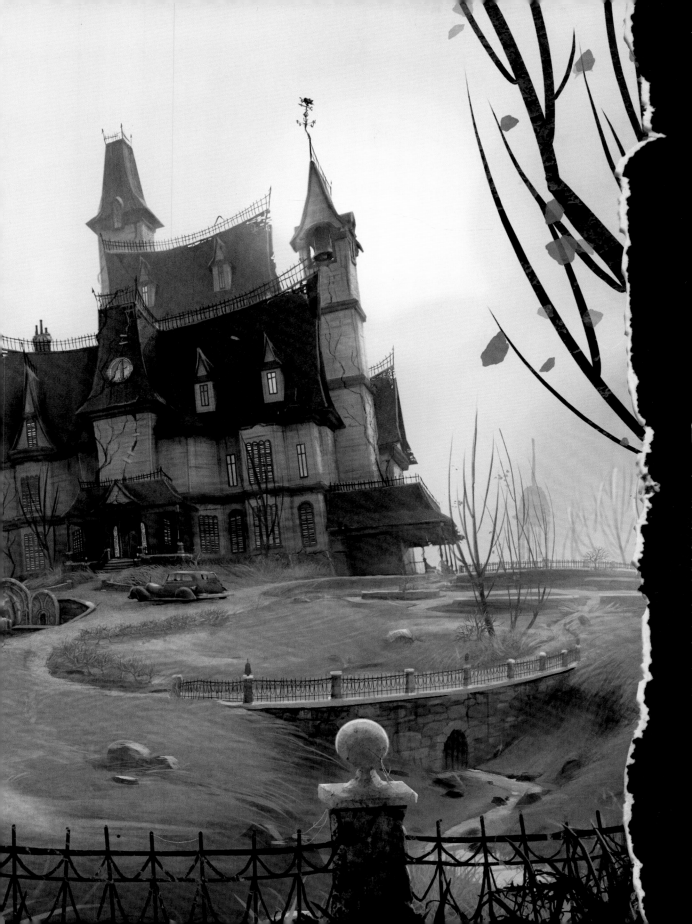

Addams Mansion

Charles Addams first introduced the family's mansion in a drawing of the clan about to pour boiling oil on a group of carolers from the roof. In the cartoons, the family's Victorian home is pictured as a dilapidated mansion atop a hill. In the TV series, the house was located at 0001 Cemetery Lane, and was packed with bizarre statues, trophies, medieval racks, nailbeds, booby traps, deadly plants and all types of explosives awaiting visitors in every corner.

Left: The Addams mansion exterior – concept painting

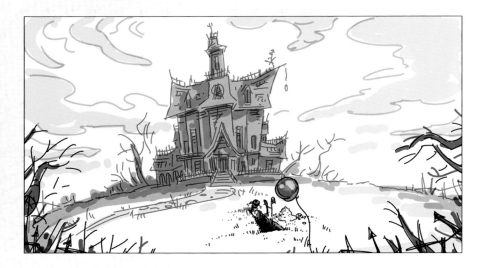

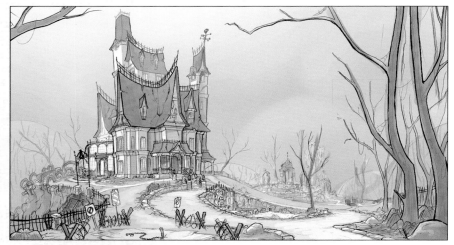

"Outside the house, we have a muted color palette, since the grass is dead and brown, the road is a dirt road, the stone work is grey and the house is mostly brown. So, we tried to balance with some spots of color, mostly with the characters, which pop up nicely against the backgrounds."

Patricia Atchison, Production Designer

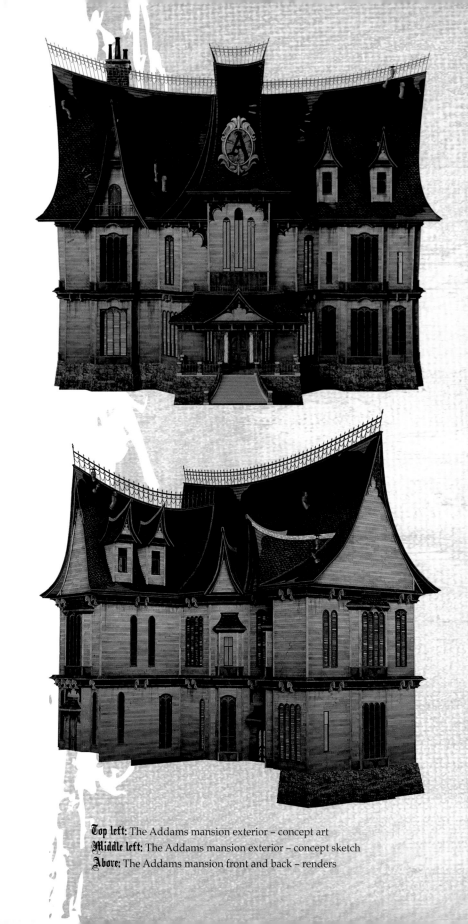

Top left: The Addams mansion exterior – concept art
Middle left: The Addams mansion exterior – concept sketch
Above: The Addams mansion front and back – renders

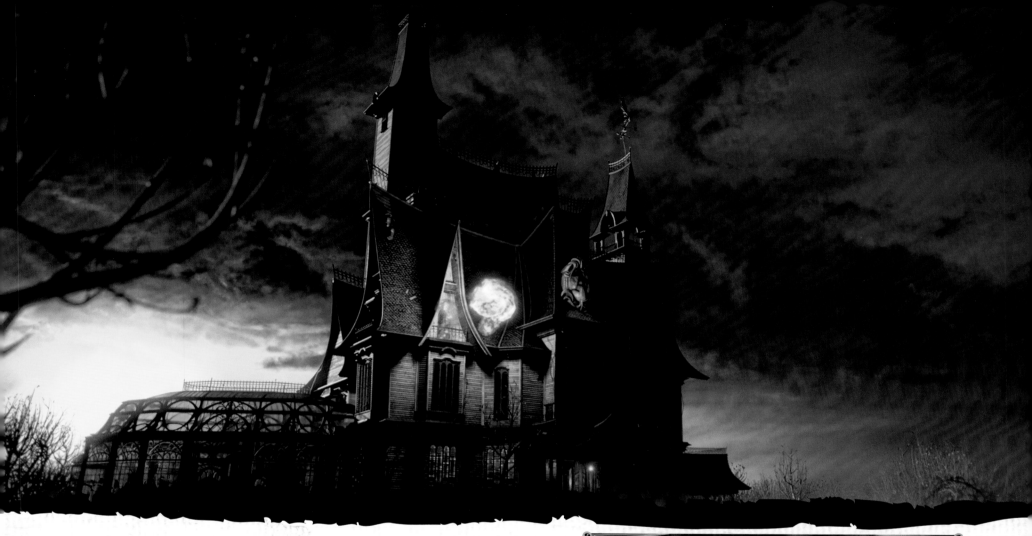

The Addams house in the animated movie is just as iconic and beautiful as we have come to expect from this elegant, spooky family. "We were allowed to use dark colors and add some fog and give it a real sense of place and mood," says director Conrad Vernon. "We wanted to make the house a real character in the movie. Something like *The Amityville Horror* immediately came to mind. So, when Morticia and Gomez first encounter the house, we give it an actual voice. We thought it was a fun idea."

According to Vernon, the artists had to take quite a few passes to get the visuals right for the house. The director and his team looked at the pictures of a lot of old mansions, but none of them felt quite right. So,

Above: The Addams mansion exterior at night with explosion – final frame still

Right: The Addams mansion exterior – concept art

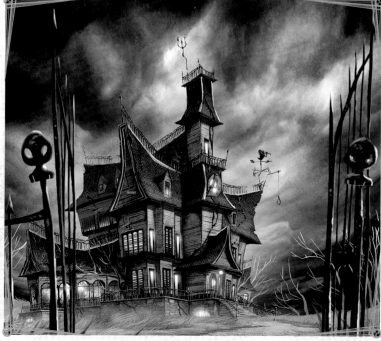

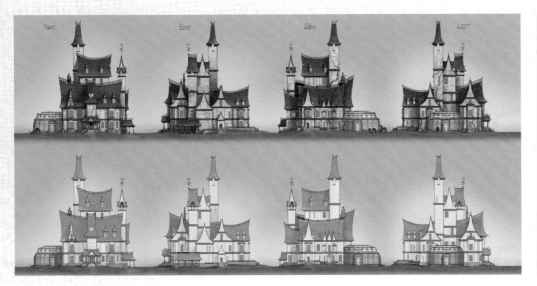

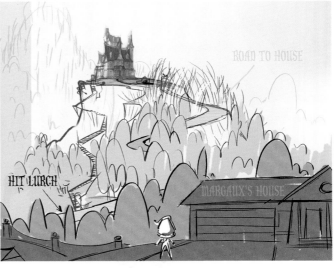

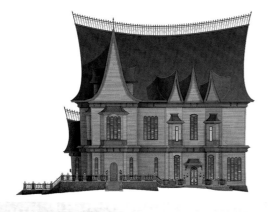

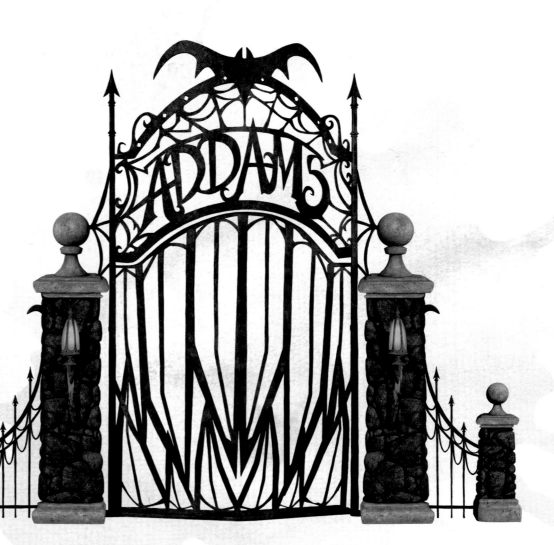

Top left: The Addams mansion exterior – design concept orthographics
Middle left: The Addams mansion exterior – design orthographic
Above: The Addams mansion destroyed – unused concept art
Top right: The Addams mansion exterior – design concept
Right: The Addams mansion front gate

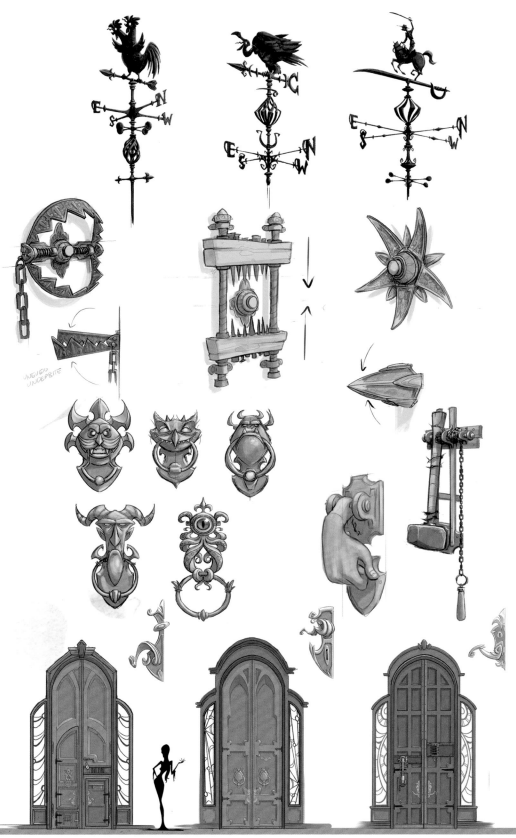

they went back to the original Addams drawings and the TV show for inspiration. "The original house had this rectangular steeple that really set it apart," says Vernon. "There's this large letter 'A' we put on the front of the house too. Looking back at the TV series, there is this great gag where the gate shuts behind this officer that goes in. So, we made the gates kind of like these opening jaws that you risk having come down on you as you walk through, with the name 'ADDAMS' written over the top of it."

Vernon mentions that in the movie lore, they imagine the house as an old abandoned insane asylum called Nutter Island. "That's actually where Lurch is from, that's where he has escaped from when Morticia and Gomez run over him," he explains. "That's why he knows where it is, and that's probably where he learned how to play the piano."

Left: The Addams mansion weather vane, doorbell, door knocker and front door – concept sketches
Above: The Addams mansion front door – look render
Right: The Addams mansion bell tower – look render

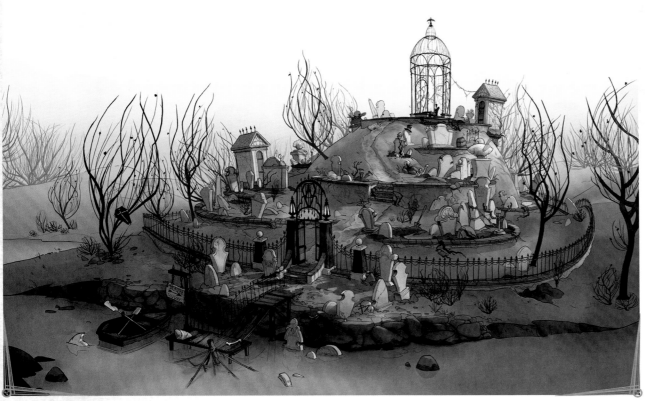

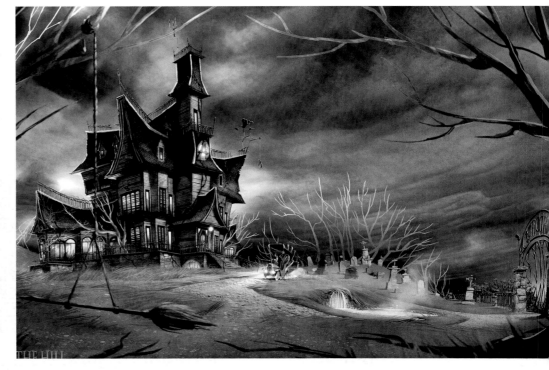

Above: Kite in the cemetery – design concepts

Above: The Addams mansion back yard cemetery – design concept **Below:** The Addams mansion exterior – concept art
Above right: Clouds over the Addams mansion – design

"Designing the exterior of the house was a major ask, because the Addamses live in a big house that is very old," says designer Patricia Atchison. "It's not falling apart—they don't live in ruins. We knew that we had to create a very strong silhouette that was familiar to everyone who knows the show and the movie. We wanted to have the bell tower, the brown house design, the style and shapes of the windows, but we also wanted to make it new. The property's relationship to the rest of the world is also important. The weather system is different from everywhere else. When you're at the house, the weather is creepy and moody, but when you leave the property, it's a bright and sunny day!"

As director Greg Tiernan points out, "I think people are really going to be intrigued by the house. Patricia did such a fantastic job. You really want to visit it, explore all the rooms and different corners, and just stay there."

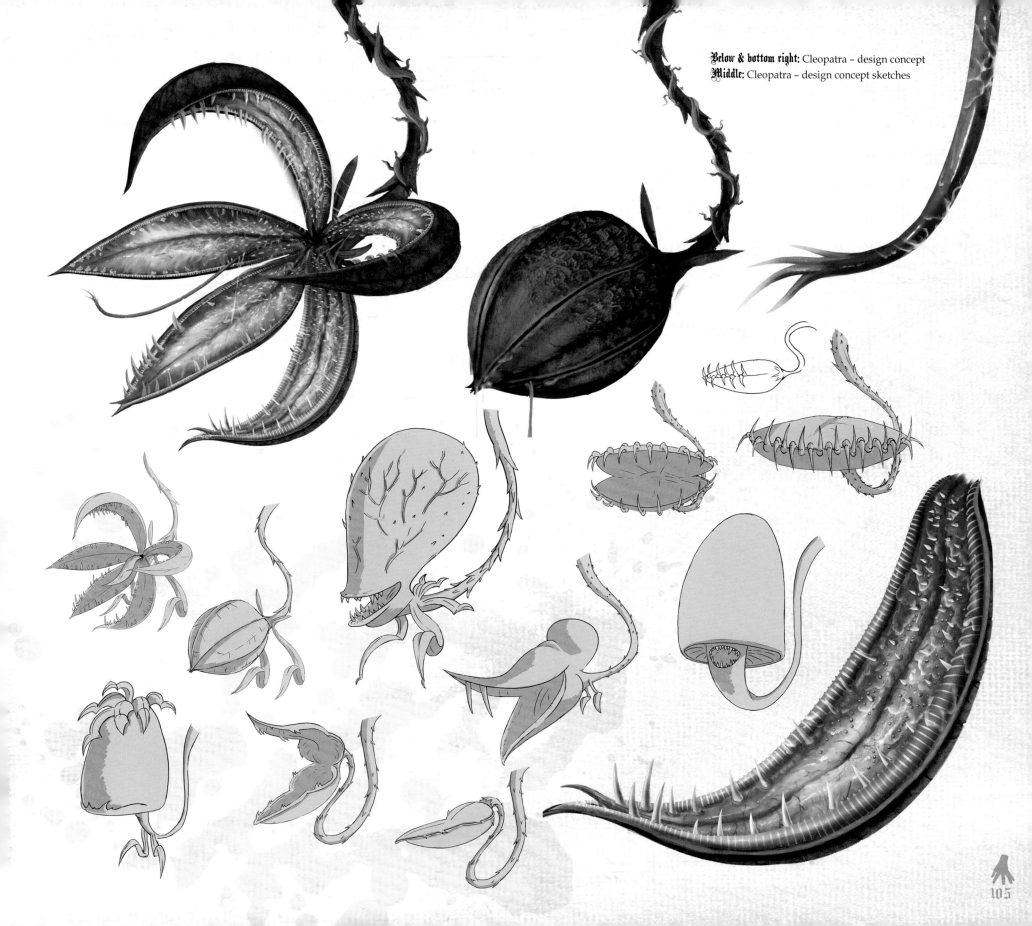

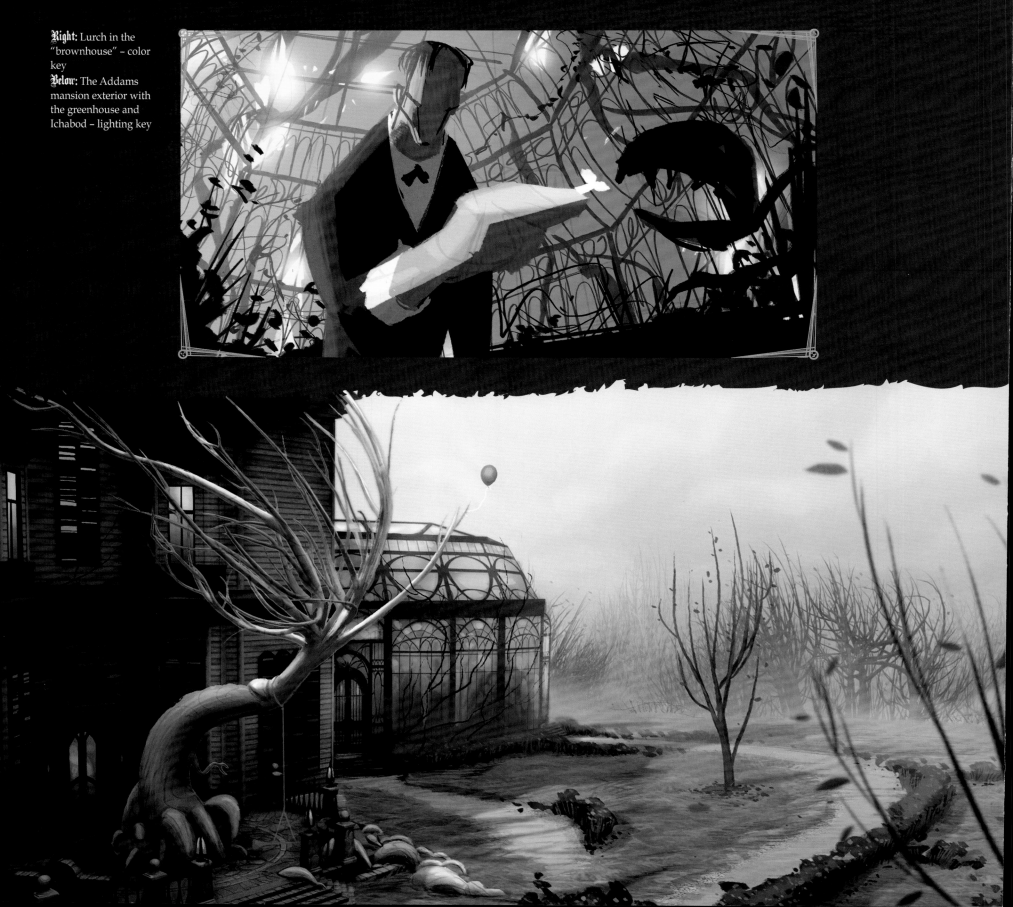

Right: Lurch in the "brownhouse" – color key

Below: The Addams mansion exterior with the greenhouse and Ichabod – lighting key

Ichabod

Throughout the movie, the filmmakers planted little homages to some of their favorite horror classics, such as *The Omen*, *The Shining* and *Poltergeist*. Ichabod, the strange living tree that wakes up Wednesday and Pugsley in the mornings, is one of these clever references. "In *Poltergeist*, there is that tree that comes smashing through the window and gets the little boy, so we thought it would be fun to have the kids being woken up every morning by this tree character," says director Conrad Vernon. "We soon begin to realize that Ichabod has a kind of adoration for Wednesday and vice versa, so we wanted to give it more to do, and that led to Ichabod's involvement in the third act of the movie."

Designer Patricia Atchison says they used Ichabod to pay a subtle tribute to the original artist's creations. "In one of Chas Addams' comics, Gomez is pushing Wednesday on a swing, so we tried to recreate that by having her on a swing hanging from one of Ichabod's branches," she says.

Right: Ichabod – design concept
Below: Ichabod – design surfacing study
Bottom: Ichabod – design concept color keys

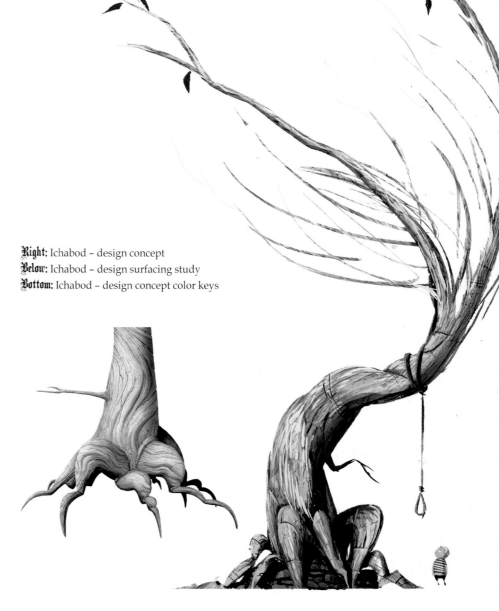

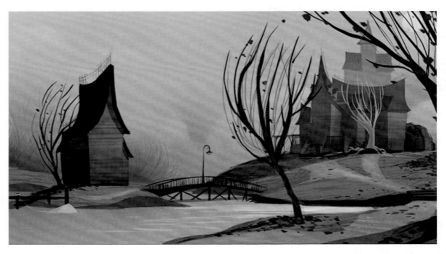

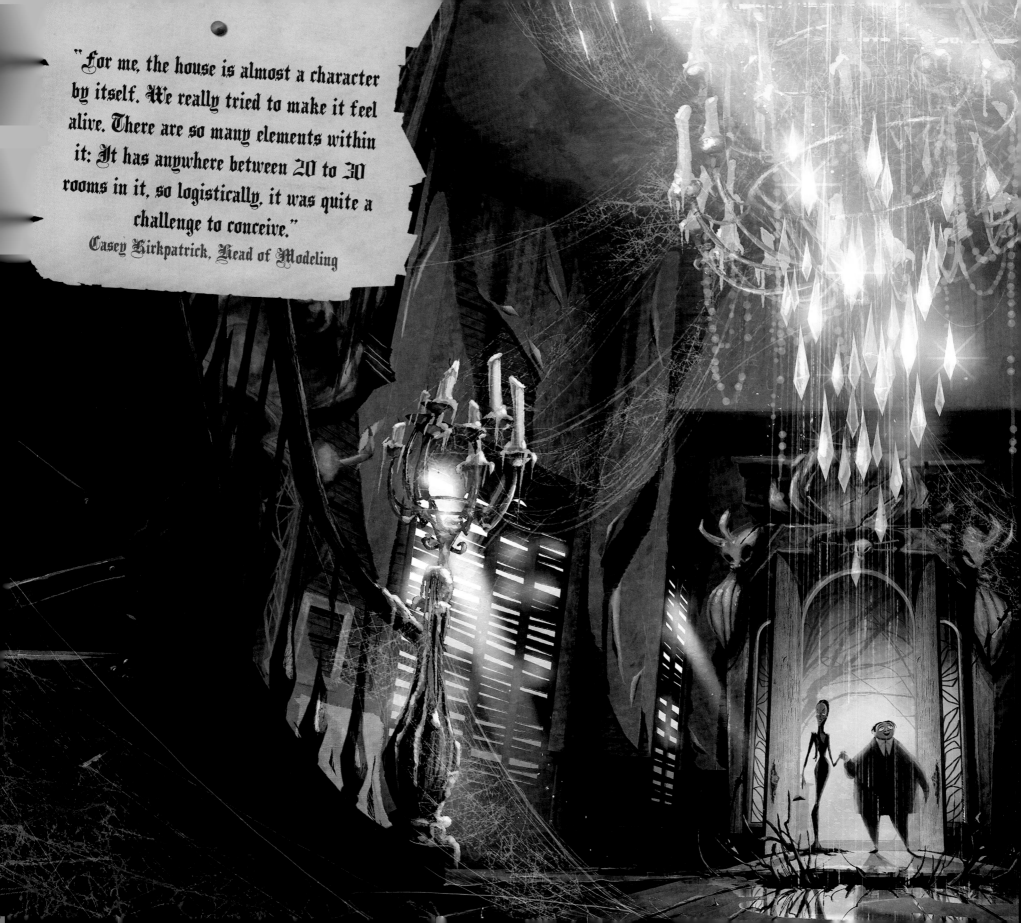

"For me, the house is almost a character by itself. We really tried to make it feel alive. There are so many elements within it: It has anywhere between 20 to 30 rooms in it, so logistically, it was quite a challenge to conceive."

Casey Kirkpatrick, Head of Modeling

Foyer

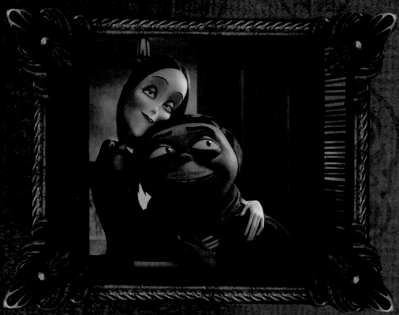

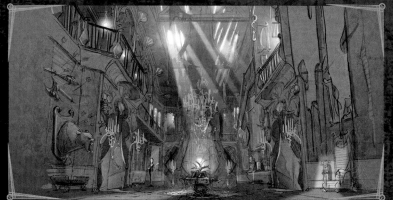

Left: Foyer – concept art
Top: Young Morticia and Young Gomez enter the mansion for the first time – final frame still
Above: Foyer – concept art

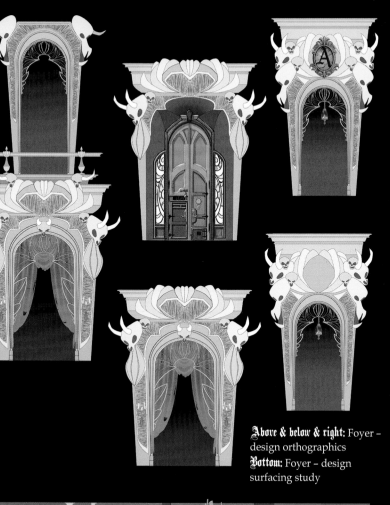

Above & below & right: Foyer – design orthographics
Bottom: Foyer – design surfacing study

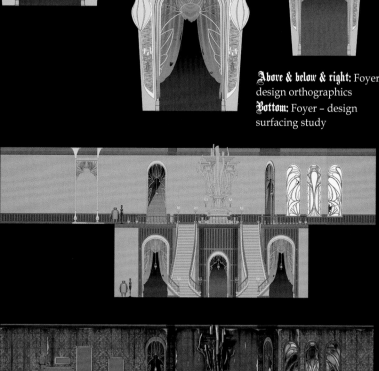

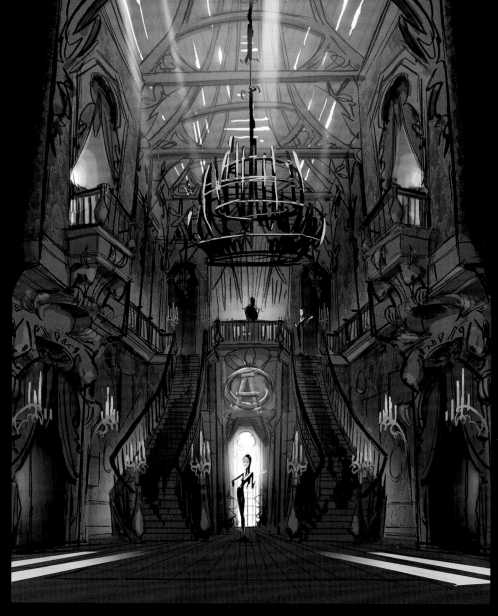

Below: Foyer bearskin rug – design concepts

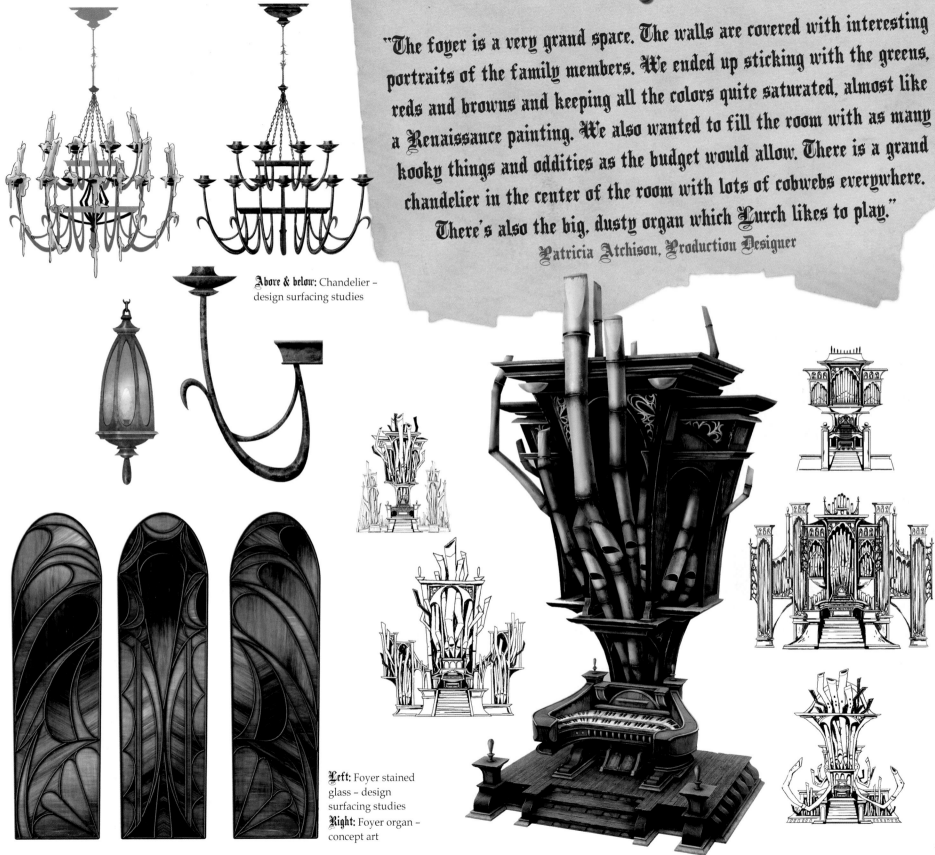

Above & below: Chandelier – design surfacing studies

"The foyer is a very grand space. The walls are covered with interesting portraits of the family members. We ended up sticking with the greens, reds and browns and keeping all the colors quite saturated, almost like a Renaissance painting. We also wanted to fill the room with as many kooky things and oddities as the budget would allow. There is a grand chandelier in the center of the room with lots of cobwebs everywhere. There's also the big, dusty organ which Lurch likes to play."
Patricia Atchison, Production Designer

Left: Foyer stained glass – design surfacing studies

Right: Foyer organ – concept art

Lurch's Padded Cell

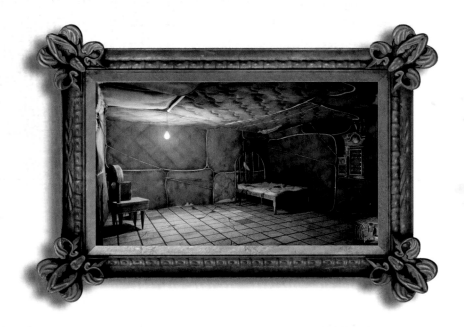

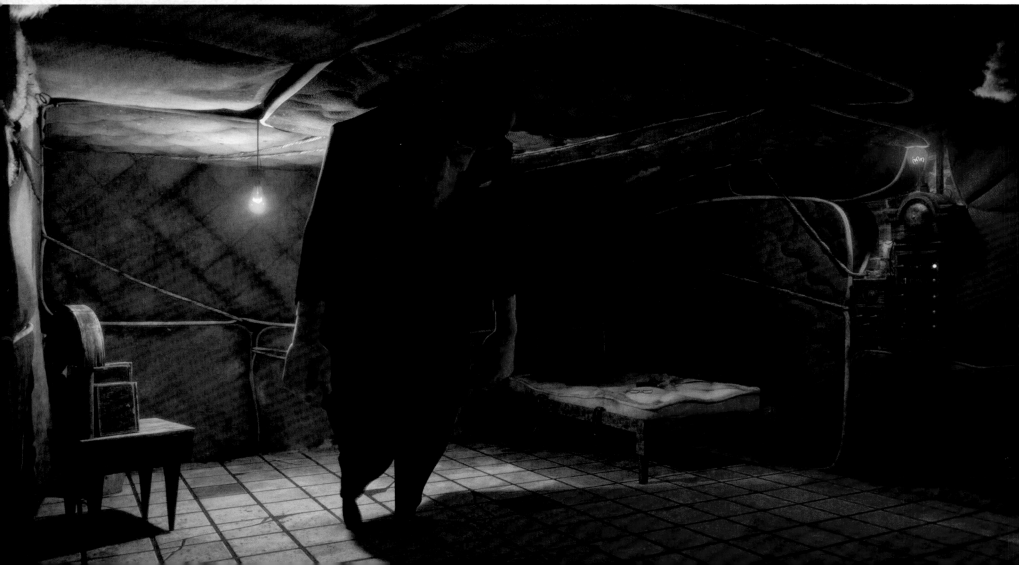

Opposite: Lurch's padded cell – design surfacing frame
Opposite bottom: Lurch in his padded cell – final frame still
Right: Padded cell callbox – concept art
Far right: Lurch in his padded cell – concept art
Below: Lurch in his padded cell – design concept

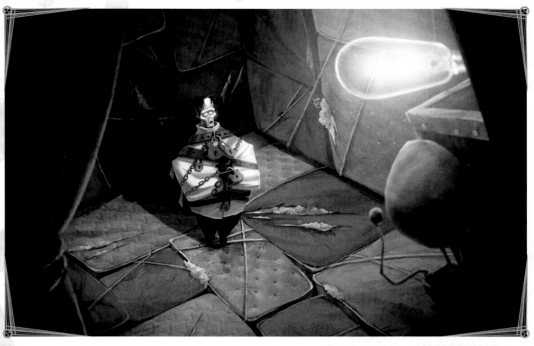

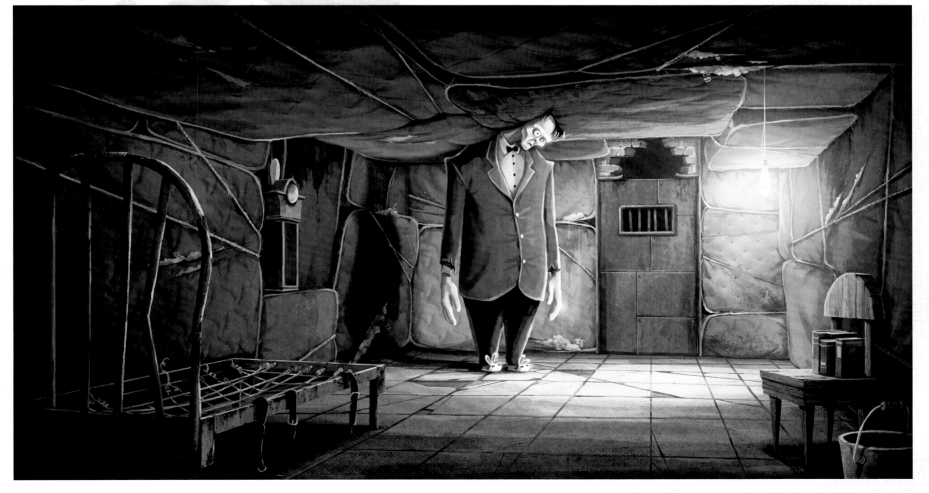

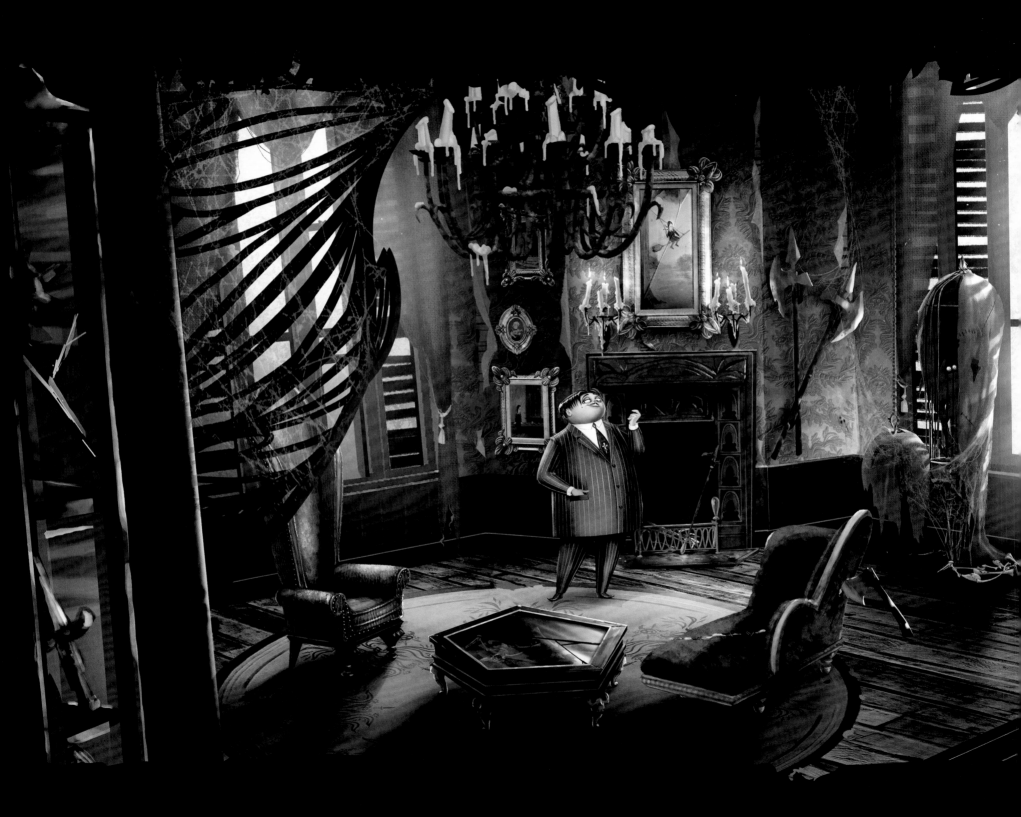

Gomez & Morticia's Rooms

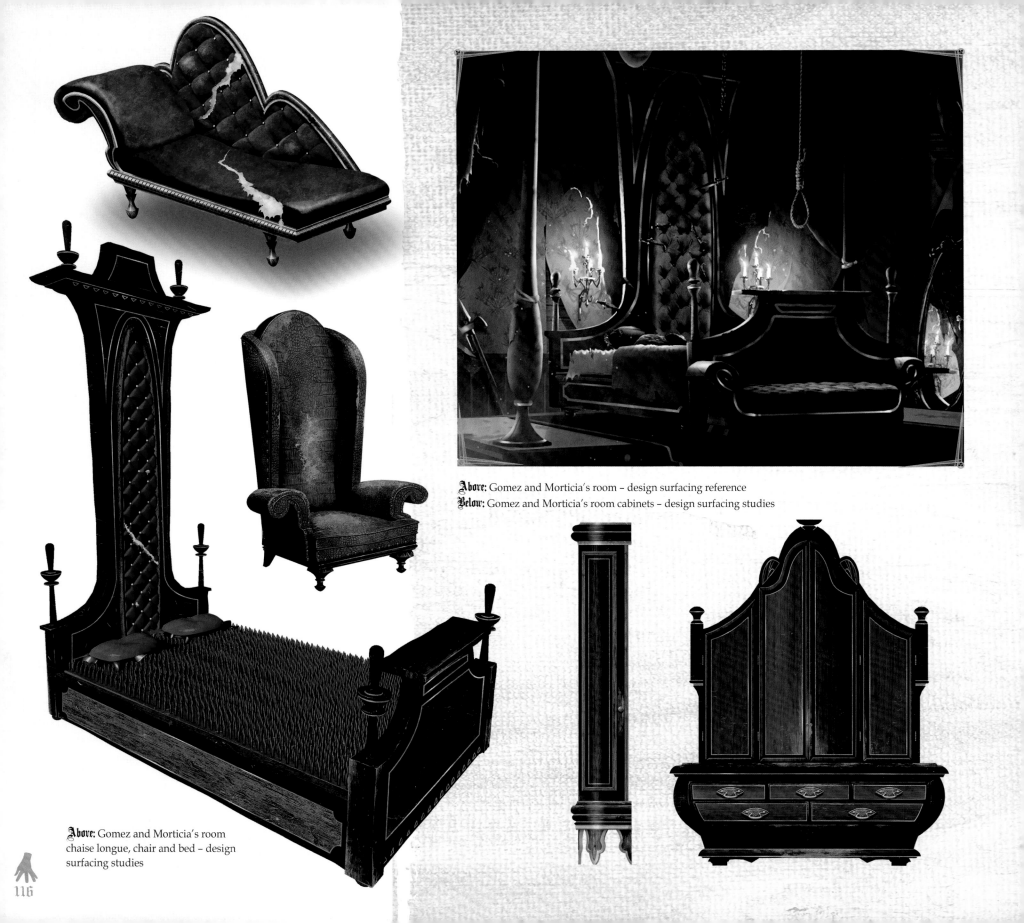

Above: Gomez and Morticia's room – design surfacing reference
Below: Gomez and Morticia's room cabinets – design surfacing studies

Above: Gomez and Morticia's room chaise longue, chair and bed – design surfacing studies

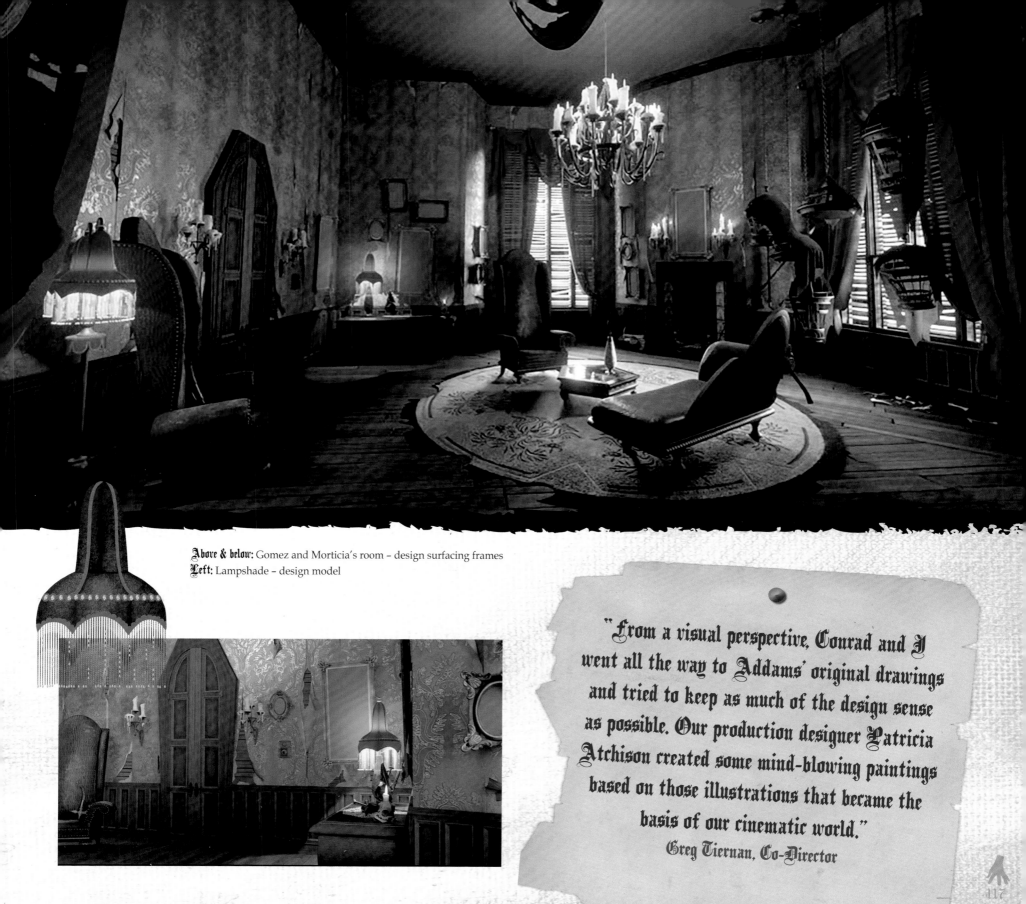

Above & below: Gomez and Morticia's room – design surfacing frames
Left: Lampshade – design model

"From a visual perspective, Conrad and I went all the way to Addams' original drawings and tried to keep as much of the design sense as possible. Our production designer Patricia Atchison created some mind-blowing paintings based on those illustrations that became the basis of our cinematic world."

Greg Tiernan, Co-Director

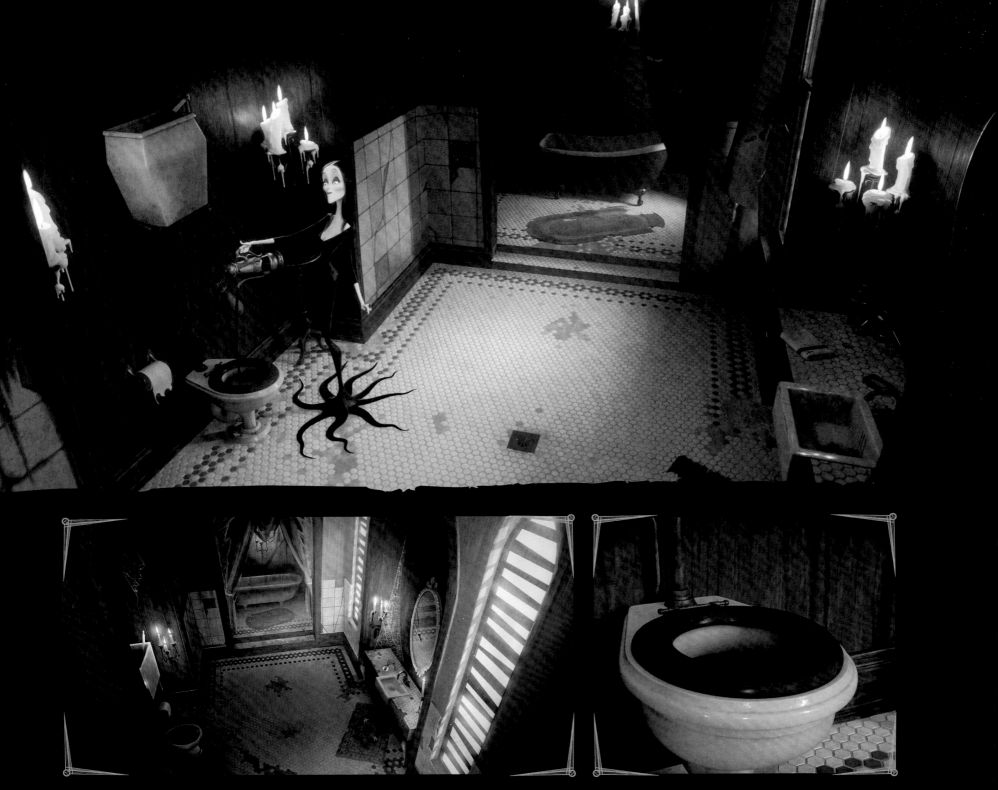

Top: Morticia pours coffee down the toilet to wake the spirit of the mansion – final frame still
Above: Gomez and Morticia's bathroom – design concept
Above right: Gomez and Morticia's bathroom – design surfacing study

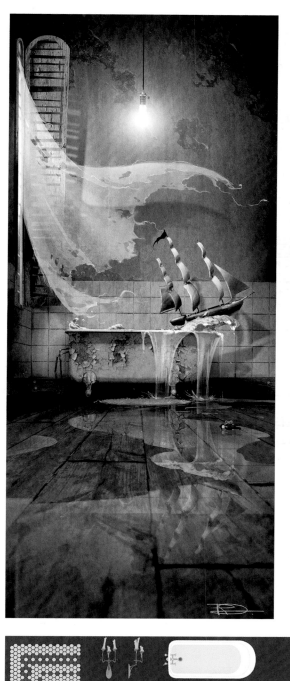

Left: Gomez and Morticia's bathroom – concept art
Below: Gomez and Morticia's bathroom – design surfacing study
Bottom: Gomez and Morticia's bathroom fixtures – design orthographics
Right: Gomez and Morticia's bathroom rug – design surfacing study

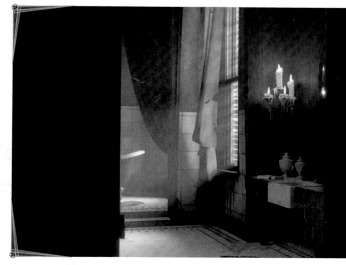

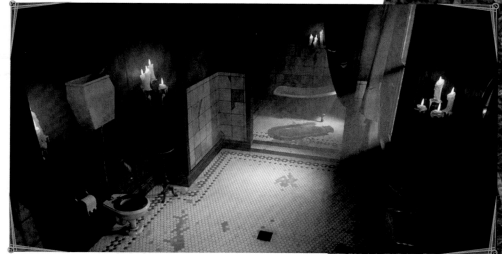

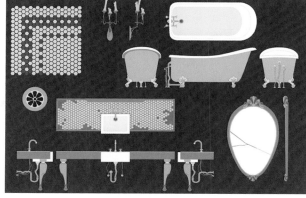

Above: Pugsley's room – design concept

Pugsley's Room

Pugsley's bedroom was one of the first sets designed by Patricia Atchison for the movie, as the room was featured more extensively in one of the earlier versions of the script. The mischievous son of the family lives in the attic, and his room is full of creepy toys, weapons and traffic signs that he has stolen from roads. The room is quite dusty, and the artists had fun adding a lot of floating particles in the room to create the foreboding atmosphere. Of course, there are lots of Pugsley's drawings everywhere—many of which depict him killing his father and sister!

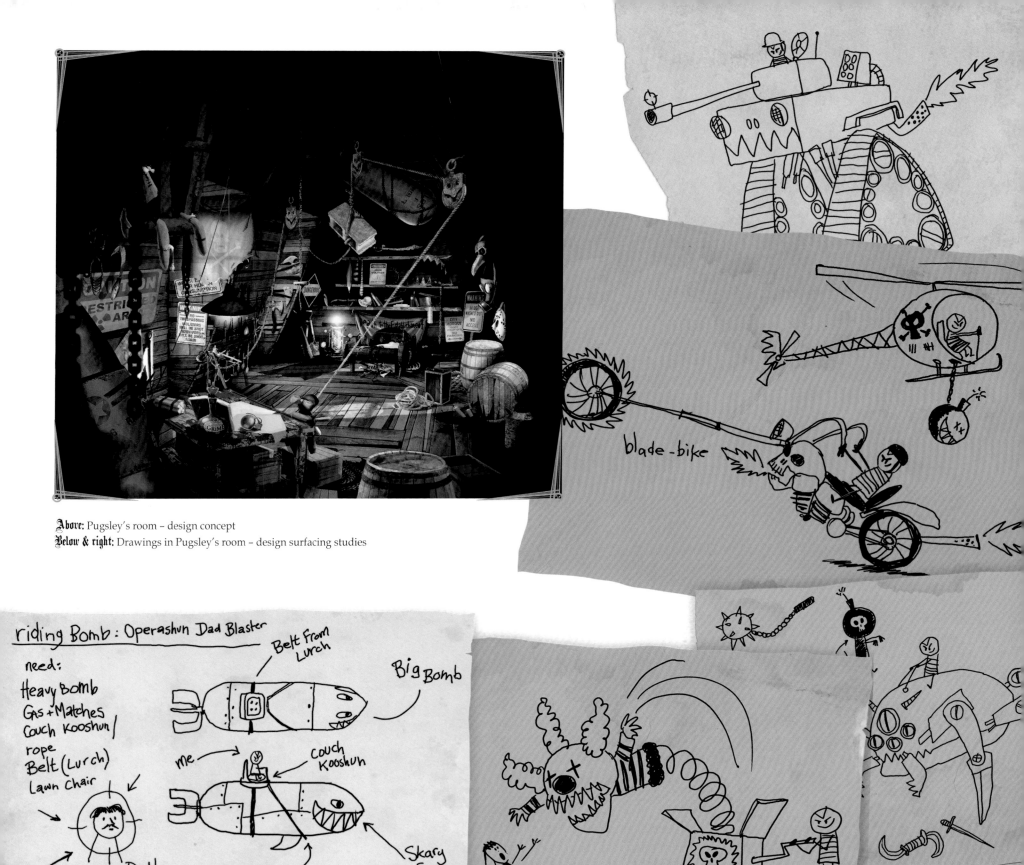

Above: Pugsley's room – design concept
Below & right: Drawings in Pugsley's room – design surfacing studies

blade-bike

riding Bomb: Operashun Dad Blaster

need:
Heavy Bomb
Gas + Matches
Couch Kooshun /
rope
Belt (Lurch)
Lawn chair

Belt from Lurch

Big Bomb

me →

couch Kooshun

Target: Dad!
Boom!!

ropes

Skary Face

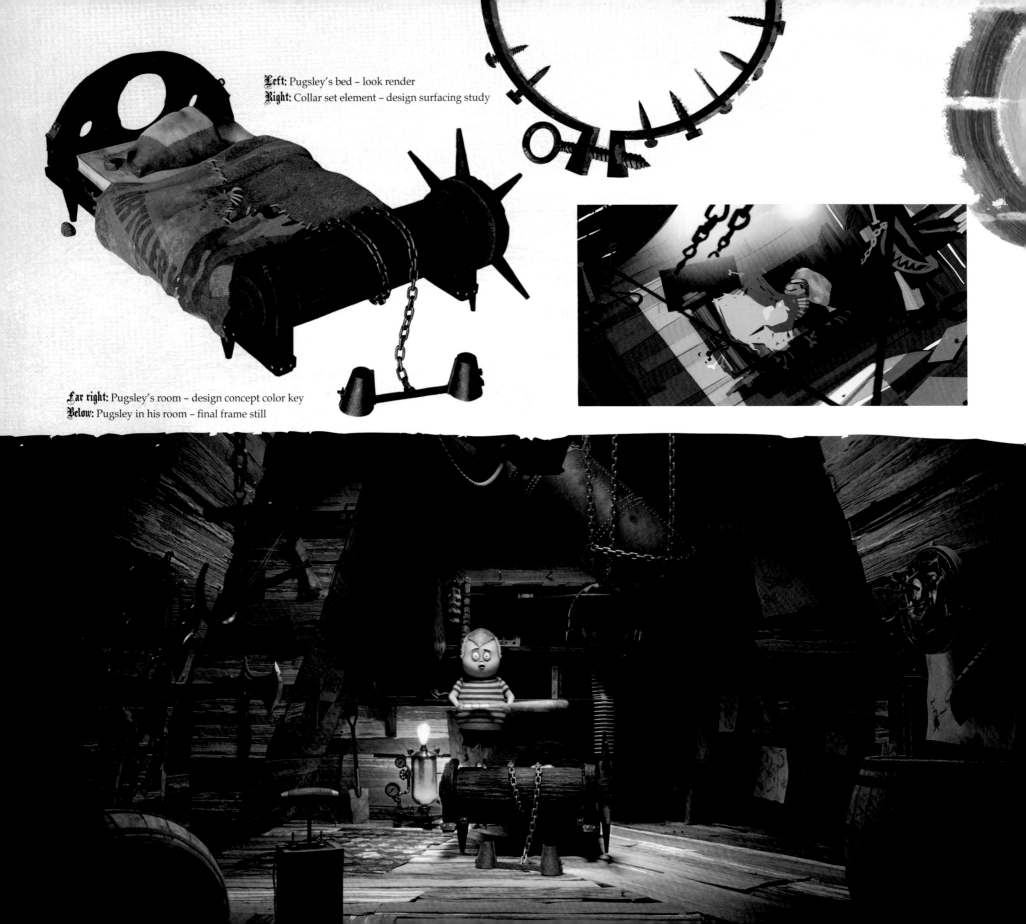

Left: Pugsley's bed – look render
Right: Collar set element – design surfacing study

Far right: Pugsley's room – design concept color key
Below: Pugsley in his room – final frame still

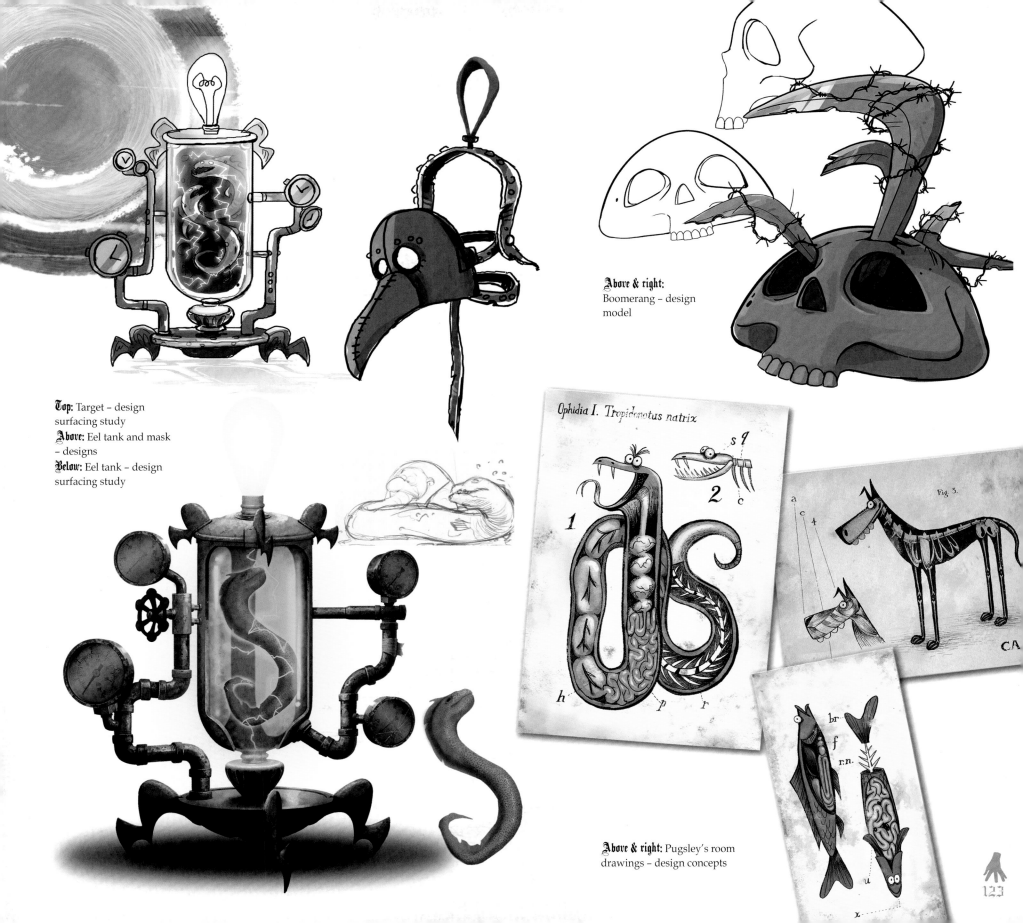

Above & right:
Boomerang – design
model

Top: Target – design
surfacing study
Above: Eel tank and mask
– designs
Below: Eel tank – design
surfacing study

Ophidia I. Tropidonotus natrix

Above & right: Pugsley's room
drawings – design concepts

Wednesday's Room

Wednesday's bedroom was featured many times in classic Charles Addams cartoons. There is an octopus painted on the footboard slat of her bed, pictures of monsters on her wall, and a treasure chest where she keeps her creepy toys. Her room is equally memorable in the movie. "We were inspired by the drawing of an octopus on the back of an Addams artbook," says production designer Patricia Atchison. "So, you can see all these octopi killing deep-sea divers and strangling mermaids on the wallpaper in her room. She keeps a voodoo doll of her brother in the room. There's also an electric chair, to which she straps one of her dolls, and her bed is actually a guillotine.

Below: Wednesday's room – design concept

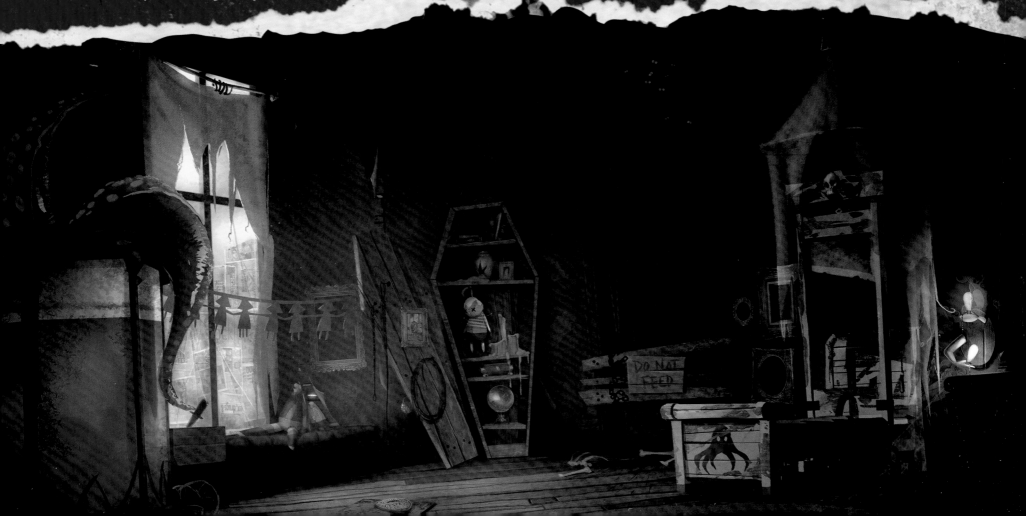

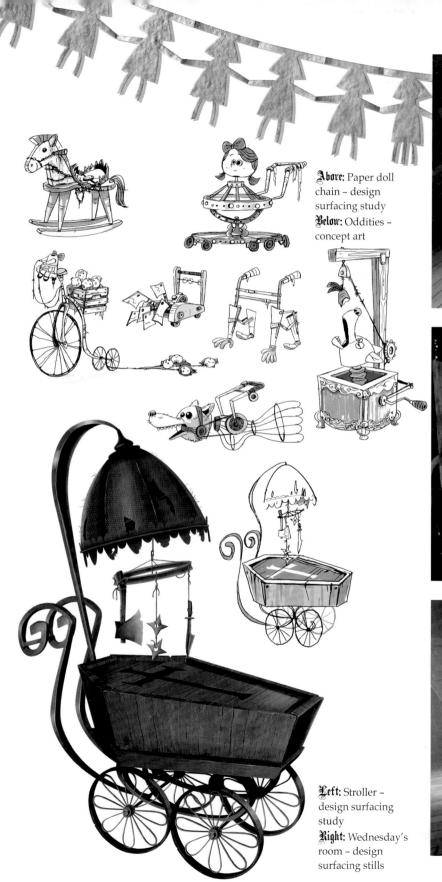

Above: Paper doll chain – design surfacing study
Below: Oddities – concept art

Left: Stroller – design surfacing study
Right: Wednesday's room – design surfacing stills

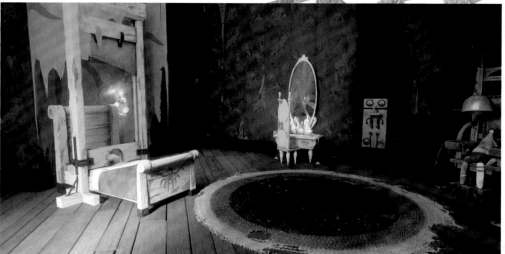

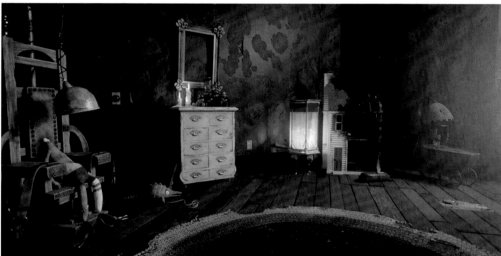

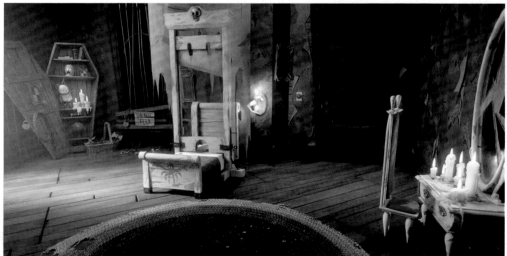

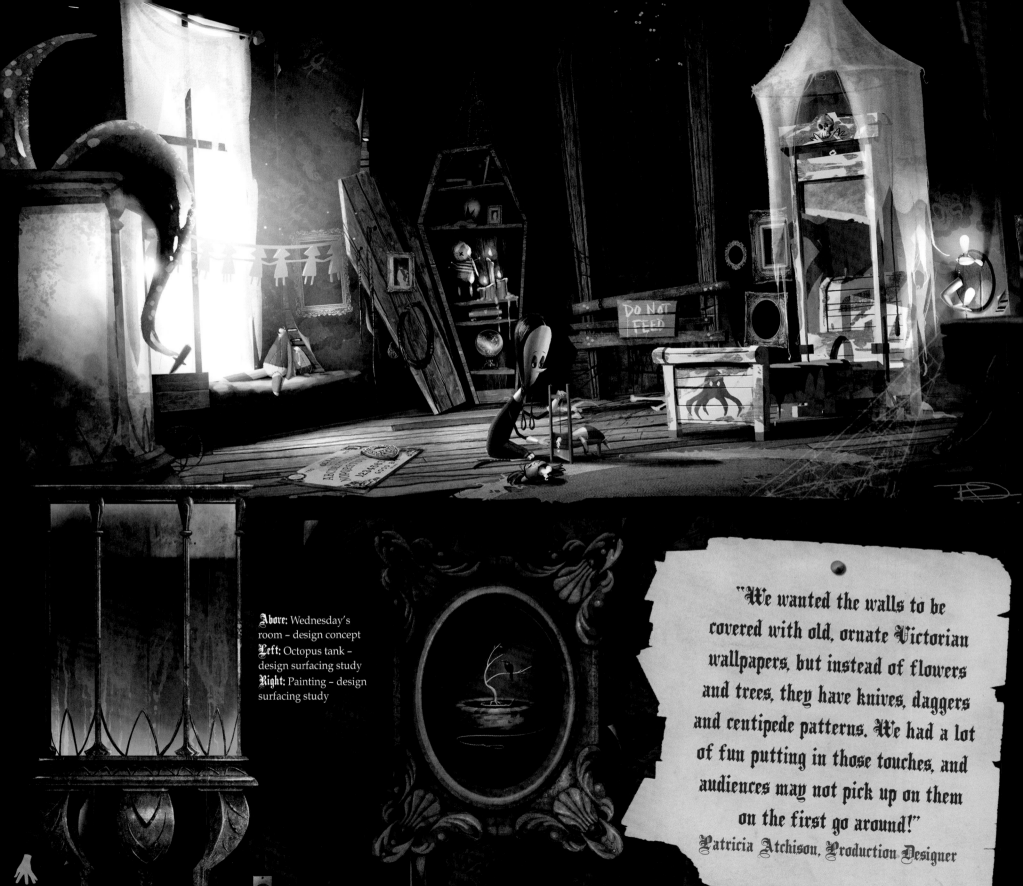

Above: Wednesday's room – design concept
Left: Octopus tank – design surfacing study
Right: Painting – design surfacing study

"We wanted the walls to be covered with old, ornate Victorian wallpapers, but instead of flowers and trees, they have knives, daggers and centipede patterns. We had a lot of fun putting in those touches, and audiences may not pick up on them on the first go around!"
Patricia Atchison, Production Designer

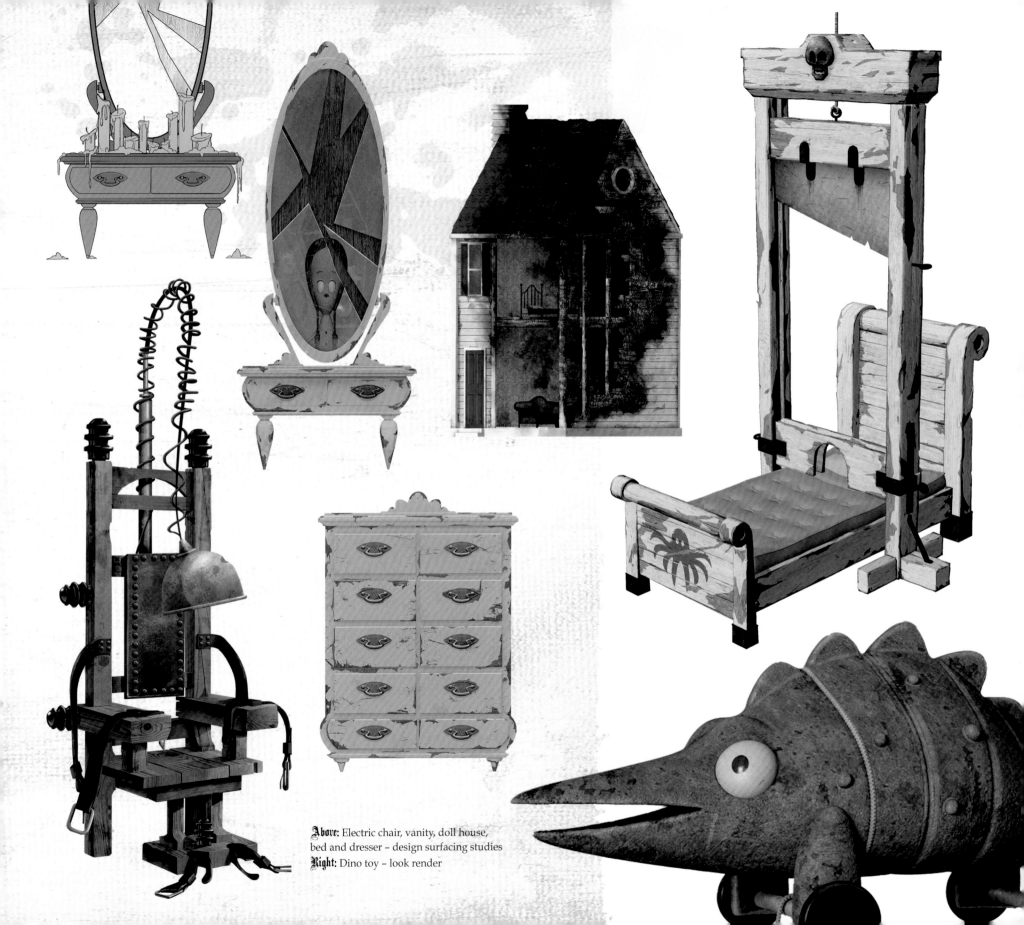

Above: Electric chair, vanity, doll house, bed and dresser – design surfacing studies
Right: Dino toy – look render

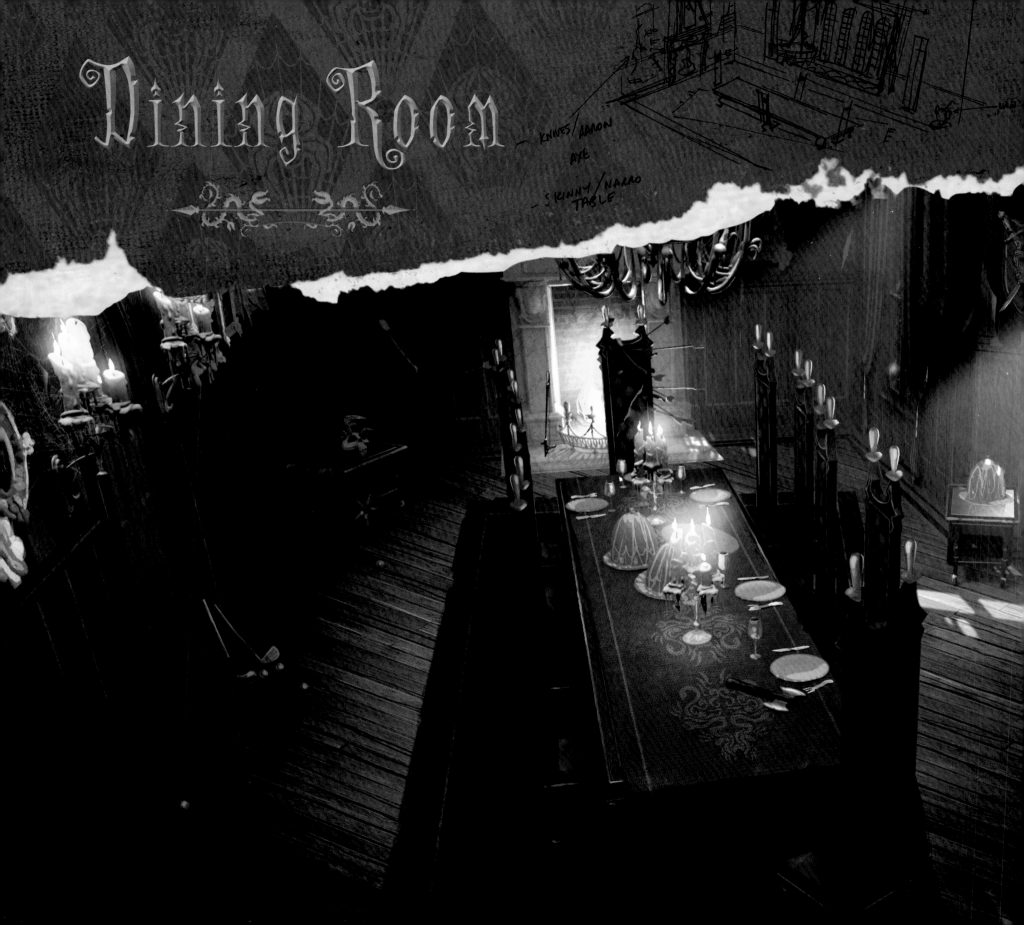

Dining Room

KNIVES/AARON
AXE

SKINNY/NARROW
TABLE

Below: Dining room – design concept
Right: Dining room – concept sketch
Middle right: The family in the dining room – design surfacing frame
Bottom right: Two-Headed Pig by Charles Addams

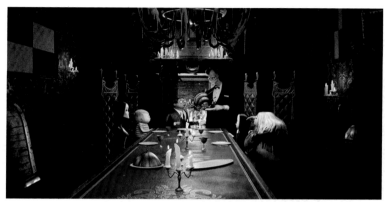

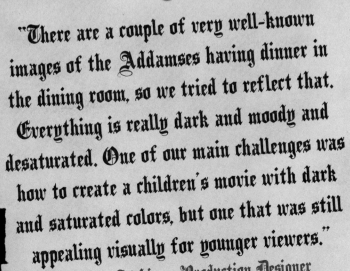

"There are a couple of very well-known images of the Addamses having dinner in the dining room, so we tried to reflect that. Everything is really dark and moody and desaturated. One of our main challenges was how to create a children's movie with dark and saturated colors, but one that was still appealing visually for younger viewers."
Patricia Atchison, Production Designer

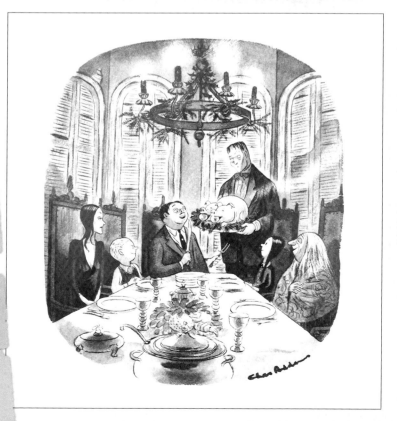

Above: Ballroom – design concept
Below: Sabre Mazurka sword

Ballroom

"The goal is to make sure the movie feels like it was shot by a single cinematographer. We don't use a lot of extreme close-ups in the interior shots as we want the house to be a character, so we don't push in very tight."

Rav Grewal, Head of Previs

Below: Sloom's chair – design surfacing studies
Right: Sloom's chair – design concept
Below middle: Ballroom podium – design surfacing study
Bottom: Ballroom floor (left) and ceiling (right) – design surfacing studies

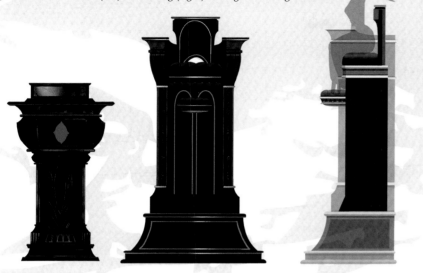

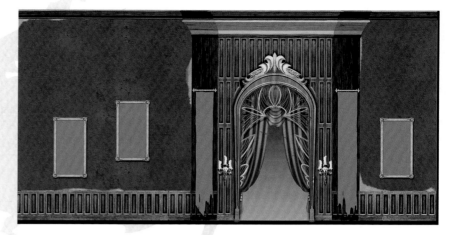

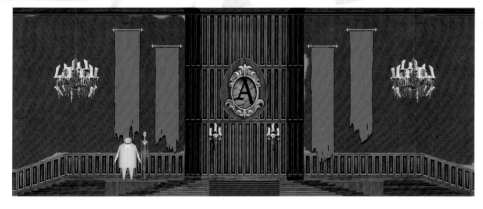

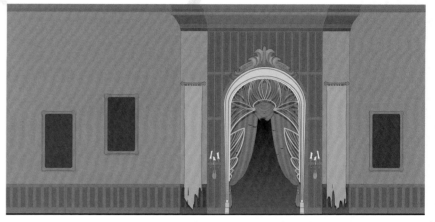

Top right: Ballroom doorway – design surfacing study (top) and design orthographic (below)
Bottom right: Ballroom windows – design surfacing study (top) and design orthographic (below)
Next spread: Sabre Mazurka – storyboard sequence

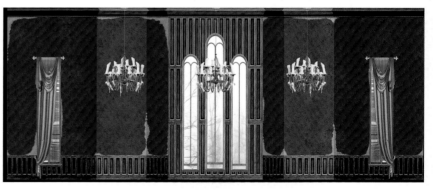

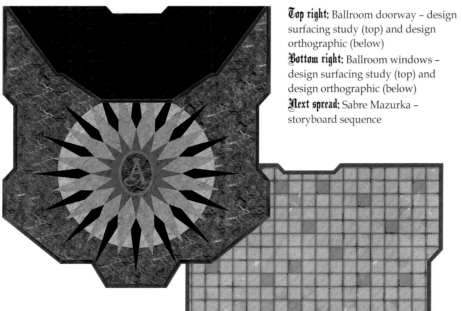

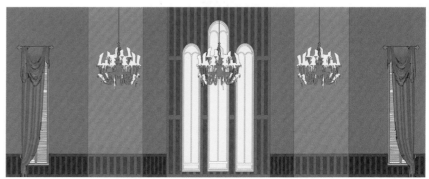

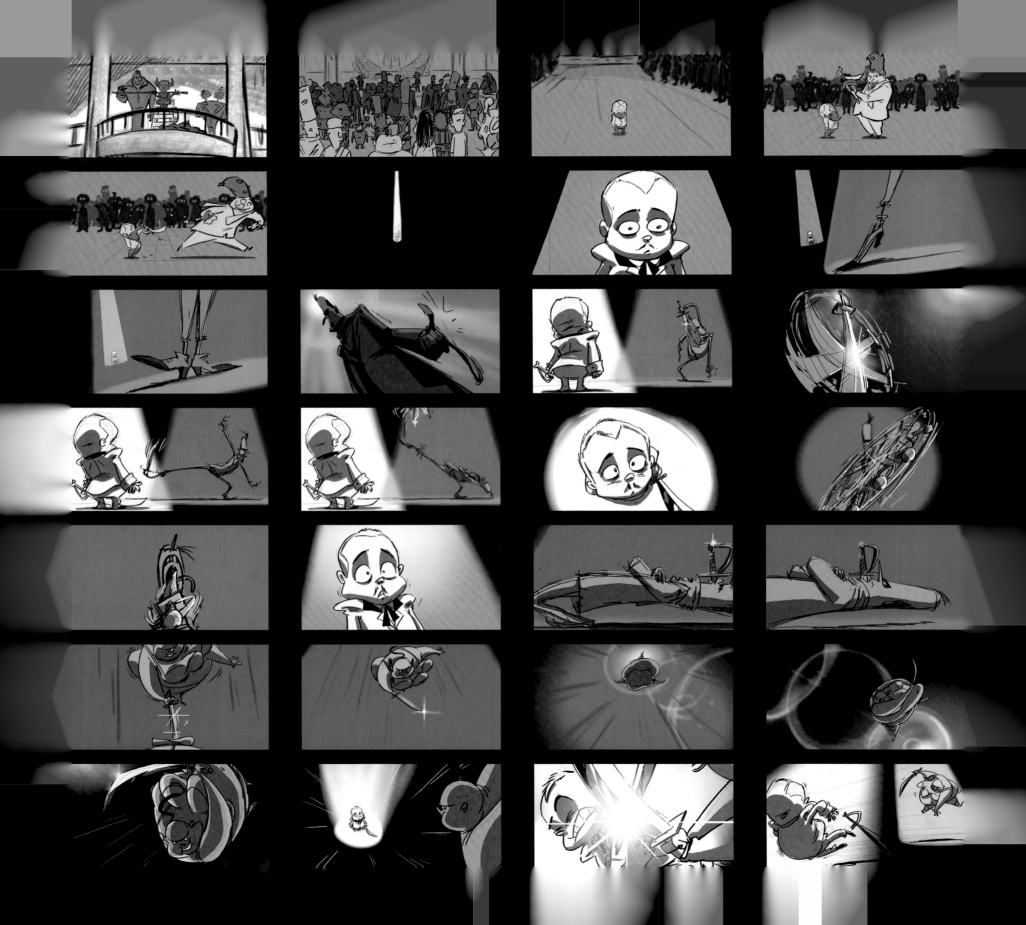

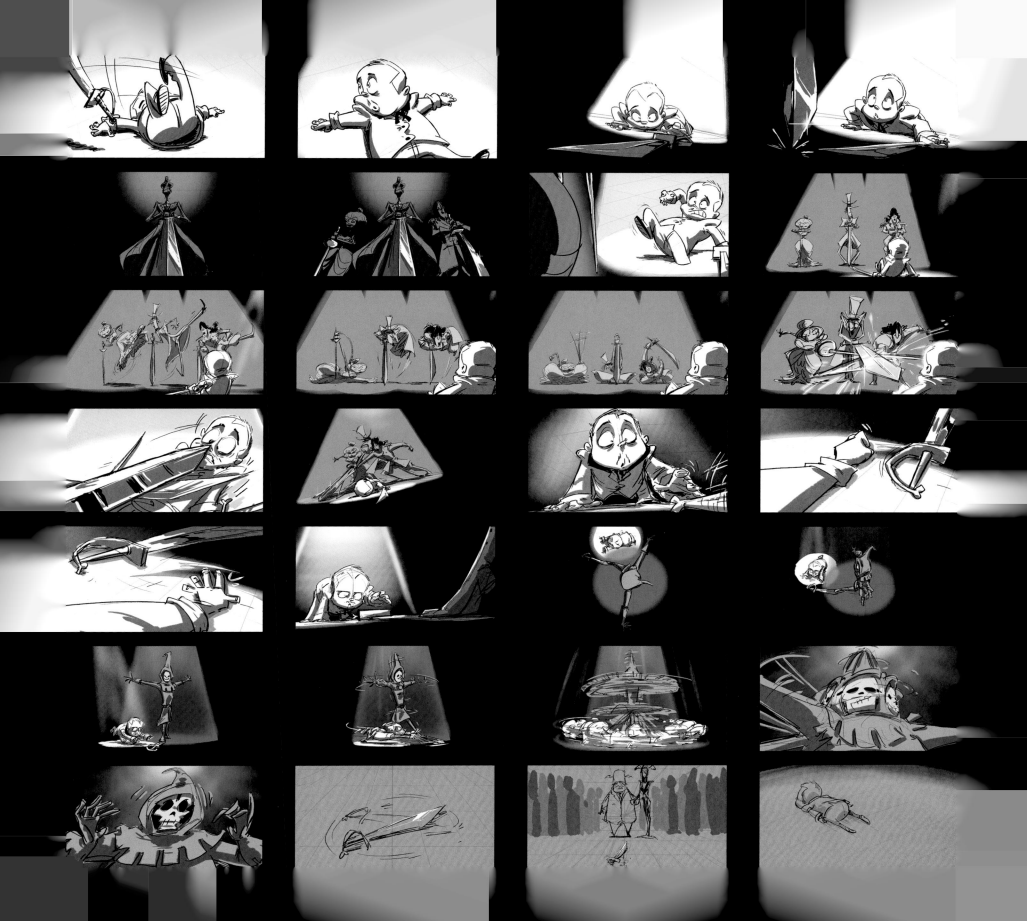

Living Room

Below: Living room – design concept

Below: Harpsichord lid interior – design surfacing study
Right: Lurch plays the harpsichord – final frame still

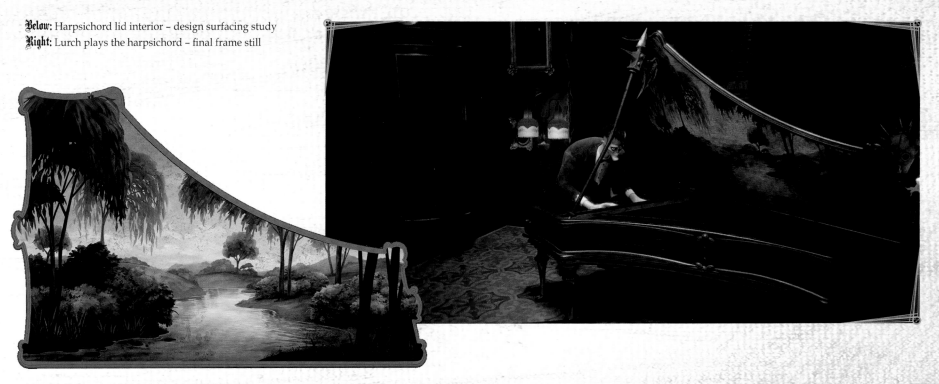

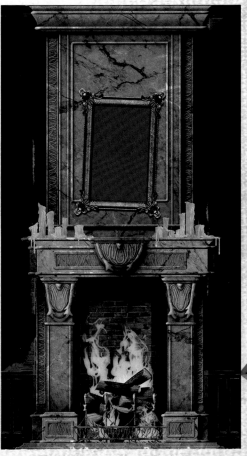

Left & right: Living room doorway, window, fireplace and floor – design surfacing studies

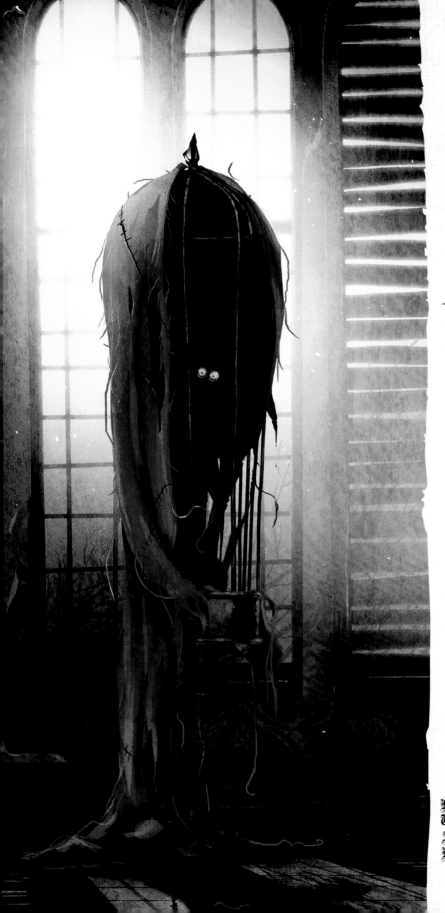

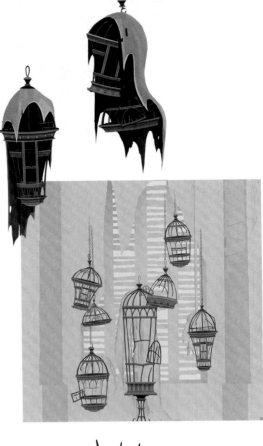

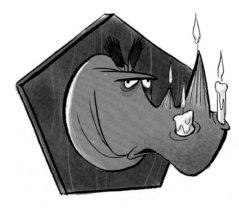

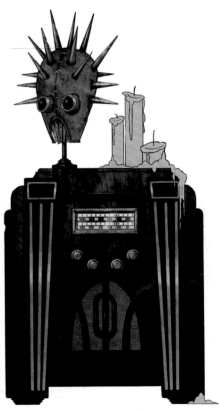

Left: Birdcage – concept art
Top: Bat cage – design models
Above: Taxidermy candle holder – design concepts
Right: Radio – design surfacing study

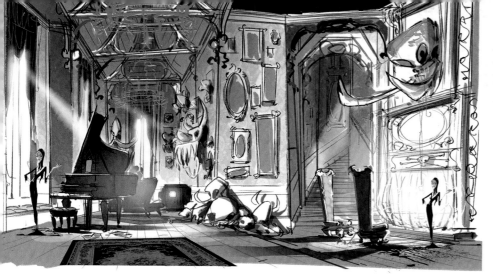

Above: Living room – concept sketch

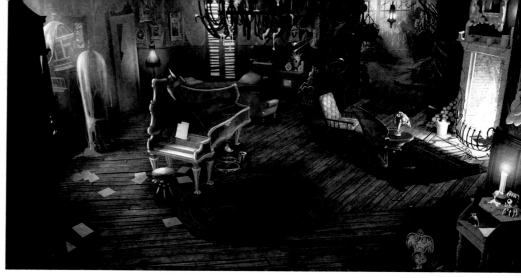

Above: Living room – design concept

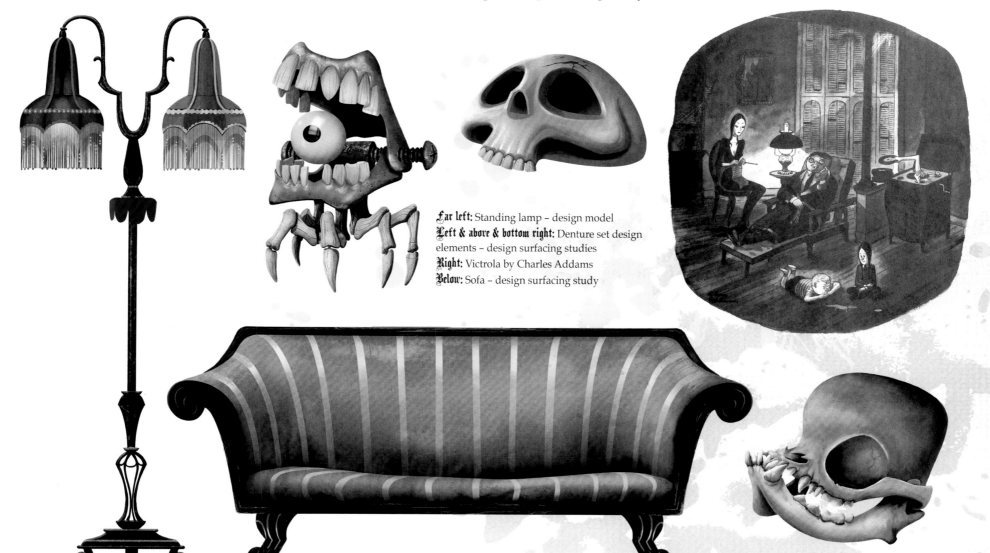

Far left: Standing lamp – design model
Left & above & bottom right: Denture set design elements – design surfacing studies
Right: Victrola by Charles Addams
Below: Sofa – design surfacing study

Kitchen

Below: Kitchen – lighting key
Right: Kitchen – design concept

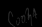

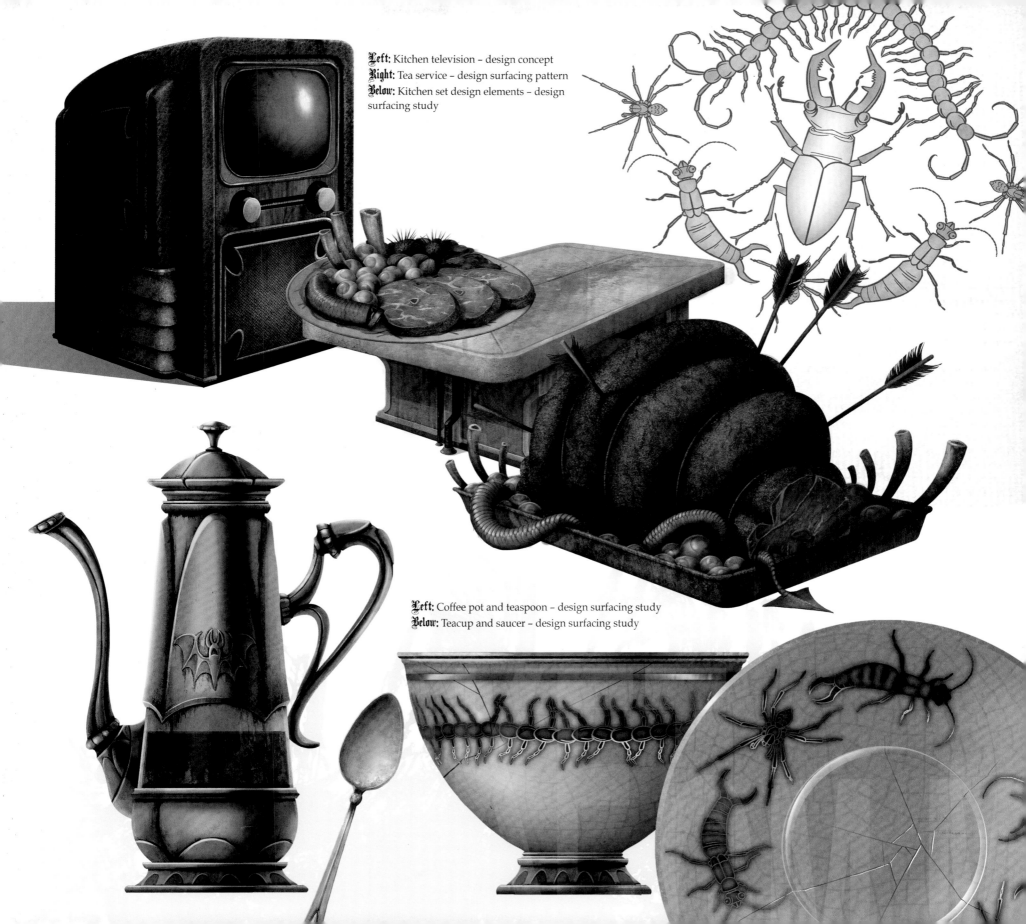

Left: Kitchen television – design concept
Right: Tea service – design surfacing pattern
Below: Kitchen set design elements – design surfacing study

Left: Coffee pot and teaspoon – design surfacing study
Below: Teacup and saucer – design surfacing study

Fester's Room

Though we do not see this location in the film, Fester's room was beautifully designed and conceptualized.

This image: Fester's room – unused design concept

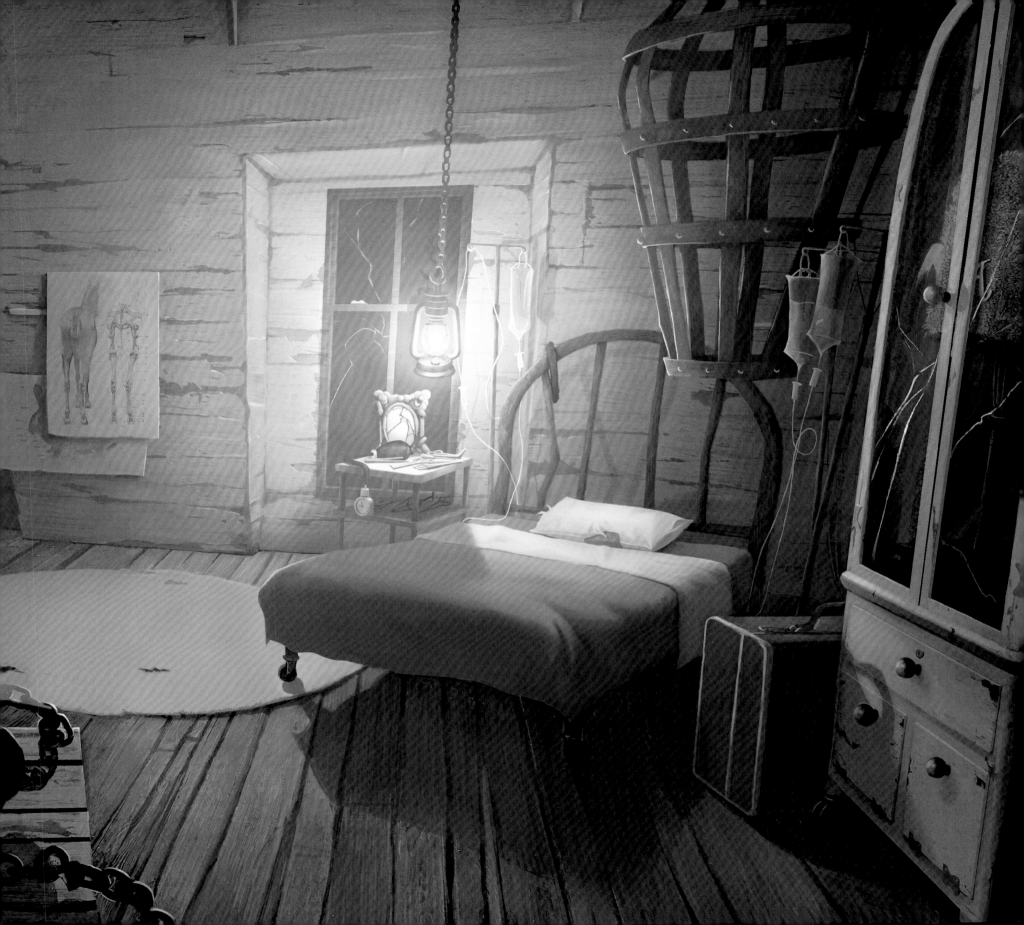

Right: Fester's room – unused design concept
Below middle: Fester in his room – storyboard panels

DIRT & STONE WALLS

MEDICINE CABINET

SINK

TOILET

SHELF OF BRAINS AND ORGANS IN JARS

DIRT FLOOR

DRESSER

DOOR

Left: Fester's room door handle – unused design surfacing study
Bottom: Fester's room – unused design surfacing studies

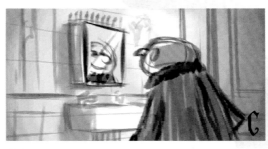

B

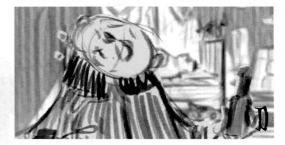

C

D

142

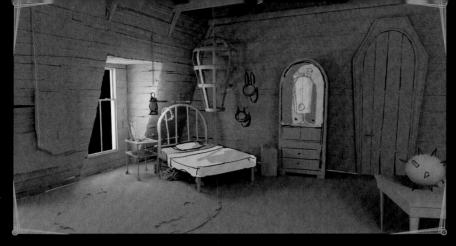
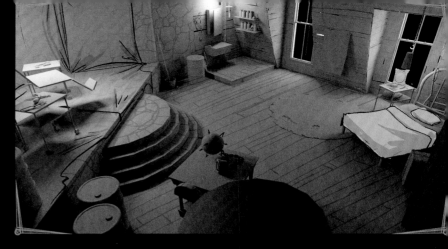
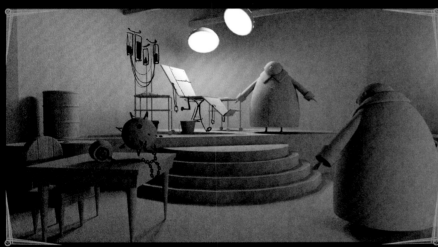
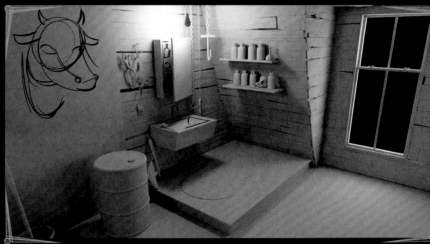

Above: Fester's room – unused design concepts
Below: Fester's room – unused design surfacing study

Above: Light switch and plug socket – unused design surfacing studies

Eastfield Estates Homes

Below: Eastfield Estates – concept art

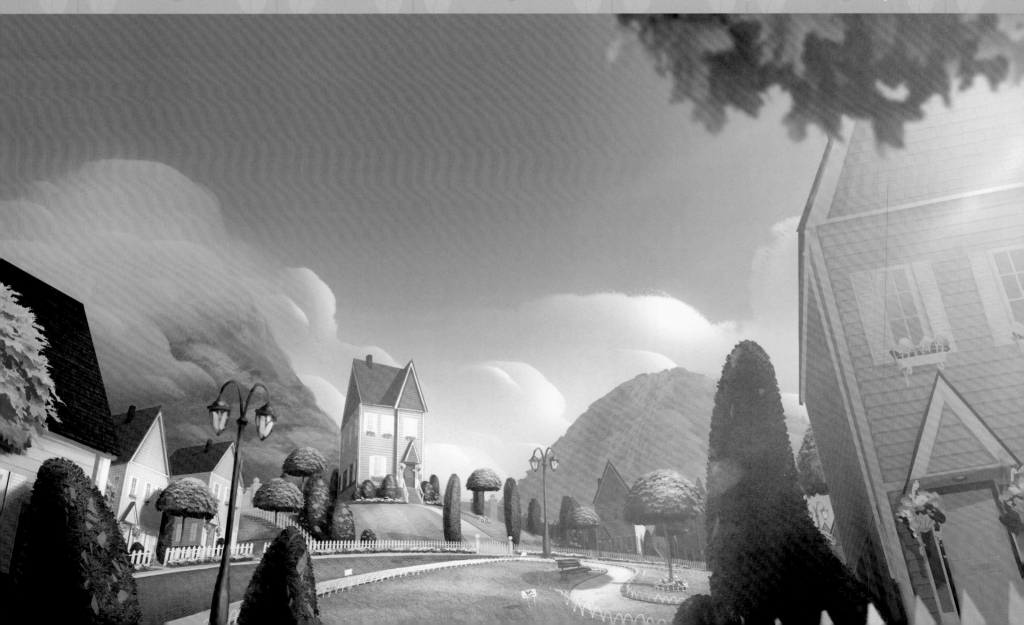

The artists had to keep the world of Margaux Needler and the perfectly manicured town outside the Addamses' home very simple. "Our original direction was that this is not a town that anyone would actually want to live in," recalls production designer Patricia Atchison. "It's very pretty and idyllic, and the town center is colonial style. The grass is perfectly cut, and the trees and hedges are all beautifully groomed. The colors are all pastels. The goal was to have it in complete contrast with the Addams house. Our challenge was to keep it very neat and simple, and not go crazy with the details."

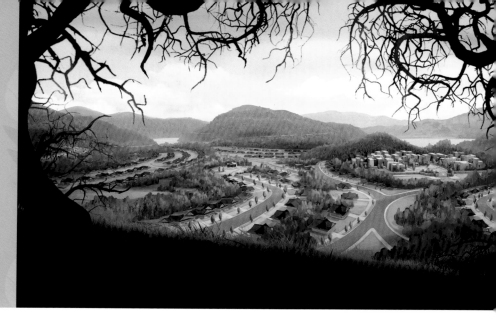

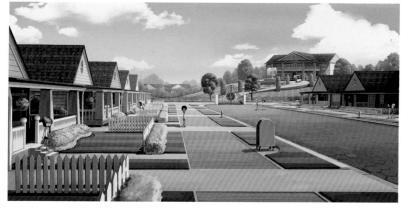

Top: View over Eastfield Estates – concept art
Above middle left: Eastfield Estates neighborhood – lighting key

Above middle right: Eastfield Estates neighborhood – design surfacing study
Above: Eastfield Estates houses – design surfacing studies

Square One

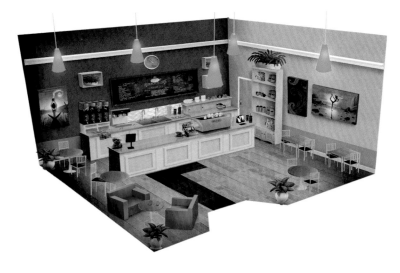

Above: Coffee shop interior – concept art
Right: Town square – design concept

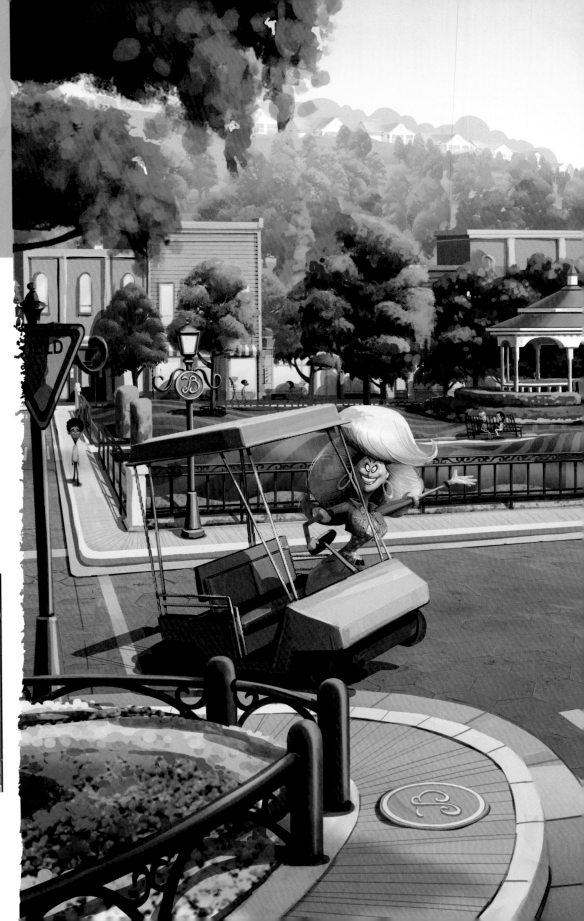

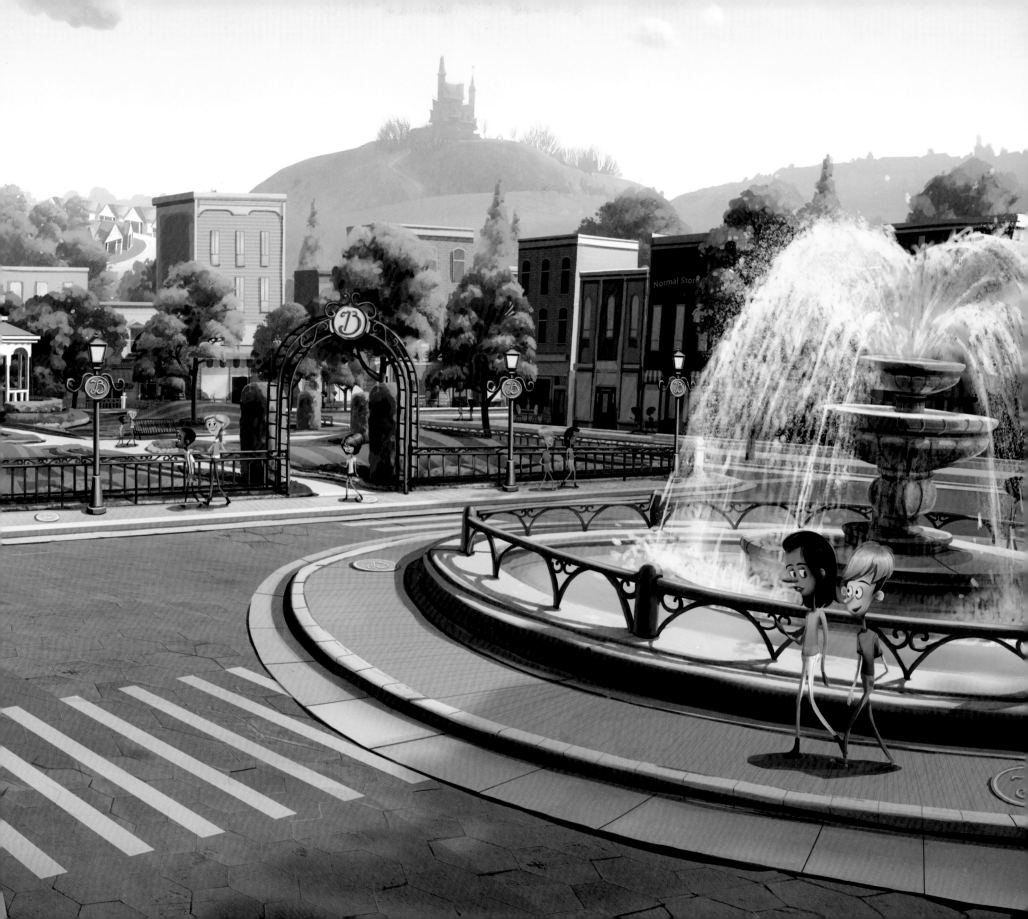

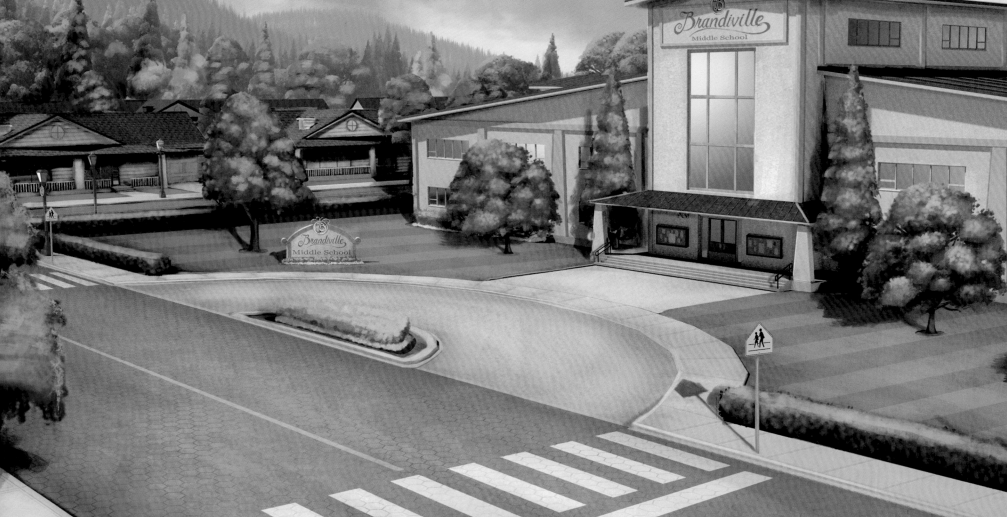

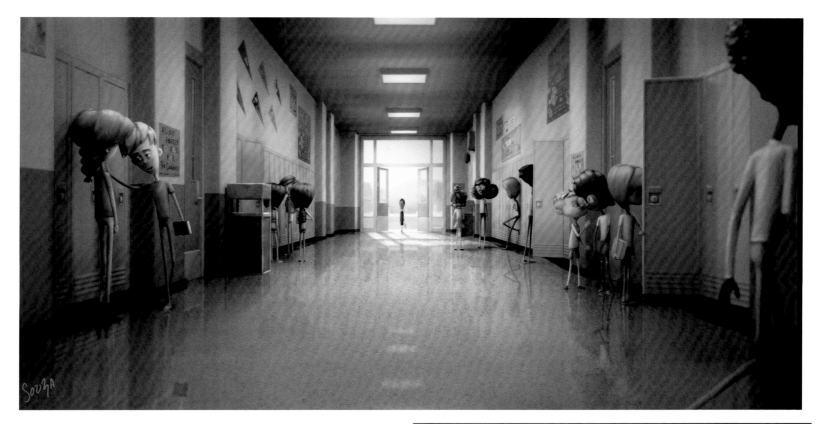

Left: Middle school exterior – design concept
Top & above: Hallway – design concepts

Above: Noticeboard – design surfacing study
Below: Middle school exterior – design surfacing study

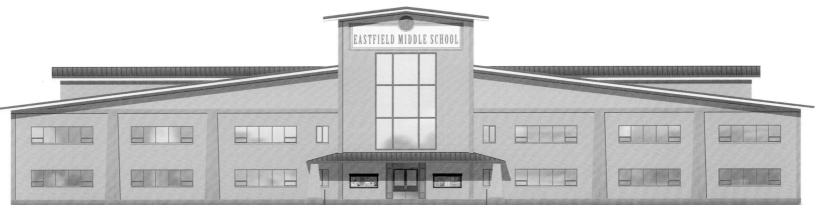

Above: Posters and banners – design surfacing studies
Below: Hallway – concept design

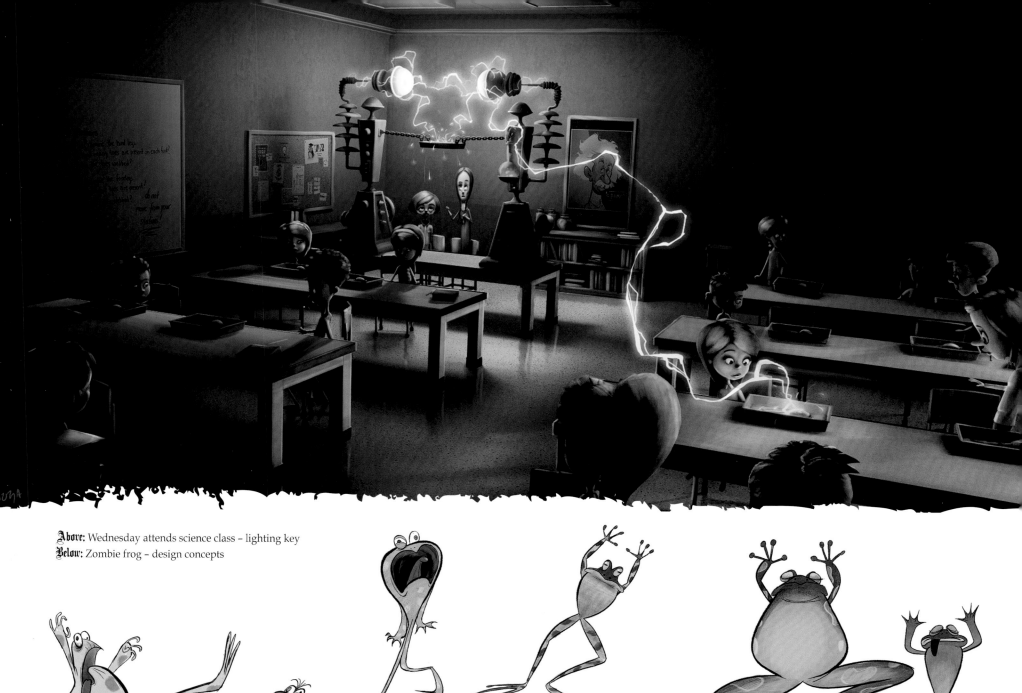

Above: Wednesday attends science class – lighting key
Below: Zombie frog – design concepts

Margaux's House

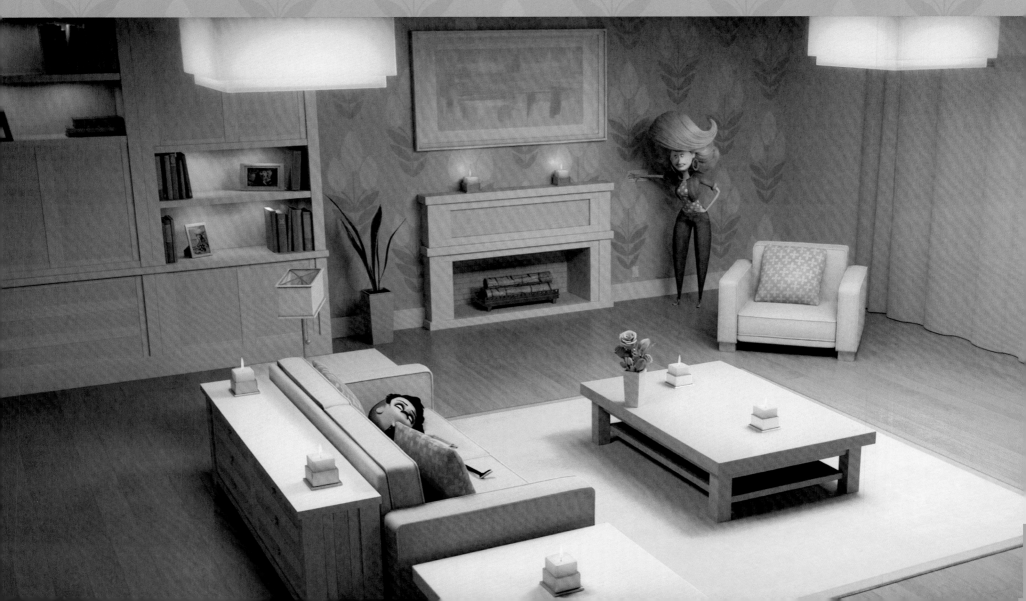

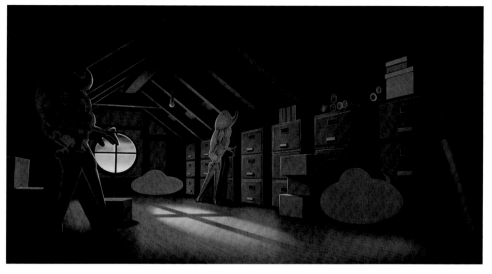

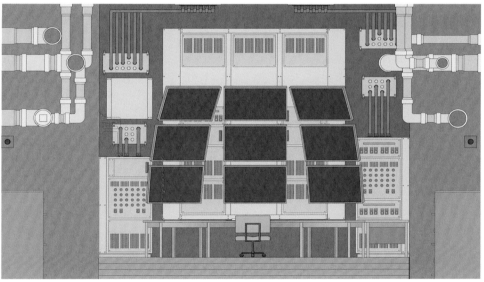
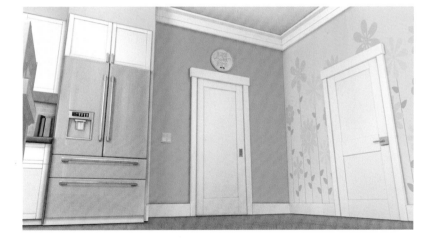
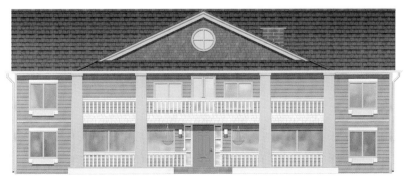
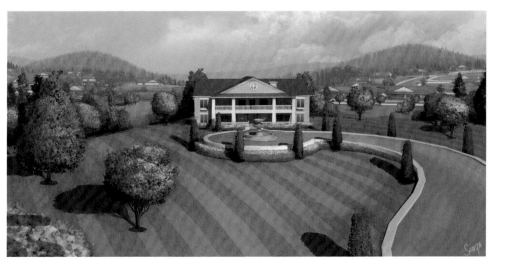

153

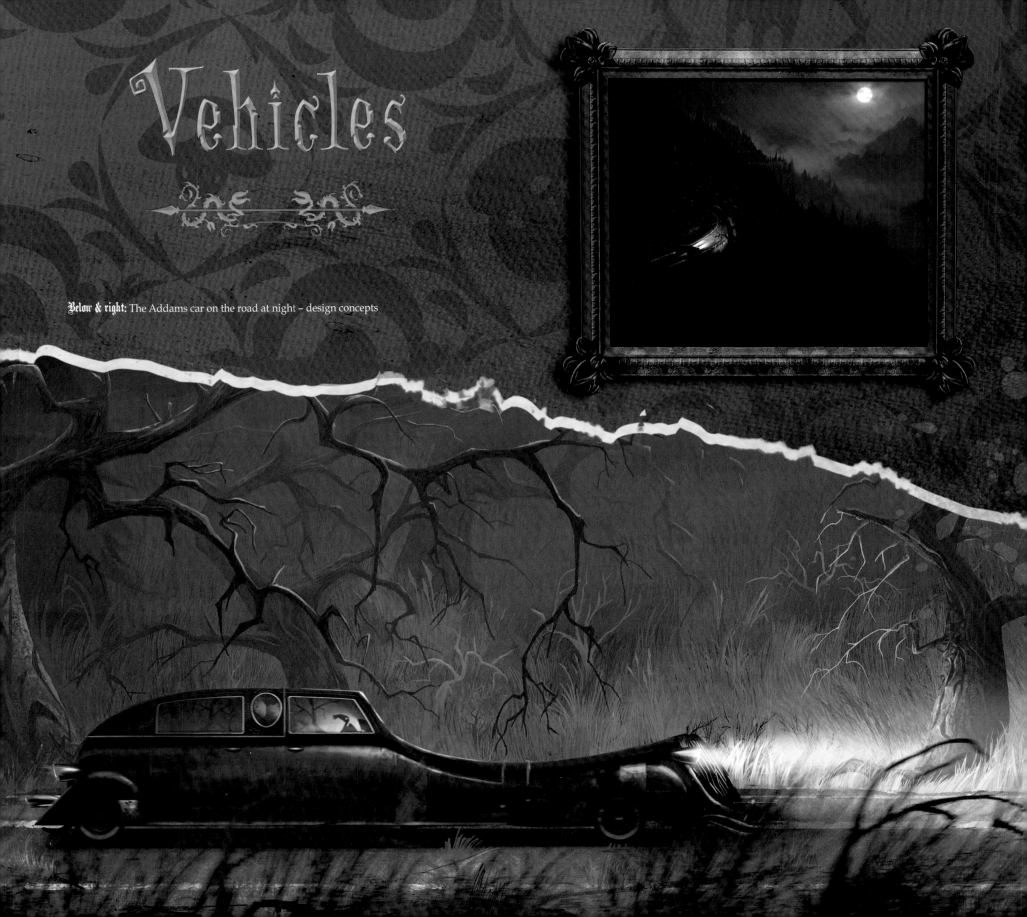

Vehicles

Below & right: The Addams car on the road at night – design concepts

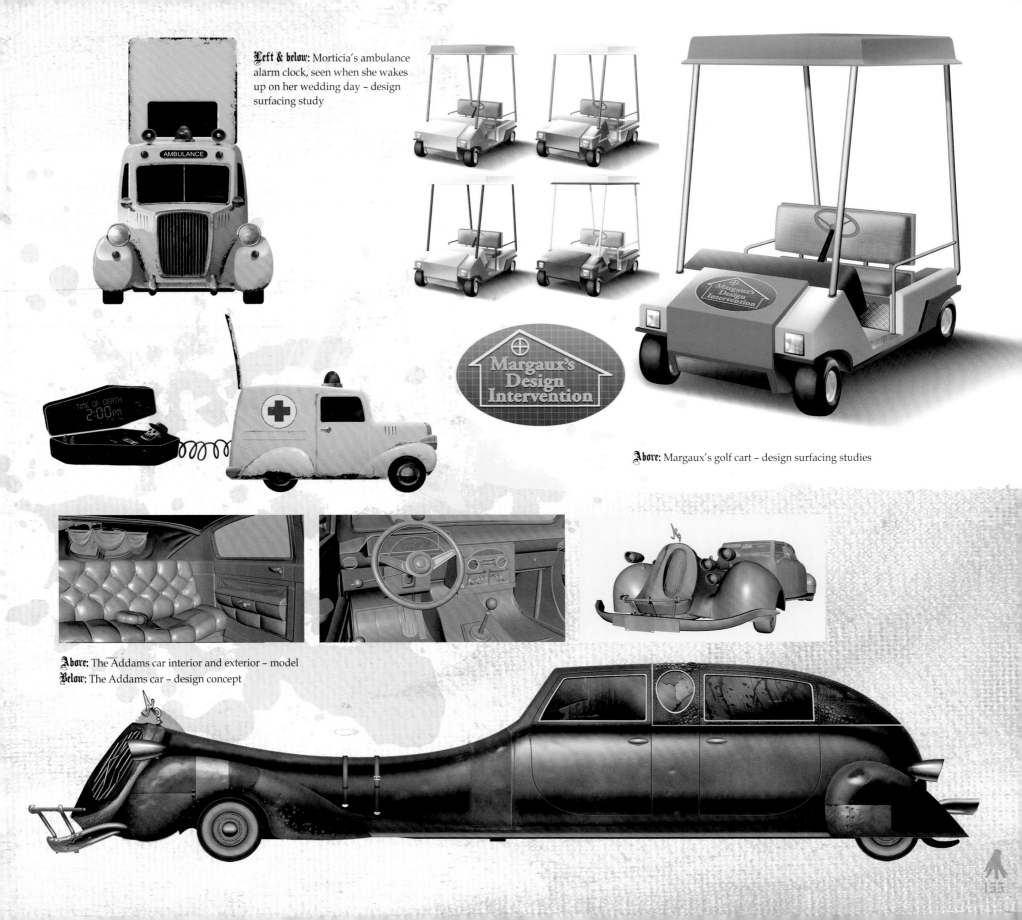

Left & below: Morticia's ambulance alarm clock, seen when she wakes up on her wedding day – design surfacing study

TIME OF DEATH
2:00 PM

Margaux's Design Intervention

Above: Margaux's golf cart – design surfacing studies

Above: The Addams car interior and exterior – model
Below: The Addams car – design concept

Anatomy Of A Scene

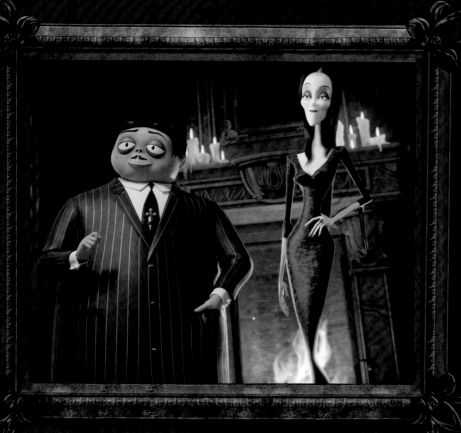

Above: Gomez and Morticia during family game night – final frame still
Opposite: Family game night – complete storyboard sequence (continued on pages 160, 161, 164 and 165)

Family Game Night

The family who plays ghoulish games together, stays together. At least, that's the case with the Addams clan. One of the key scenes of the movie happens early on in the first act, where we get to see the family enjoying a typical game night together, which offers a glimpse of how they all interact and sets up the film's central theme of daughter Wednesday feeling like an outsider in her own family.

"Here we see Morticia worrying because Wednesday is late for game night, and also have Gomez and Pugsley playing their own version of Battleship as they hide explosives in the house and use actual navy instruments to blow up Uncle Fester in the bathroom upstairs," explains director Conrad Vernon. "When Wednesday shows up, she is wearing a pink unicorn barrette, which is the first indication we have that she is being influenced by her new friend. We also see a lot of the house for the first time, both in terms of exterior shots and interiors."

According to animation director Mike Linton, the confrontation between Morticia and Wednesday proved to be a challenging sequence. "We have these two standoffish and very aloof characters locking horns," he recalls. "Trying to convey her as a rebellious teenager, but still being ironically Wednesday, was an interesting puzzle to solve."

Linton also really enjoyed animating Lurch grooving on the piano and introducing Grandma in this scene. "We had a lot of fun with Lurch there," he notes. "The directors really pushed for a contrast between his dead-eyed zombie expression and his soulful performance on the piano. We also meet Granny for the first time. Animating to Bette Midler's voice recordings was awesome. She brought so much to Granny's character. You really feel the gleeful-

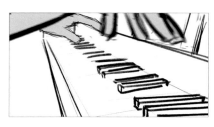

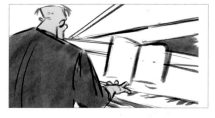

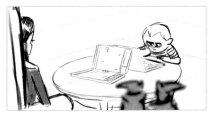

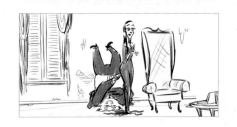

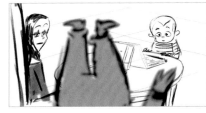

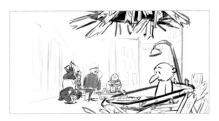
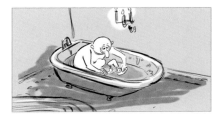

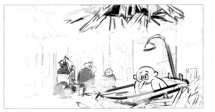

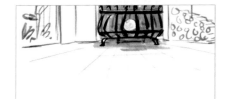

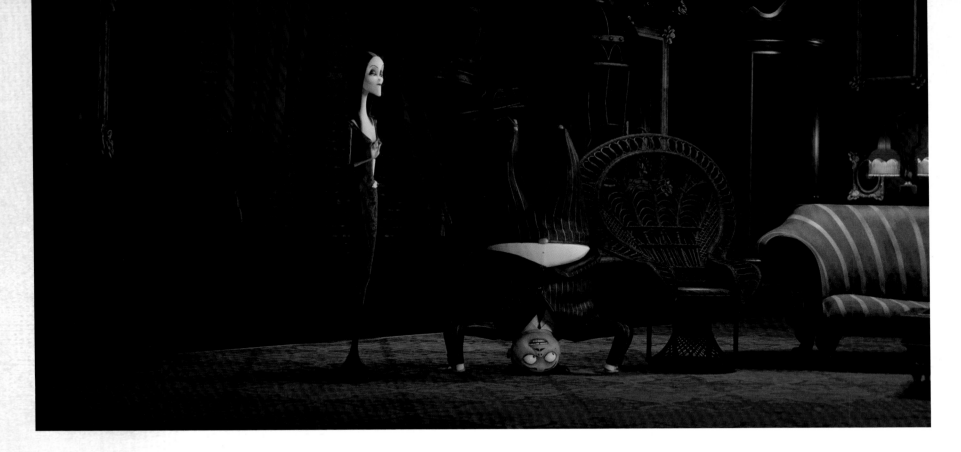

scoundrel personality oozing out of Granny's voice. Building that awkward funny tension between Morticia, Gomez and Granny took a bit of work. Granny revealing Gomez had confided in her his concern for Morticia and Gomez slowly realizing he screwed up and is now caught between his mother and his beloved took a bit of work to get right."

Previs and layout supervisor Rav Grewal says the scene is important since we really get to know everyone's personality for the first time in the movie. "It was one of the movie's scenes that went through many iterations," he remembers. "We are introducing Grandma and Wednesday. You see how Wednesday is after visiting the real world, and how protective Morticia is of her daughter. We also observe the playfulness of Gomez and Pugsley and the fun they have destroying the house together. Originally, the scene was boarded very loosely, but we had to restage the living room to make Grandma's entrance

work, as well as Morticia looking outside through the window. My team interprets the storyboards to CG, so in essence we have to deliver the bible for what the scene will be."

For modeling supervisor Casey Kirkpatrick, the scene had its share of interesting dilemmas as well. "The scene takes place in the living room and features most of the characters in the movie," he notes. "There is an explosion as they are playing Battleship: Pugsley bows up the F-6 location, Fester's tub comes crashing through the roof, and there's water everywhere. That living room was one of my favorite sets, because we included a lot of fun details. If you look closely, you can see a taxidermied pig's head next to a pig's butt. There's a wood pile with dynamite shoved in it. Then, you have axes and arrows everywhere. We also worked closely with the effects team to get the details of the explosion right, and there's water interacting with

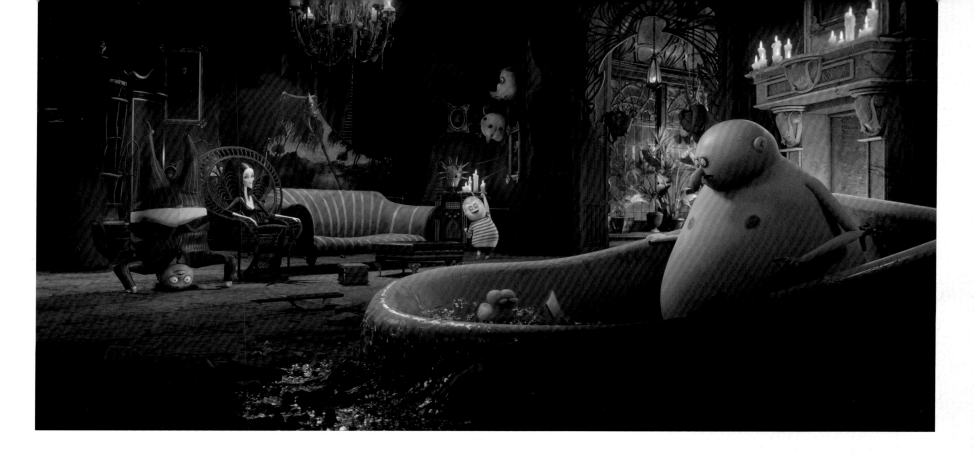

the destruction, since Fester was in a full tub."

Surfacing supervisor Marie-Eve Kirkpatrick says the Game Night scene was quite labor-intensive, because it is one of the first times the audience gets to see the house in great detail. "The carpet alone was a lot of work, because we have a lot of close-ups," she explains. "We established the plaster walls as well. We also see the harpsichord in the room. There are so many elements to take care of in every set in the Addams world. For example, we have over 450 assets in that scene: There are trinkets, cushions, couches and little candles everywhere. Each set took about three or four weeks."

Fester's fall through the ceiling also kept the surfacing team busy. "We had to make sure that when he lands on the carpet, it doesn't deform in a strange way," Kirkpatrick notes. "The team worked together to make sure everything was well integrated."

Story lead Todd Demong recalls that, in one version of the script, the family was playing a game of Hangman instead of Battleship. "It was quite funny since it was Lurch who was being hanged. It's just a cool idea to see them play their own versions of harmless family games. In the end, we went with Battleship instead, which also gave us a lot of laughs."

Director Greg Tiernan mentions that the scene also needed to balance the comedic elements with an underlying feeling of anxiety as Wednesday is missing from this regular family gathering. "This is where we introduce the fact that she may be pulling away from the family," he notes. "When Wednesday finally shows up, the scene shifts from fun and games to a serious discussion between Morticia and her daughter. The scene also makes great use of lighting to weave together all these different emotions quite well."

Above: Pugsley sinks Fester's battleship – final frame still

159

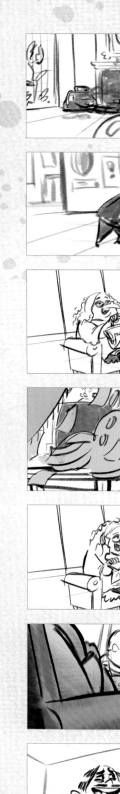
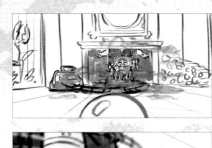
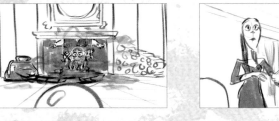
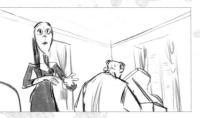
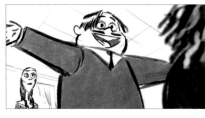
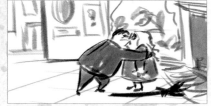
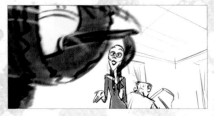
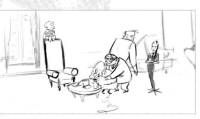
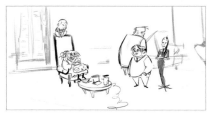
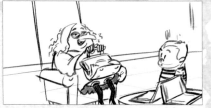
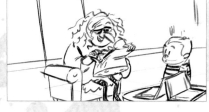

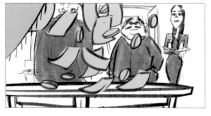
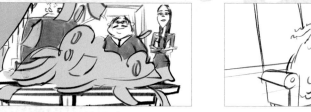
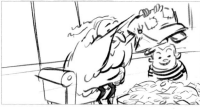
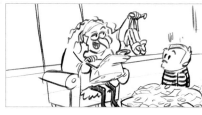
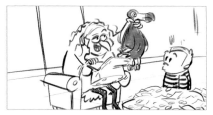
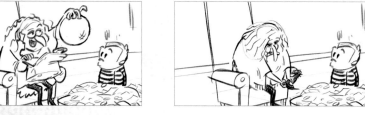

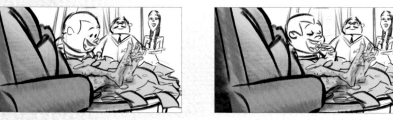
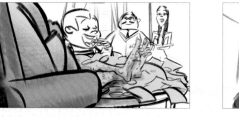

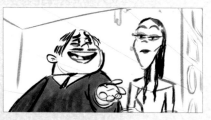
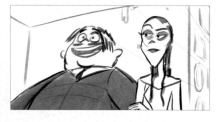
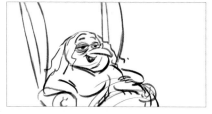
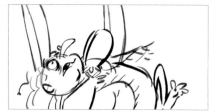

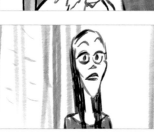

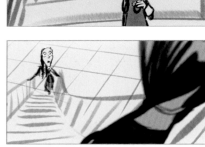

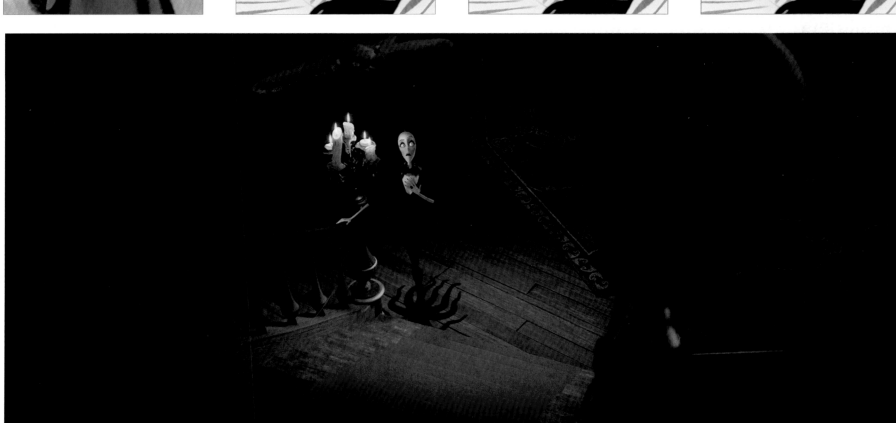

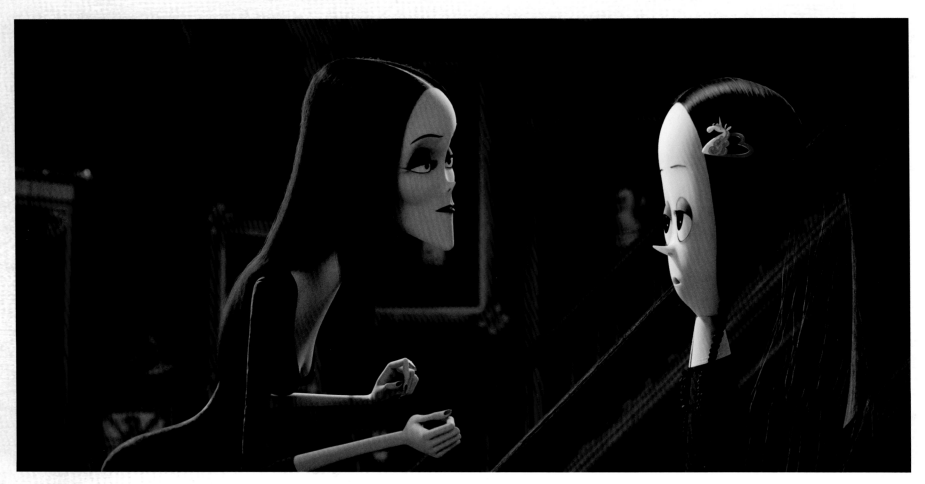

Previous page bottom: Morticia is alarmed by Wednesday's appearance – final frame still
Above: Morticia asks Wednesday about her new barrette – final frame still
Below: Barrette – design concepts

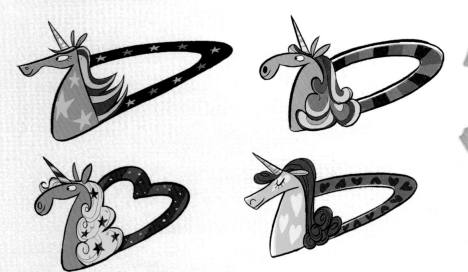

"I am super proud of the emotional beats that we've been able to achieve with the movie, where we are able to show what it's like not to be accepted as 'normal' by society, and how wrong it is to mistrust people of different nationalities, backgrounds and sexual preferences."
Greg Tiernan, Co-Director

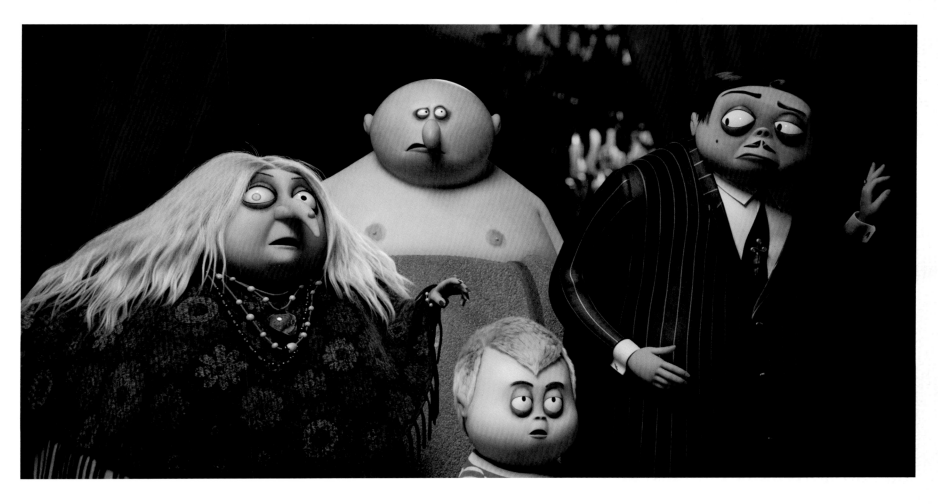

As lighting supervisor Laura Brusseau explains, "We had to express this contrast in moods, as Morticia is questioning the reasons why Wednesday is pulling away from her. Meanwhile, the rest of the family hasn't noticed this, and they're having fun playing the game and blowing things up. As Morticia looks longingly through the window, we have this cool moonlight shining on her, while we can also see a huge roaring fire behind her. We re-emphasize the story points with the colors we use. Her eyes are sparkling, and we can feel the warmth of the room behind her."

Granny's arrival at the house also posed a few questions for surface effects supervisor Yiqun Chen and her team. "This is the first time we see this fascinating character in the movie, and we needed to develop a special rig for her hair," she recalls. "Other complications were caused by the things that she wears—her shawl, necklace and bracelets, and they all had to react correctly to her movements. We also had a lot of fun grooming her hairy legs! Gomez is standing on his head in this scene, which posed more challenges, since we had to make sure his hair and clothing all hang realistically. Because this was one of the first scenes we worked on and it had its share of challenges, it had the effect of making our team (sixteen people in our department) tighter and closer, as we all worked together to make sure everything looked realistic and natural."

Above: Grandma, Fester, Pugsley and Gomez eavesdrop on Morticia and Wednesday's conversation – final frame still

Next spread top right: Wednesday guillotines dolls in her room – final frame still

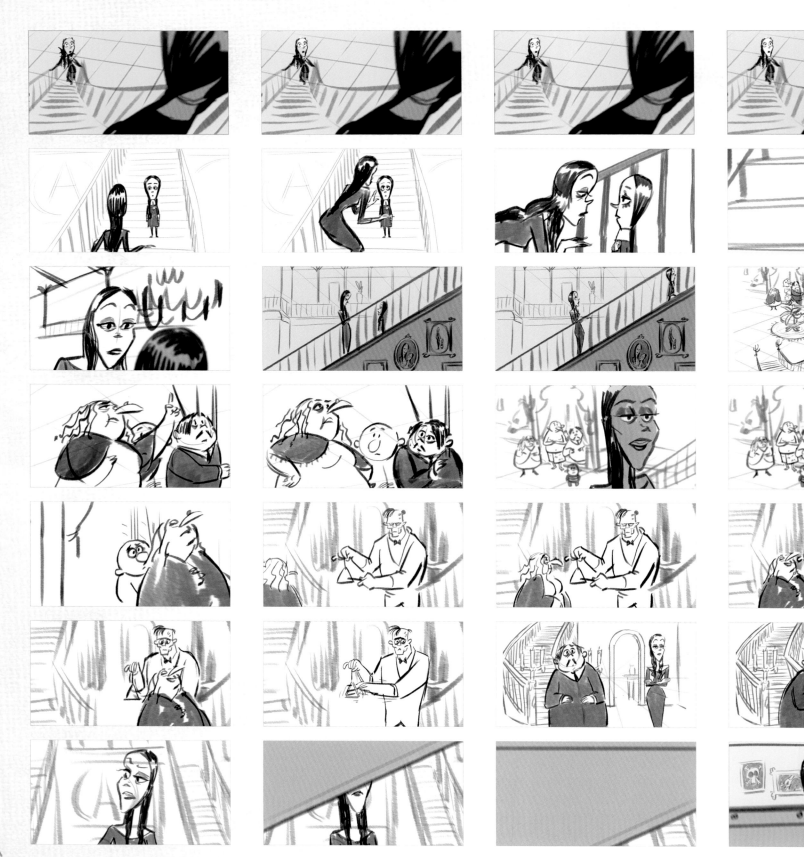

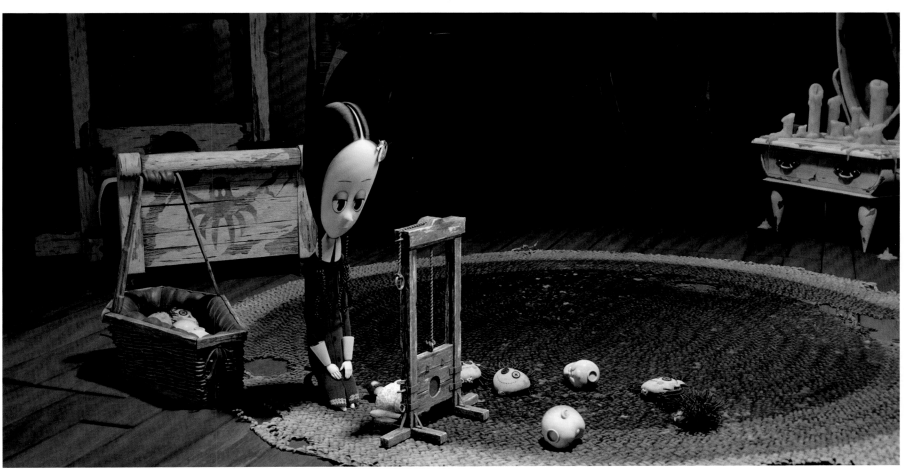

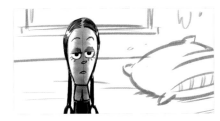
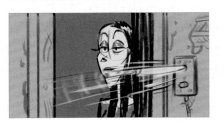

Conclusion

The mere mention of the names Morticia, Gomez, Wednesday and Pugsley or a snippet of the famous *Addams Family* theme song can bring smiles to fans' faces. That's because Charles Addams' brilliant, macabre and hilarious clan has a way of making you fall in love with their crazy antics and twisted universe.

Now, thanks to the exquisite work of directors Conrad Vernon and Greg Tiernan and their talented team at Cinesite Studios, a new generation of audiences around the world will be introduced to these evergreen characters. As the artistic and technical teams behind *The Addams Family* have pointed out in these pages, the film's cutting-edge CG animation allowed the filmmakers to explore new opportunities and visual possibilities for the well-known characters. We are invited to learn more about the beginnings of the love affair between Morticia and Gomez, and discover new storylines and characters that intrigue and entertain us. At the same time, the artists play with dark color schemes and nuanced details in every scene and background.

More importantly, the movie explores the very timely notion of embracing outsiders and those who don't fit the usual definitions of normalcy. In the words of Addams himself, "Normal is an illusion. What is normal for the spider is chaos for the fly." We hope he would have loved the inspired lunacy and clever visuals of this new animated take on his creations.

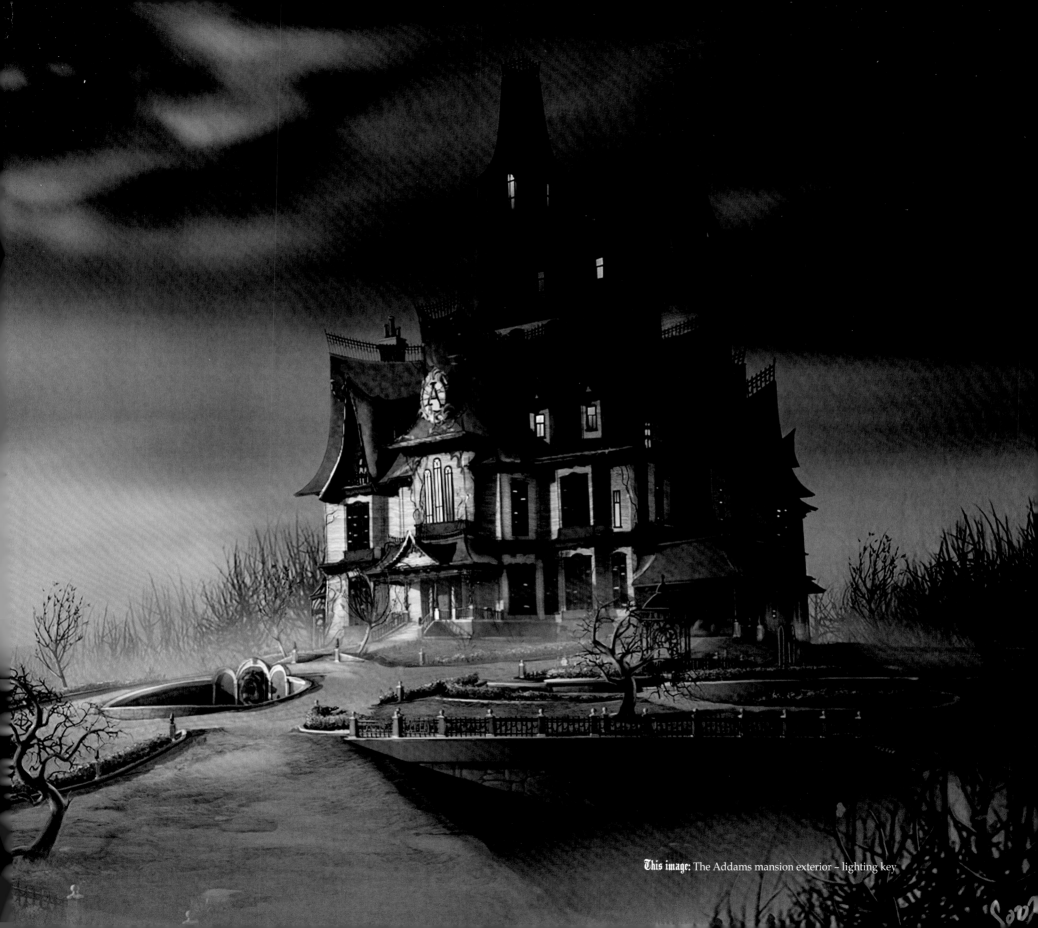

This image: The Addams mansion exterior – lighting key

CONTRIBUTING ARTISTS

In alphabetical order: Negar Ahmadi, Patricia Atchison, Jake Collinge, Fran Delgado, Florian Fiebig, Nicole Garber, Alex Juhasz, Damien Labonte, Michelle Lannen, Jeannie Lee, Mike Linton, Maisha Moore, Bastien Pourchier, Alfonzo Salazar, Chris Souza, James Tohill, Jack Yu.

Author's Acknowledgements

It has been a huge honor to write about the making of the new *Addams Family* animated movie, and I would like to thank all the talented people at Cinesite Animation and MGM who worked long and hard hours to re-introduce these wonderful characters to modern audiences in 2019. I am forever indebted to the talented directors Conrad Vernon and Greg Tiernan who patiently talked about their creative process with me and gave me a sneak peek of their baby.

A big thanks to the film's producers Gail Berman, Alison O'Brien, Alex Schwartz, Danielle Sterling, character designer Craig Kellman, production designer Patricia Atchison, head of story Todd Demong, animation director Mike Linton, previs and layout supervisor Rav Grewal, modeling supervisor Casey Kirkpatrick, surfacing supervisor Marie-Eve Kirkpatrick, lighting supervisor Laura Brusseau, effects supervisor Yiqun Chen and everyone else on the film's crew who were kind enough to talk about their experiences with me. Also, a big thanks to the lovely, always helpful and super organized Karol Mora at MGM Consumer Products Publishing who held my hand throughout the whole process.

Thank you to the fantastic team at Titan Publishing, especially my gifted and patient editor Jo Boylett and talented designers Natalie Clay and Tim Scrivens who sprinkled their magic on every page of this book.

Finally, I'd love to raise a glass of bat juice to toast the genius of Charles Addams, who first introduced this magnificent, timeless family in the pages of *The New Yorker*. What a terribly dull world this would be without Morticia, Gomez, Wednesday, Pugsley, Fester, Grandmamma and all his other kooky and creepy characters, and how lucky we are to enjoy all these years of macabre magic.

MGM Acknowledgments

Thank you to all involved for making this book project such a joy! To Jo Boylett and her team at Titan, and our golden author, Ramin, you are all so wonderful; to Conrad Vernon and Greg Tiernan, your time and thoughts are invaluable and so greatly appreciated; Lindsay Verbil, we truly could not have done it without all your help and patience; to Patricia Atchison and the artists for taking the time to provide us with the beautiful art that fills this book; special thanks to Bruce Franklin, Alex Schwartz, Alison O'Brien, Gail Berman, Danielle Sterling, Marcela Cantu, Danielle Clifford, Gavin Bedford, and to everyone who took the time to interview for the book. Thank you to H. Kevin Miserocchi of the Tee and Charles Addams Foundation for providing the wonderful original cartoons. Hats off to Charles Addams!

Glossary

Color Key: Color keys show locations in neutral lighting for palette.

Design Ortho[graphic]: A two-dimensional graphic representation of an object in which the projecting lines are at right angles to the plane of the projection.

Design Surfacing: Enhancing the appearance of characters, props, and environments according to the visual style of the animated film.

Lighting Key: Lighting keys show said locations in different lighting scenarios.

Look Render: Rendering is the final process of creating the actual animation from the prepared scene; a look render shows how an element should look in the final animation.

Storyboard: A sequence of often rough drawings, sometimes including directions and dialogue, representing the shots for a movie.